Preparing Educators for Arts Integration

Preparing Educators for Arts Integration

Placing Creativity at the Center of Learning

Gene Diaz and Martha Barry McKenna, Editors

Foreword by Jane R. Best

TEACHERS COLLEGE PRESS

TEACHERS COLLEGE | COLUMBIA UNIVERSITY
NEW YORK AND LONDON

Published by Teachers College Press, 1234 Amsterdam Avenue, New York, NY 10027

Copyright © 2017 by Teachers College, Columbia University

Cover design by Rebecca Lown Design. Cover art by Taigi / Shutterstock.

Figure 3.1 originally appeared in CAST, *Universal Design for Learning guidelines* (2011, Version 2.0), and is reprinted by permission of CAST, Inc. © CAST, 2015.
Figure 6.1 is reprinted by permission of Gary Peterson.
The photo featured in Figure 13.1 is reprinted by permission of photographer Lee Choo, CSUN Today

Library of Congress Cataloging-in-Publication Data is available at loc.gov

ISBN 978-0-8077-5848-9 (paper)
ISBN 978-0-8077-5849-6 (hardcover)
ISBN 978-0-8077-7581-3 (ebook)

Printed on acid-free paper
Manufactured in the United States of America

24 23 22 21 20 19 18 17 8 7 6 5 4 3 2

Contents

Foreword

Whether consciously or not, many of us have welcomed the role of the arts as critical to our learning experiences. Some people are quick to recognize that concepts are more readily understood through the integration of the arts into curriculum. Others come to understand the significance of the arts when given time to reflect on their best learning experiences. My position as the director of the Arts Education Partnership (AEP) has offered me the opportunity to be mindful of how differently people come to such realizations. It has also allowed me to be intentional about the emphasis I place on integrating the arts into teaching and learning.

My career path to leading AEP is deeply rooted in the community where I was educated. I grew up in Elkhart, Indiana, which at the time of my childhood was home to over 60 musical instrument manufacturers. I consider myself a fortunate recipient of a community's commitment to its citizens and schools that the arts would be an integral part of student learning. The arts were vital to my hometown's culture, so we valued music as well as the visual arts, dance, and theater in schools and community centers. Growing up in this environment taught me that every child should be exposed to the power of the arts in learning.

Formed in 1995 as an interagency agreement between the National Endowment for the Arts and the U.S. Department of Education, AEP is the nation's hub for over 100 education, business, cultural, government, and philanthropic organizations that strive to make it possible for every child to succeed in school, work, and life by including arts as an integral part of their education. Today the opportunities that exist for communities to put theories about arts integration into practice are plentiful. Passage of the Every Student Succeeds Act (ESSA) suggests wonderful opportunities to engage educators in arts integration—preparation for which is described in the timely and topical issues explored in this book.

The authors of this text are members of AEP who came together to create a community of practice for preparing educators in arts integration. Through their chapters the authors demonstrate the diverse partner organizations and priorities of AEP in bringing the arts to students. We all work together on the common goal of including the arts in education. The AEP 2020 Action Agenda for Advancing the Arts in Education outlines goals and

strategies to raise student achievement and success, support effective educators and school leaders, transform the teaching and learning environment, and build leadership capacity and knowledge.

Preparing Educators for Arts Integration: Placing Creativity at the Center of Learning addresses these AEP priority areas and the demands of the field in a meaningful way. It brings to the forefront empirical research, statewide models, and educator training programs that provide successful approaches for arts integration that address pedagogy, standards alignment, and professional development with its many challenges. This book also affirms an ideal of helping more schoolchildren and communities realize the importance of arts integration and how it can make a difference in the classroom, improving the preparation of all for work and life.

—Jane R. Best, director, Arts Education Partnership

Acknowledgments

We'd like to thank all the wonderful folks at the Arts Education Partnership (AEP) who have supported this work over several years. AEP has been bringing people together in their national forums, where ideas are sparked and new projects are germinated. We are especially grateful to Dick Deasy, founding chairman of AEP, for his encouragement and support for our gatherings and for always ending each forum with the question, "Did you meet someone new here?" Everyone in the group always raised their hands. Dick created the Higher Education Working Group in AEP, which led to the colleagues in this book coming together to learn from one another about the work in arts integration that is happening across the country. In large measure this publication is a result of Dick's vision to expand understanding and advocacy for arts integration as a path for all students to have access to the arts every day. Dick also generously contributed to our Introduction to ensure that we captured the catalytic role of AEP in promoting arts education, and in particular integrated arts education. We are grateful that Sandra Ruppert, former director of AEP, continued in Dick's path by encouraging those of us in higher education to pursue publishing our efforts. This book was initially guided by Scott Jones, researcher at AEP, who helped us conceptualize what it could be.

We are especially grateful to all our colleagues who have contributed to the chapters in this text. This community of practice met for several years at AEP forums and online to share the ideas that created this publication. We hope that the approaches they present throughout the book will inform colleagues across the nation who prepare educators for arts integration. We appreciate their commitment to education and generosity in reflecting on their work so that others might benefit.

We are deeply indebted to our colleagues and students at Lesley University; to the faculty in Creative Arts in Learning, who have traveled thousands of miles across the United States to offer arts integration to educators and who have always believed in the innovative work they do through good times and bad; and especially to our students in these arts integration programs, who have shown us the value of teaching in, through, and with the arts in their classrooms. Our students have always been our best and most imaginative teachers.

To our families who have supported this project from its inception, we are most grateful. They have always encouraged our work and supported our growth as teachers and scholars. As we prepared this text, our families were forgiving when work took us away from time with them. We are especially thankful for Kevin McKenna, who supported us during long days of writing.

To each other we offer a special gratitude. As we work together, we continue to grow in our appreciation for what each of us contributes. We both consider ourselves fortunate to be able to share the burdens and the joys of creating this work.

—Gene Diaz
Martha Barry McKenna
Cambridge, MA, 2016

Introduction

Gene Diaz and Martha Barry McKenna

> Arts Education Partnership organizations affirm the central role of imagination, creativity, and the arts in culture and society; the power of the arts to enliven and transform education and schools; and collective action through partnerships as the means to place the arts at the center of learning. (Arts Education Partnership, 2002, p. 1)

"Art Makes You Smart," states the headline of the *New York Times* review section (Kisida, Greene, & Bowen, 2013). And the headline on the blog of the Royal Conservatory of Canada reads, "Learning Through the Arts Students Achieve Better Academic Results" (Embleton, 2014). If art makes you smart and learning through the arts leads to better academic achievement, then why don't we have the arts in every school, for every student, every day? The research behind the headlines identifies the gap between what's demonstrated to be effective for learning and what students experience in their schools every day. The authors of this book see the arts as fundamental to every child's learning because they have engaged in research in schools and observed the benefits for children when teachers are able to integrate the arts into and across the curriculum. The arts allow children to express and communicate their ideas, feelings, and thoughts through multiple modalities. Thus the arts allow equity of access to learning for all children.

WHY ARTS EDUCATION?

According to *Art for Art's Sake? The Impact of Arts Education,* a research-based publication of the Organisation for Economic Co-operation and Development (OECD), the main benefit of education in the arts is the acquisition of artistic habits of mind. These habits of mind include the development of craft and technique in arts fields, as well as "skills such as close observation, envisioning, exploration, persistence, expression, collaboration, and reflection—the skills in thinking and creativity and the social and

1

behavioral skills that are developed in the arts." In addition, the authors note that arts education matters for innovation because "people trained in the arts play a significant role in the innovation process in OECD countries" and that "the intrinsic value of the arts and the related skills and important habits of mind that they develop" should be the primary justification for education in the arts (Winner, Goldstein, & Vincent-Lancrin, 2013).

How do these benefits relate to the overall goals of education in the United States in the current climate of the Common Core State Standards (CCSS)? And how do the CCSS relate to the goals of arts education? To address these questions, David Coleman, one of the CCSS's authors, developed *Guiding Principles for the Arts*, in which he recommends that arts teachers and students "engage in deep, sustained study of a limited number of works of art . . . and utilize the arts as powerful tools to develop and refine skills of observation and interpretation that are a cornerstone of the Common Core" (Coleman, 2011).

In an article in *The Arts and Common Core*, Amy Charleroy, one of the contributors to this book, writes that the alignment of arts education with CCSS objectives may provide arts teachers with a common language with which to describe the cognitive skills that they cultivate through meaningful arts experiences (The College Board, 2012). In this document she and her co-authors note the areas in which the Common Core State Standards explicitly recommend arts-based study. They point out that opportunities for more complex and richer alignment arise when we look at the philosophies, goals, and habits of mind that are present in both the CCSS and in the National Core Arts Standards. We address this issue here not for the sake of CCSS, currently in dispute across the nation, but for how the CCSS identifies good teaching practices.

The philosophical foundations and lifelong goals established by the National Coalition for Core Arts Standards (NCCAS), as the basis for the new (2014) standards in arts education linked to the CCSS, suggest that five basic values shape the expectations for arts learning. The **arts shape communication**: "The arts provide unique symbol systems and metaphors that convey and inform life experience (i.e., the arts are ways of knowing)." **The arts foster creative personal realization**: "Participation in each of the arts as creators, performers, and audience members enables individuals to discover and develop their own creative capacity, thereby providing a source of lifelong satisfaction." The **arts offer connections across time and space**: "Understanding artwork provides insights into individuals' own and others' cultures and societies, while also providing opportunities to access, express, and integrate meaning across a variety of content areas." **The arts foster well-being**: "Participation in the arts as creators, performers, and audience members (responders) enhances mental, physical, and emotional well-being." **The arts promote community engagement**: "The arts provide means

for individuals to collaborate and connect with others in an enjoyable inclusive environment as they create, prepare, and share artwork that brings communities together" (NCCAS, 2014).

To be fully prepared when they leave high school for college, career, and life, students need comprehensive education that "includes deep, expansive knowledge in a broad range of subjects as well as advanced reading, writing, and computational skills" (Arts Education Partnership, 2015). Students must be able to think creatively and synthesize information across disciplines, combining it in innovative ways. They learn analytical reasoning, effective communication, and collaboration by developing knowledge, skills, and competencies through an active and participatory engagement with the arts.

The Arts Education Partnership research database, ArtsEdSearch.org, demonstrates that students who study the arts outperform students with little or no arts involvement; they receive better grades, have more positive attitudes about school, and are more likely to graduate from high school. Economically disadvantaged students are shown to benefit the most from arts education, yet they are the most likely to have little or no access to the arts.

THE ROLE OF ARTS EDUCATION PARTNERSHIPS

We recognize that many educators don't know *how* to bring the arts to students. This book seeks to rectify the problem by offering perspectives and practices of arts integration. We describe and analyze professional development programs in arts integration from across the nation that function despite the real limitations of budgets, regulations, and policies. The programs that we have developed and lead are based in partnerships that require collaborations of all members of what is known as the arts teaching workforce:

> The *arts teaching workforce* is defined as classroom teachers, arts specialists, teaching artists, higher education faculty and members of arts and cultural institutions who provide arts instruction. The [Higher Education] Task Force recognizes that this broader definition of teachers of the arts in schools is necessary if the arts are to be part of the everyday life of every child, and that higher education must play a central role in preparing this highly qualified *arts teaching workforce*. (Arts Education Partnership, 2007)

Before we examine these approaches for the preparation of teachers and school leaders, which form the core of this book, we review what arts educators, philosophers, and educational theorists say about learning in the arts.

LEARNING IN THE ARTS

The late Maxine Greene, former philosopher in residence at the Lincoln Center Institute, founder of the Center for Social Imagination, and mentor to many teacher educators throughout the world, points out that the arts are intrinsically valuable and release the imagination of those who engage in artistic experiences. She writes,

> Arts experiences, aesthetic experiences, are intrinsically valuable, many of us would say; they do not have to lead to further goods or measureable outcomes to be justified. Even so, it may not be too much to say that the wide-awakeness, the thoughtfulness, the sense of the unexpected associated with such experiences may be precisely what are needed to stimulate the kinds of reflective practice and reflective learning that all of us hope to see. No encounters can release imagination in the way engagement with works of art of aesthetic enactments can release it. Imagination, as is well known, is the capacity that enables us to move through the barriers of the taken-for-granted and summon up alternative possibilities for living, for being in the world. (Greene, 2004, p. 18)

As we consider what is most important to teach today, we recognize that we don't know the world that our students will encounter tomorrow. We do know that the solutions to their problems cannot be found in the "taken-for-granted," and that these problems will require Greene's alternative possibilities. These alternatives need imaginations that have been given opportunities to flourish and grow, to expand and take flight. All children should have the opportunity to release their imagination, to imagine new possibilities. But the sad truth in our society is that those most disadvantaged have the fewest opportunities to engage in arts experiences to encourage this kind of thinking. In "The Qualities of Quality," Steve Seidel of Harvard's Project Zero and others note that "for students living in or near poverty, access to formal arts learning experiences is nearly absent" (Hetland et al., 2009, p. 6). And as Cyrus Driver, former director of Program Learning and Innovation at the Ford Foundation, notes in the foreword to *Artful Teaching*, "we also came to understand more clearly how access to quality arts education in general, and arts integration in particular, was not just a matter of access, but a central issue of equity in our public schools" (Donahue & Stuart, 2010, p. vii).

The arts have been shown to be intrinsically valuable, as noted above by Greene, so why advocate for arts integration and not arts education? If we see that arts integration is more than using the arts to teach academic subjects, more than seeing the arts as a tool or a method, we can understand that arts integration leads to artistic processes within the classroom. That is, when the use of what are sometimes known as "studio habits" or "creative processes" become integral to teaching, possibilities open up, and students'

imaginations can lead to new and alternative ways of knowing and be-ing. Meryl Goldberg, professor of visual and performing arts at California State–San Marcos, emphasizes the role the arts take in teaching across cultures and suggests that we teach with, through, and about the arts—a full spectrum of integration. Supporting the idea that arts integration is about process, she suggests that

> The arts, as a methodology for teaching and learning, provide the teacher with an expanded repertoire of actions and activities to introduce subject matter. By exercising their imaginations through subject matter-related artwork, children are more likely to make new connections and transcend previous limitations. Being imaginative and creative is an attribute that not only serves artists. (Goldberg, 2006, p. 5)

We call the method in which artists engage *creative method* or *creative process*. When these processes are integrated into instructional practices, we engage in creative process as pedagogy. Within this creative pedagogy based in the arts, teachers move beyond the received experiences characteristic of more traditional educational practices, such as rote memory and repetition, to open spaces for exploration. Teachers of arts integration attempt to undo the damage of education that contributes to the sacrifice of the spontaneity of imagination and creativity on the altar of heightened craft and critique of practice. Looking for the novel and the lyrical, the picturesque and the graceful, we can then encourage a new aesthetic in our students.

As Donahue and Stuart note in their book of arts integration teaching practices, *Artful Teaching: Integrating the Arts for Understanding Across the Curriculum, K–8*, "When the arts are central to the lesson's purpose, students are more likely to see how thinking in art connects to, furthers, or challenges thinking in the disciplines you teach. Similarly, they see how thinking in other disciplines connects to, furthers, or challenges thinking in art" (Donahue & Stuart, 2010, p. 5). Diaz, Donovan, and Pascale, in the proceedings of the UNESCO World Conference on Arts Education, further describe the process of arts integration as an artistic exploration of the curriculum with the arts as the pathway into expression and representation: "Arts integration is the investigation of curricular content through artistic explorations where the arts provide an avenue for rigorous investigation, representation, expression and reflection of both curricular content and the art form itself" (Diaz, Donovan, & Pascale, 2006, pp. 4–5).

ARTS INTEGRATION PARTNERSHIPS

The Arts Education Partnership (AEP), a collaboration of the U.S. Department of Education and the National Endowment for the Arts (NEA), has played a

leadership role over the past two decades in documenting and disseminating models of arts integration partnerships through their national forums where research and practice on exemplary programs have been shared. Similarly, the U.S. Department of Education has funded research on best practices in arts integration through their Model Programs grants. In addition, the National Endowment for the Arts and the President's Committee on the Arts & Humanities have identified arts integration as a central approach to expanding the arts education for all children across the nation.

In 2007 AEP published *Arts Integration Frameworks, Research, and Practice: A Literature Review* to gather together the many articles and studies that informed and helped shape the field of arts integration. In the report Gail Burnaford, professor of curriculum, culture, and educational inquiry at Florida Atlantic University, notes that "There is little research on the effectiveness of arts integration preparation for future or practicing teachers" (Burnaford, with Brown, Doherty, & McLaughlin, 2007, pp. 49–50). She identifies the critical importance of training preservice and inservice members of the arts teaching workforce in arts integration if the field is to expand and deepen. In this book we examine effective programs and approaches that prepare teachers, teaching artists, art specialists, and school leaders in arts integration practices, many of them grounded in the same research that Burnaford notes in her review of the literature in the field.

Dick Deasy, former director of AEP, recognizes the complexity of defining the field of arts integration when he writes in *Creating Quality Integrated and Interdisciplinary Programs*:

> "Arts integration" refers to the effort to build a set of relationships between learning in the arts and learning the other skills and subjects of the curriculum. The effort appeals to many educators and arts educators, but often for quite different reasons. Some embrace the work out of a theoretical, research-based or philosophical conviction that it is a powerful way to learn and practice fundamental skills, knowledge and attitudes in the arts and other disciplines. Others view it as a pragmatic and, perhaps, expedient way of providing comprehensive instruction in the arts and other disciplines within the confines of the limited school day and within the constraints of available manpower and financial resources. The term, therefore, means different things to different people. (Deasy, 2003, p. 3.)

You will find many different meanings and different interpretations of arts integration among the programs and approaches described in this book. We reflect on the multiple ways to enter the field, provide a variety of perspectives, and emphasize the value of diversity in this work. We do not seek to define the field, but to illuminate it with a broad spectrum of perspectives and programs, identifying promising practices for teacher professional development programs in arts integration.

The need to illuminate the field comes from recognition of the variability of the quality of arts integration and the inconsistency of arts-integrated

offerings in schools today. Indeed, the term *arts integration* means different things to different people, including different ways to connect arts and academic subjects and different levels of support by school leaders. Because of the uneven resources distributed across the nation's schools, even the same professional development model will lead to very different outcomes. Since the growing diversity of students in public schools and the variability of school resources means that one model or approach will not fit all schools or all learners, we critically evaluate applications of effective approaches that could cut across these differences.

School leaders seeking effective methods to create environments that support high-quality arts integration will benefit from this book. Those who seek to support and empower teachers to integrate the arts and who want to use design thinking or create professional learning communities will also benefit. Educators searching for ways to make arts integration more purposeful, systematic, and inclusive of diversity will find ideas and lessons learned. Teachers who address the needs of *all* learners through Universal Design for Learning (UDL) will see how supporting learning designs that are more accessible, varied, and flexible leads to arts integration that addresses diversity and equity alike (Meyer, Rose, & Gordon, 2014).

Preparing Teachers for Arts Integration reveals essential characteristics of effective approaches for professional development for teachers and administrators in arts integration, many of which have been in place for decades. Recognizing that higher education has primary responsibility for the preservice training of the arts teaching workforce and a critical role in partnership in inservice training with schools, cultural organizations, and artists, we address both levels of professional development to ensure comprehensive preparation in arts integration.

COMMUNITIES OF PRACTICE

The 2011 report of the President's Committee on the Arts and the Humanities, *Reinvesting in Arts Education: Winning America's Future Through Creative Schools*, identifies the need to "develop the field of arts integration." The report summary states:

> Currently, models for training teachers, arts specialists and teaching artists in this approach are spread all over the country. There is promise in creating **communities of practice** among model arts integration programs to identify best practices in arts integration, organize curriculum units, bring together training approaches, and create a common frame for collecting evaluation results. (President's Committee on the Arts and Humanities, 2011, pp. 5–6)

Such a community of practice exists in the members of the Higher Education Working Group of the Arts Education Partnership (AEP). Meeting

since 2005, this national group of leaders in arts and learning shares a common interest in the professional development of teachers and school leaders to further their preparation in the arts. Our goal in this community is to develop the field of arts integration in various contexts and to share this work with others. While much has been written over the past decade on models of arts integration programs, less attention has been paid to the training of teachers and school leaders in arts integration theory and practice, training that is needed if the field is to expand and deepen across the nation.

Responding to the call of the President's Committee, the Higher Education Working Group brought together higher education faculty and their partners involved in training preservice (those learning to teach) and inservice (those already in the classroom) teachers and school leaders in arts integration to identify best practices in training programs. This book is the result of our meetings (face-to-face and virtual) over the past years to examine various approaches for professional development in arts integration and to critically reflect on our experiences in carrying out this work.

In 2007, AEP published the report of the Higher Education Working Group, *Working Partnerships*, which examined promising practices of 11 successful higher education pre-K–12 school partnerships. The report recommended action steps for institutions of higher education to expand their role in the professional development of the arts-teaching workforce through partnerships. Building on this earlier research, the Higher Education Working Group illustrates the application of these recommendations in this text, in particular the recommendation that "Reciprocal sustainable partnerships between higher education and pre-K–12 schools and communities must be created if we are to provide quality professional development that integrates theory and practice" (Arts Education Partnership, 2007, p. 11).

Through the work of preparing this book, we have become a more effective community of practice, learning together about various training approaches in arts integration across the country, reflecting on our experiences in founding and/or directing these programs, and distilling the central elements or characteristics of success as well as the challenges for our colleagues to consider. In the best sense of a community of practice, as defined by Wenger in *Communities of Practice* (2008), we have been able to engage in the complex process of learning together about various models across the country to define critical ingredients of our distinct approaches.

Communities of Practice presents a theory of learning that starts with this assumption: Engagement in social practice is the fundamental process by which we learn and so become who we are. The primary unit of analysis is neither the individual nor social institutions but rather the informal "communities of practice" that people form as they pursue shared enterprises over time. In order to give a social account of learning, the theory explores in a systematic way the intersection of issues of community, social

practice, meaning, and identity. The result is a broad conceptual framework for thinking about learning as a process of social participation.

PREPARING EDUCATORS FOR ARTS INTEGRATION

In this book we examine programs that integrate the arts in preservice and inservice professional development for teachers and leaders in schools that are changing the ways that students learn. Each of these approaches involves different stakeholders, including teachers (classroom teachers and arts teachers), students, school leaders, cultural arts organizations, teaching artists, higher education, and state education and arts agencies. Having learned from the experiences of participants in these programs, we provide suggestions for practical applications stemming from their different approaches, different geographic locations, and different demographics. We identify multiple pathways to integrate the arts into schools that have yielded more engaged students with heightened academic achievement and stronger skills in creativity, collaboration, communication, and critical thinking.

The authors are quick to point out that there is not one best approach for training the arts-teaching workforce in arts-integration theory and practice. Rather, there are a variety of approaches and entry points, as described and illustrated in the following chapters. Some of the approaches note the importance of working with school leaders in their training (both preservice and inservice) as curriculum leaders in arts integration in their schools. Other approaches focus on training arts specialists and teaching-artists to coordinate arts integration in their schools. Still others focus on training classroom teachers to develop partnerships with artists to ensure arts integration across the disciplines. The following approaches are also included: preparing the arts-teaching workforce to connect the arts to the Common Core State Standards (CCSS), linking community folk resources, and integrating universal design for learning. These approaches reflect the various priorities and resources of educational and arts institutions and their community partners in developing the field of arts integration.

Fully integrating the arts into learning requires knowledge and use of the standards that guide teaching in schools across the United States. Since the authors describe models for arts integration that include professional development for teachers, whether in the form of a graduate degree program, artist residency, or artist mentor, they include the appropriate state standards for the arts and academic disciplines that are addressed and applied within the model. In addition, several chapters analyze different methods of arts-based assessment strategies that document student learning, and they provide evidence of the need for moving toward more authentic assessment practices in schools. We don't argue *against* testing, we argue *for* the

inclusion of more fully developed differentiated arts-based opportunities for students to express their understanding and to communicate their learning.

ORGANIZATION OF THE BOOK

The book is arranged in five Parts to provide readers with different ways to enter into the dialog about these approaches for preparing educators in arts integration. Each Part includes a brief introduction by the editors in which we give an overview of the chapters, pointing out the possibilities for further implementation and noting which stakeholders are involved, or could contribute to the effort. The chapters reflect the unique circumstances of the authors' work and the limitations and constraints that each find as they implement their professional development projects. Because the work of professional development in arts integration needs to be carried out in partnership with others, the chapters include ways for the various stakeholders to identify resources and form partnerships within the community and across the country. Within the chapters, readers will find both programs and strategies to guide the design of professional development in arts integration for teachers and school leaders. The authors will provide an analysis of the elements of successful programs and approaches, including the challenges and limitations inherent in each, with suggestions on how these can be of use to the reader. At the conclusion of the book the editors offer practical recommendations to guide the reader in making changes in their own schools and communities.

In Part I we look at specific learning theories and their relationship to practices of arts integration for students of all abilities. We acknowledge that practice in arts integration requires familiarity with constructivist pedagogy, in which students *construct* as opposed to *acquire* new knowledge. This applies at both the professional development level and in schools with students. In addition, teachers who can develop an ability to apply abstract concepts across disciplines, seeing the connections that integration offers, will be most effective in implementing arts integration. Another challenge for advocates of arts integration are the tensions that exist among the constituencies of the arts-teaching workforce, reflecting reluctance to share responsibilities among teachers, artists, art teachers, and teaching-artists. Diaz and McKenna discuss the creative process as pedagogical practice in professional development of teachers in arts integration in a graduate program in education. Reflecting on their own creative processes as visual artist and musician, they explore the intersections of the arts and teaching.

Charleroy and Paulson explore strategies for applying the Common Core State Standards to arts-based teaching. Their search for the connections between the goals of these standards and the creative practices of arts education leads them to identify similar habits and skills in each field.

They have successfully identified the alignment between the standards, the creative practices, the philosophical foundations, and the lifelong learning goals associated with learning through and in the arts.

Donovan and Glass discuss the design of high-quality, inclusive, and flexible curriculum and assessment in arts integration. With examples from the VSA organization (formerly named Very Special Arts) at the Kennedy Center and Lesley University's Creative Arts in Learning program, they provide methods and strategies for the professional development of teachers to include in arts-integrated school classrooms at all levels.

In Part II we examine the challenges and successes of statewide network-building for whole-school reform. Clearly whole-school reform demands full-school buy-in, along with the resources and support structures from district level to parents. The approaches included here rely on a partnership with an institution of higher education (IHE), as well as support for policy at the state legislative level. Hendrickson discusses the Oklahoma A+ Schools approach of arts-based professional development that builds the capacity of teachers so that students can learn in and through the arts. Her approach to whole-school transformation demonstrates the value of creative communities of lifelong learning. Mears, O'Dell, Rotkovitz, and Snyder examine the alliance of the Arts Education in Maryland Schools (AEMS), an approach that fosters high-quality arts integration programs supported by professional development for teachers. AEMS advocates for arts integration, leading to changes in policies at state and local levels. These policy changes have led to statewide arts integration in Maryland schools.

Part III explores the important role of academic leadership in promoting awareness of, and implementing strategies for, arts integration. The authors have found that a critical element in transforming teaching and learning through arts integration is the involvement of the principal as a visionary academic leader of the process. Preservice training and district inservice training of educational administrators are two avenues to consider for reaching school leaders and raising their awareness of the potential of the arts in student learning. Ideally, this role as arts-integration leader needs to begin in preservice education and then be maintained through ongoing professional development and program support, and it needs to be informed through research at the university based on practitioners in the field. Engdahl and Winkelman discuss their efforts at California State University–East Bay to bring together preservice principals through arts-integration activities with preservice teacher candidates. McAlinden highlights the work of ArtsEd Washington, which provides inservice professional development for school leaders, beginning with a catalytic experience and culminating with a comprehensive arts plan for their schools. Hallmark's research on the impact of one principal's creative strategies for implementing professional development in arts integration illustrates how persistence and commitment to quality arts experiences for students can change a school.

In Part IV the authors take on the challenges of collaboration between the teaching-artists and arts specialists (dance, drama, music, and visual arts) who work with classroom teachers. A longstanding tension among the different artists in the schools—the art specialists versus the teaching-artists—is resolved when both artists recognize the power of collaboration in working with classroom teachers in arts integration. The authors have identified a lack of consistency in training arts specialists, teaching-artists, and classroom teachers in arts integration. A clear limitation for this effort is the paucity of cultural arts organizations in many communities and access to IHEs in some communities. Huser and Hockman suggest that it is the role of the arts specialist to lead arts integration by envisioning and implementing a whole-school arts-integration program. Citing examples from across many states, and based in the State Education Agency Directors of Arts Education (SEADEA), the authors highlight the roles that we all play, from community members to higher education faculty, in promoting successful full-school models of arts integration. Barnum then directs our attention to an approach to art integration that is based upon the partnership of artist mentors and classroom teachers in Washington State. This approach for professional development of classroom teachers using artist mentors and community cultural partners includes summer institutes and individualized in-school coaching.

In Part V we look further into the impact of arts-integrated professional development approaches on curriculum and pedagogy across various art modalities and academic disciplines, with examples from the perspectives of higher education professionals. These approaches integrate disciplinary methods with arts methods to train teachers in specific art forms as they relate to academic disciplines. Each approach addresses a different scope of content and reaches a unique population, ranging from regional to international. Examples of these approaches include Marshall, of San Francisco State, who integrates arts and science; Bradley and McGreevy-Nichols of the National Dance Education Organization, who integrate dance and literacy; Dean and Sweeting's work across the disciplines of folk dance and physical literacy at Cal State–Northridge and UNESCO; and Bernstorf's work with arts integration for special populations at Wichita State University–Kansas. As we noted above, the ability to work across disciplines to integrate complex and abstract ideas remains a challenge for many academics. We also recognize that certain areas of the arts, such as folk art and dance, have been missing from the mainstream conversations involving the arts in learning. More importantly, special student populations, such as those with different abilities, cultures, languages, and gender orientations, often suffer marginalization within schools. Those who seek to engage in effective professional development in arts integration will most likely encounter challenges to inclusion and interdisciplinarity. The approaches these authors have used can serve as examples of the benefits of encountering and overcoming these challenges.

In our concluding chapter we offer recommendations for practice drawn from our experiences in leading various arts-integration professional development initiatives across the country. The recommendations have been grouped into four categories to reach those who are in a position to create change. The first category, Recommendations for Arts Integration Programs, addresses those who work in higher education and cultural arts organizations. The second category, Recommendations to Build Understanding in Schools, addresses the needs of various groups within school communities to increase understanding of the benefits for learners derived by integrating the arts, as well as to offer professional development in arts integration. The third category, Recommendations for Policy Actions, addresses those who work at the local, regional, and national level in education administration. And the fourth category, Recommendations to Grow the Community, speaks to all of the above.

CALL TO ACTION

Arts integration as a transformative instructional strategy has expanded into many more schools in the last decade. Across the nation, comprehensive programs integrating visual and performing arts into non-arts disciplines have flourished in educational and community settings. Mandates tied to state certification/licensing credentials often present challenges to integrating the arts into teacher education programs, but successful preservice programs nonetheless exist and are augmented by robust inservice arts-integration professional development initiatives. Classroom teachers, many of whom never considered themselves artists, have discovered a new sense of possibility. As they develop new capacities within themselves, these teachers find ways to encourage the same in their students (Deasy & Stevenson, 2005).

We offer this book as part of the continuing dialog among educators and artists across the country. Those who want to build on these approaches and programs are invited to join us. We will continue to gather at the annual forum of the Arts Education Partnership, to sponsor meetings at our various organizational homes, and to present our work at national and regional conferences across the country. As we build a stronger, more vibrant community of practice, we engage in the work of making the arts a part of education at all levels in the United States.

We plan to use the digital world to our advantage by creating a website, artsintegrationus.org, where we will post new research, include an interactive blog, and offer live conversations with the chapter authors. We envision a community of practice that is dynamic, mobile, and creative. We envision the arts as part of learning for all students, everywhere. We invite you to join us in this important work.

REFERENCES

Arts Education Partnership. (2002). *Teaching partnerships*. Washington, DC: Author.

Arts Education Partnership. (2007). *Working partnerships: Professional development of the arts teaching workforce*. Washington, DC: Author.

Arts Education Partnership. (2015). *The arts leading the way to student success: A 2020 action agenda for advancing the arts in education*. Washington, DC: Author. Retrieved from www.aep-arts.org/wp-content/uploads/AEP-Action-Agenda-Web-version.pdf

Burnaford, G., with Brown, S., Doherty, J., & McLaughlin, H. J. (2007). *Arts integration frameworks, research, and practice: A literature review*. Washington, DC: Arts Education Partnership. Retrieved from 209.59.135.52/files/publications/arts_integration_book_final.pdf

Coleman, D. (2011). *Guiding principles for the arts: Grades K–12*. New York, NY: New York State Education Department. Retrieved from usny.nysed.gov/rttt/docs/guidingprinciples-arts.pdf

The College Board. (2012, December). *The arts and the common core: A review of connections between the Common Core State Standards and the National Core Arts Standards conceptual framework*. New York, NY: Author.

Deasy, R. (2003). *Creating quality integrated and interdisciplinary programs: Report of the AEP National Forum of September 2002*. Retrieved from njpsa.org/documents/EdLdrsAsSchols/SupportingResearch/DeaseyCreatingQualityIntegratedandInterdisc2002AEP.pdf

Deasy, R., & Stevenson, L. (2005). *Third space: When learning matters*. Washington, DC: Arts Education Partnership.

Diaz, G., Donovan, L., & Pascale, L. (2006, March). Integrated teaching through the arts. Paper presented at the UNESCO World Conference on Arts Education, Lisbon, Portugal.

Donahue, D. M., & Stuart, J. (Eds.). (2010). *Artful teaching: Integrating the arts for understanding across the curriculum, K–8*. New York, NY: Teachers College Press.

Embleton, J. (2014). Learning through the arts students achieve better academic results. (2014). Retrieved from www.rcmusic.ca/connecting/rcm-blog/learning-through-arts-students-achieve-better-academic-results

Goldberg, M. (2006). *Integrating the arts: An approach to learning in multicultural and multilingual settings* (3rd ed.). Boston, MA: Pearson.

Greene, M. (2004). Carpe diem. In G. Diaz & M. B. McKenna (Eds.), *Teaching for aesthetic experience*. New York, NY: Peter Lang.

Hetland, L., Palmer, P., Seidel, S., Tishman, S., & Winner, E. (2009). The qualities of quality: Understanding excellence in arts education. Cambridge, MA: Project Zero for the Wallace Foundation. Retrieved from http://www.pz.harvard.edu/resources/the-qualities-of-quality-understanding-excellence-in-arts-education.

Kisida, B., Greene J. P., & Bowen, D. H. (2013, November 24). Art makes you smart. *The New York Times*. Retrieved from www.nytimes.com/2013/11/24/opinion/sunday/art-makes-you-smart.html?_r=1&

Meyer, A., Rose, D. H., & Gordon, D. (2014). *Universal design for learning: Theory and practice*. Wakefield MA: CAST.

National Coalition for Core Arts Standards. (2014). National Core Arts Standards: A conceptual framework for arts learning. Retrieved from nccas.wikispaces. com/Conceptual+Framework

President's Committee on the Arts and the Humanities. (2011). Reinvesting in arts education: Winning America's future through creative schools. Retrieved from pcah.gov/sites/default/files/PCAH_Reinvesting_4web_0.pdf

Wenger, E. (2008). *Communities of practice: Learning, meaning, and identity.* New York, NY: Cambridge University Press.

Winner, E., Goldstein, T. R., & Vincent-Lancrin, S. (2013). *Art for art's sake? The impact of arts education.* Paris: OECD Publishing. DOI: dx.doi.org/10. 1787/9789264180789-en)

Part I

THEORY AND PRACTICE
IN ARTS INTEGRATION

This Part includes three chapters that introduce the educational components and practices necessary for educators who are engaged in preparing for arts integration: engaging in creative pedagogical practices, aligning curriculum and instruction with standards, and designing curriculum that addresses the needs of all students.

Pedagogical practices in arts integration require familiarity with constructivist pedagogy in which students *construct* as opposed to *acquire* new knowledge. Constructivist learning principles apply at both the professional development level and in pre-K–12 schools. In Chapter 1, Diaz and McKenna introduce the concept of creative process as pedagogy to define the integration of artistic processes into both what and how they teach. Creative process as pedagogy shares some basic assumptions with constructivist teaching, and they differ basically in the artistic ways of knowing. Both ways of teaching share the constructivist premise of engagement through the senses (aesthetic engagement) and reason, and both rely on the notion of student as constructor of meaning and knowledge.

Chapter 1 describes the four components that make up this pedagogical approach in the context of an inservice master's degree in arts integration offered at Lesley University in Cambridge, MA. The authors suggest that this approach to teaching can be adapted to other contexts, for example professional development for faculty in higher education, and that by using the creative process as pedagogy, or as pedagogical practice, they integrate the arts across these other contexts as well. In the chapter, they provide illustrations for each of the four components of creative practice in their classes in the professional development program in arts integration, and they conclude with suggestions for ways that others might employ this approach as well.

In Chapter 2, Charleroy and Paulson discuss how the alignment of the Common Core State Standards (CCSS) with arts-integrated practices in schools builds a common ground on which to base arts-integrated teaching. They have outlined an alignment between the standards, the creative practices, the philosophical foundations, and the lifelong learning goals associated with learning through and in the arts. This alignment can serve as a model

upon which educators can base their own design of quality arts-integrated teaching and learning.

In Chapter 3, Glass and Donovan introduce the design of high-quality, inclusive, and flexible curriculum and assessment in arts integration. They move beyond the "what" and "how" of arts integration to suggest two curriculum design frameworks that can guide the design and implementation of arts integration teaching and learning. Drawing upon their experience in creating professional development courses and programs for VSA and Lesley University, Glass and Donovan use the curriculum design frameworks of Understanding by Design (UbD) and Universal Design for Learning (UDL) in their approach to professional development for teachers, arts educators, and arts administrators in arts integration.

Using the Creative Process as Pedagogy

Gene Diaz and Martha Barry McKenna

We are all born creative. This belief resides at the core of this chapter and at the core of our work in higher education, primarily in graduate teacher education. In this chapter we explore ideas about what it means to be creative and what we mean by the creative process as pedagogy. We illustrate these ideas with stories of teaching in an arts-integrated graduate education program for classroom teachers. In addition to exploring how these ideas shape our teaching in formal and informal settings, primarily as providers of inservice teacher education but also as educators of learners across the lifespan in various fields, we will also reflect on the different ways that we have expanded these ideas about creative process as pedagogy from a basic teaching concept into projects that involve multiple contexts, cultures, and communities. We use the phrase "creative process as pedagogy" to define our integration of artistic processes into both what and how we teach. Engaging in creative process as pedagogy has led us to understand teaching, learning, and leading in new ways, ways that are dynamic and continuing to evolve. Robinson writes that "creativity is the process of having original ideas that have value . . . creativity is a process more often than it is an event" (2011, pp. 151–152).

Since many students in K–12 schools across the United States do not have access to high-quality learning in and through the arts, they have few opportunities to enhance their creativity or exercise their imagination (President's Committee on the Arts and the Humanities, 2011). Recognizing this lack of access, faculty at Lesley University in Cambridge, MA, designed in 1984 the first master's degree program in arts integration education that offer professional development for educators around the country, to engage them, and their students, with sustained experiences in the creative processes of the arts. In these programs educators learn to integrate the arts across the curriculum, or within their work in the community, and to expand opportunities for their students to engage in the arts. In a nation in which arts education is perceived to hold little value by many school districts (when available, it is

frequently underfunded), these programs offer teachers and other educators approaches for making the creative arts accessible to all students. Faculty who are artists and educators themselves designed this approach to learning for teachers, community-based artists, and other educators.

The challenges for creating and sustaining a viable arts-integrated graduate program for educators are many, from state and federal regulation changes (the No Child Left Behind Act dealt a heavy blow to these programs), to the risks for faculty and teachers developing creative and interactive pedagogical practices in an environment that emphasizes digitally mediated learning, measureable outcomes, and standardized curriculum. Without a whole-school change effort, teachers struggle to apply their learning when they take arts-integrative practices into their schools without support for, or recognition of, the value of the arts in learning. While the Lesley programs include exploring arts in the community, meeting artists, partnering with arts specialists, and building a team for arts integration, this team cannot fully function without support from school leaders. (For more perspective on the role of leaders, see the chapters in Part III.) To be clear, applying the creative process as pedagogy in an arts-integrated program requires moving beyond the arts as craft and skill and toward a grounding in aesthetic experience as meaning making.

Often classroom teachers have little time to question their approaches to teaching. The teachers who study in Creative Arts in Learning programs, however, learn other ways to engage with teaching. And they know from their everyday lives in classrooms what needs to change to make learning more accessible and more meaningful for their students. The arts offer even more to our students than the aesthetic qualities so recognized and cherished in the field. They offer a way of thinking that stimulates innovation, curiosity, and new ways of being in the world. Again, from *Working Partnerships* (Arts Education Partnership, 2007), we find that

> Our society increasingly makes its living off innovation and discovery, and the arts provide forms of inquiry that engage our minds, our senses, and our creative and inventive capacities. They provide a language of possibility for futures yet to be imagined, and insights that are only gained through aesthetic experiences. (p. 10)

WHAT IS THE CREATIVE PROCESS AS PEDAGOGY?

A process that is creative in any field includes elements of imagination, design, innovation, and originality. We suggest that a creative process includes the following four broad components: a safe environment, imaginative exploration, design and construction, and critique. Artistic creative process, as we know it, begins with building an environment in which it is safe to

engage in an initial exploration, whether of a concept, a design, materials or media, or space and context. This exploration is coupled with emerging skills in form and content, as well as media and methods. Exploration informs the design and construction of products, or works of art, music, or poetry, etc., that aesthetically express and communicate new meaning for the artist, and frequently for an audience through exhibition or performance. This process includes some form of reflective assessment and/or critique, which takes place throughout the progress of the work.

These four components of creative process shape the pedagogical practices in Lesley's programs. Beginning with specific goals, we create a space or environment in which students explore pathways to achieve the course objectives. As the creative products of their learning develop, we engage with them in reflective feedback and critique. New meanings about teaching and learning flow from their aesthetic engagement with the arts and artistic process, and enhance their understandings about theories and practices in education. The content varies across the courses in the program, but our instructional practices model the components of this creative process.

We introduce students to music, dance, drama, poetry, storytelling, and visual art not by telling, but by doing. We have discovered that where words fall short, music, images, and gestures illuminate both teaching and learning. Drawing upon our experiences as artists/scholars/teachers, we engage students in exploring each of the art disciplines to make connections to their own professional practice. The pedagogical models and practices at work in this program have been derived from various artistic experiences, and thus they reflect the creative processes we work through as artists who teach. As colearners with our students we take risks in our curriculum design, we innovate instructional strategies, and we imagine a world where the arts will be accessible to all.

Looking for the novel and the lyrical, the picturesque and the graceful, we encourage the development of an enhanced aesthetic in our students. With educators who don't believe they are artists, or even that they are creative, we introduce a sense of possibility that they themselves have called transformative. Learning of new capacities within themselves, educators then find ways to encourage the same in their students. Frequently, teachers come to the program in twos or threes from the same school, which allows them to collaborate on projects and teaching practices and support each other as they introduce arts integration into their classrooms. While they have expressed a sense of renewal, they also acknowledge frustration with the resistance at their schools, and many are challenged to make changes alone. While these arts-integrated programs that use the creative process as pedagogy support personal and professional transformation, no longitudinal research has been conducted to determine how long these changes endure.

The U.S. standard for art teachers calls for educators who "are able to organize a safe, interesting, and psychologically positive environment

that is conducive to creativity, expression and making art" (National Art Education Association, 2009, p. 1). Similarly, the creative process as pedagogy opens up space for educators to explore. As faculty we come to each course in this program as an artist comes to the medium of creative expression. Our students, educators all, bring their knowledge of the world of learning, the students they teach, and the relationships they foster, and with us they engage in exploring a learning landscape and discover the territory of the creative.

WHY USE THE CREATIVE PROCESS AS PEDAGOGY IN ARTS INTEGRATION?

Creative thinking finds grounding in the many possibilities that surround ideas and concepts. The artistic process pushes artists to explore perspectives and to find or create new ones, and to actively evaluate their worth as they create. As part of our teaching in the arts we lead students into this exploration, thereby encouraging critique and critical thinking as integral to the process (Diaz & McKenna, 2004). Teachers who integrate the arts in their teaching have many opportunities to model creativity and imagination (Burnaford, with Brown, Doherty, & McLaughlin, 2007; Donahue & Stuart, 2010). As they explore an art form and engage their students in constructing ideas in and through the arts, they engage with the novel and the new, creating authentic learning experiences as they construct new knowledge. Educators who integrate the arts learn to appreciate multiple perspectives and model this appreciation for their students (Deasy & Stevenson, 2005; Eisner, 2002).

Educators who integrate the arts using creative process as pedagogy become more comfortable with ambiguity and are able to confront and accept what Greene (1978) notes as that which is not yet, that which is still in the process of becoming. Although schools traditionally value facts and data, information and typologies, the arts push teachers into the realm of the unknown. As they themselves uncover new directions for learning and design new methods for teaching, they become explorers as well. What better teacher than one who is actively exploring ideas and seeking new knowledge? Creating something original always requires taking a risk and moving into the unknown, just as attempting to construct authentic learning experiences in the arts demands creative thinking and a creative process.

Teachers using creative process as pedagogy offer their students options to communicate and express their knowledge and learning in multiple ways (i.e., musical, kinesthetic, poetic, dramatic, visual, and storytelling). This respect for students' varying capacities opens up learning to those who have often been left out because of one-dimensional or single-intelligence-based teaching practices. Schools in the United States have long emphasized learning in mathematical and analytical skills, and they have prioritized language

through text and thinking in linear pathways. Students who express their ideas through image or movement or music have been excluded. As teachers integrate the arts through the creative process as pedagogy, they open access to learning for all students, creating a more democratic classroom and a more equitable learning environment (Deasy & Stevenson, 2005; Greene, 1978).

In the following sections we illustrate the four components of creative process as pedagogy with stories of the practice through experiences of four of our students in the Integrated Teaching through the Arts program as they created new knowledge and meaning. We briefly describe the components of the process and introduce an example of a student's efforts that led to new understanding. In the final section we will look at broader implications for teaching practices that integrate the arts and engage students in creative process as pedagogy.

Building the Environment for Creative Process

The catalyst for creative engagement is the environment that we create for exploring works of art both in and outside the classroom. Similar to a Reggio Emilia atelier, we fill classrooms with art objects, books, musical resources, and art materials for individual and group exploration. Engagement with works of art goes beyond slides, musical tapes, and filmed performances in the classroom to live performances and exhibits in the community. Placing the learning in artistic spaces transforms the process and deepens creative engagement in making and interpreting works of art. This story of Anna, a music specialist in Charleston, SC, demonstrates how artistic space can influence learning.

Anna chose Boone Hall Plantation for an architecture study because it provided a rare opportunity to examine slave quarters in contrast to the great house of the master. The small, single-room brick homes of slaves that housed an entire family were in sharp contrast to the large brick mansion. In examining the elements of materials, structure, fenestration, scale, space, and style of the contrasting homes, the students soon moved beyond the discussion of elements and form to the more difficult dialog of content or meaning of these buildings. The injustices were vividly present in the homes that stood before us, and Black and White teachers engaged in a conversation that would not have been possible in another space. John Dewey describes the critical role of the arts in life in *Art as Experience* (1934/1958):

> Instruction in the arts of life is something other than conveying information about them. It is a matter of communication and participation in values of life by means of imagination, and works of art are the most intimate and energetic means of aiding individuals to share in the arts of living. (p. 336)

Anna, the granddaughter of one of the last slaves at Drayton Hall Plantation, found that this experience awakened in her the need to tell her grandfather's story. This engagement with architecture led her to a final course project that would eventually lead to a districtwide curriculum that tells the story of slavery through exploration of the arts on a plantation, a curriculum funded by the South Carolina Humanities Council. Anna's engagement in an art space created by the architecture of Boone Hall Plantation became the impetus for developing a curriculum that would transform a district.

Exploring Together

For philosopher Herbert Marcuse, "art is always a demand for authentic freedom" (Reitz, 2000, p. 188). Within our pedagogy of creative process, authentic freedom is manifest in the act of exploration, where we discover, along with our students, ways to see new possibilities in teaching and learning in the arts. This exploration leads us into an enhanced engagement with the senses and embodied knowing, what Maxine Greene (1978) calls "wide-awakeness." In our courses we give students permission to imagine different ways to demonstrate their knowledge. We provoke them to originate ideas, to innovate change, and to co-construct meaning through risk-taking activities. Paul, a student in Bend, OR, chose to explore how offering freedom to his 7th-grade students, with guidance and facilitation in an innovative art form, would lead them to new science learning that was relevant to their lives.

After introducing his class to the work of Scottish sculptor Andy Goldsworthy through a film by Thomas Riedelsheimer (*Rivers and Tides*), Gene discussed Goldsworthy's work and his own commentary on art and why he creates what he does. We wondered together how any of this information might have an impact on our work as teachers and learners. Paul used that experience, and others, to invent ways to engage his students through the arts. Later he showed us the product of his exploration, a video of his students engaging in outdoor sculpture creation with natural elements, even with some of the same elements that Goldsworthy used in the film. Paul had questions about engaging teens in earth science learning activities that would be relevant to their daily lives. These questions led him to observe that his students were enthusiastic about learning activities that they found interesting, exciting, and open to discovery. After showing his own students the Goldsworthy film, he invited them outside to explore and create their own learning products. At the end of his video, Paul captured the whole class working together to gather bright yellow dandelion flowers and using them to create a large labyrinth in the grass under the bluest of skies.

Paul's students' explorations were profound, and they involved risk-taking and imagination. In reflecting on the process with the rest of us, Paul

explained the difficulty that he had in putting into words his relationship to knowledge and his perspective on being in the world, his epistemological and ontological perspectives. So he chose to move away from, or perhaps beyond, words to demonstrate his knowledge, perspectives, and experiences through the images and movement in his video work. In so doing he related his sense of being to the natural world that surrounded him. He is not apart from nature, he told us, he is part of nature. As Peter Abbs notes, "Unlike any other symbolic system the arts have the power to disclose the lineaments of being. To engage with the arts is to engage with the meanings and possibilities of human existence" (2003, p. 40).

Designing and Constructing

Students in this integrated-arts program are encouraged to create original works of art that express or explore themes relevant to contemporary society as final projects for their courses. For Molly, a classroom teacher in Olympia, WA, the creative design and construction of a quilt moved beyond an assignment to an act of courage and healing. After they viewed the film *Hearts and Hands: 19th Century Women and Their Quilts* (Ferris & Ferrero, 1987), Martha engaged the students in a discussion on the role of folk art in society, and noticed Molly had been crying. A student later informed Martha that Molly's husband had died recently, so the film's reference to quilts memorializing death must have been difficult for her to watch. It was a surprise when Molly announced the next day that she would like to create a quilt in memory of her late husband as her final project for the course. She went on to say that after he died she was unable to give away his shirts and ties, so she would like to use these fabrics to design and construct a quilt. It was clear that this would be much more than a final project, but rather a work of art that would bring memories of her husband to life in some unique way.

Through the process of artistic creation, Molly played with colorful fabrics to construct images of memorable places, including where she and her husband had met, lived with their daughters, and vacationed. As Ken Robinson points out:

> Creativity is a dialogue between the ideas and the media in which they are being formed. . . . Being creative is not just a question of thinking of an idea and then finding a way to express it. Often it's only in developing the dance, image or music that the idea emerges at all. (2011, p. 153)

Ties and shirts, which would have otherwise hung in a closet, were transformed into a work of art. In the long-held tradition of quilting, Molly used scraps of fabric for a new purpose, to create a quilt that would provide warmth and comfort in both its materials and design.

Engaging in Critique

The art critique provides an opportunity for the creator of an art product to reflect on and speak about the process of fabrication, including decisions about the formal components, as well as the intention for the artwork that influenced his or her choices. Through the critique process, art students learn to self-assess, and to assess with others, and then to build new learning upon this self-assessment, "touching their learning" as if it were a tangible process, interpreting their work and building meaning through dialog. As artists we engage in a similar process individually throughout the production of an artwork. Like Doren (2010), through the critique we seek to give an account of why something happened, and not look for an objective truth. In our pedagogy of creative process we include inquiry as a valuable component of the critique, as illustrated by the example of Steve, a student who engaged in an arts-based research project about young boys' learning in his 5th-grade classroom.

Steve focused on the ways that boys learn writing differently than girls, so his presentation about the use of poetry to prompt interpretive drawings and writings by his students led us to assume he was working with boys' drawings. He showed us drawings depicting children in various states of disarray, with dark smudges on their faces and hands, rough crayon strokes suggesting messiness, and words across their bodies like "Call me dirty" and "Clean or not!," then asked us to work in groups to create poems based on the drawings. One group began their poem with "Filthy boys." Steve then read the poetic prompt that inspired the drawings, "Grungy Grace," written in first person by a child who hated to bathe. He pointed out that the drawings were by both boys and girls, and that our effort to interpret them was colored by our erroneous assumption. Our critique of Steve's process linking poetry and drawings led us into an engagement with meaning-making with Steve as we realized that one piece of information can influence the processes of interpretation and expression.

We are frequently blind to our own assumptions unless we intentionally focus on them. In this case, the people in the group focused on their assumptions through the analysis and interpretation of the activity that Steve designed. Critique, whether in artistic creation or in creative pedagogy, welcomes and honors unanticipated moments of meaning-making and insight.

IMPLICATIONS FOR PRACTICE

While we have defined creative process as pedagogy as an approach that permeates arts-integrated professional development programs, one can apply this approach to other educational settings. The four steps of creative process as pedagogy can be constructed in other ways, or they can be

expanded to include exhibition or performance as the final step as well. We encourage both interpretation and innovation of the process, as well as the use of all of the arts.

We have found that using creative process as pedagogy throughout the 11 courses of the Integrated Teaching through the Arts graduate program has been an effective approach for preparing educators to integrate the arts across the curriculum. However, this approach can also be applied to professional development programs within schools, districts, and community settings if artists and teachers have the opportunity to work together to reimagine curriculum and instruction. It will require the collaboration of teachers with knowledge of students' needs and curriculum goals and artists with experience in the creative process, but such integration of professional expertise can result in informed approaches for arts integration across the curriculum. Central to expanding this work is the support of academic leaders who provide the resources for teachers and artists to work together so that this creative approach to teaching and learning can take hold in schools.

An important consideration of this approach is the requirement that artists in schools, whether arts specialists, teaching-artists, or cultural institutions in partnership, must have time to work with teachers in classroom settings. This approach has implications for how we prepare teachers to collaborate in arts integration in higher education, as well as how we define positions in schools and organizations to allow for teacher professional development as part of the workload of both teachers and artists in schools.

REFERENCES

Abbs, P. (2003). *Against the flow: Education, the arts, postmodern culture.* New York, NY: RoutledgeFalmer.

Arts Education Partnership. (2007). *Working partnerships: Professional development of the Arts Teaching Workforce.* Washington, DC: Author.

Burnaford, G., with Brown, S., Doherty, J., & McLaughlin, H. J. (2007). *Arts integration frameworks, research, and practice: A literature review.* Washington, DC: Arts Education Partnership. Retrieved from 209.59.135.52/files/publications /arts_integration_book_final.pdf

Deasy, R., & Stevenson, L. (2005). *Third space: When learning matters.* Washington, DC: Arts Education Partnership.

Dewey, J. (1958). *Art as experience.* New York, NY: G. P. Putnam's Sons. (Original work published 1934).

Donahue, D. M., & Stuart, J. (Eds.). (2010). *Artful teaching: Integrating the arts for understanding across the curriculum, K–8.* New York, NY: Teachers College Press.

Diaz, G., & McKenna, M. B. (Eds.). (2004). *Teaching for aesthetic experience.* New York, NY: Peter Lang.

Doren, M. (2010). Re-thinking critique: Questioning the standards, re-thinking the format, engaging meanings constructed in context. In E. P. Clapp (Ed.),

20under40: Re-inventing the arts and arts education for the 21st century (pp. 126–141). Bloomington, IN: Authorhouse.

Eisner, E. (2002). *The arts and the creation of mind.* New Haven, CT: Yale University Press.

Ferris, B. (Writer), & Ferrero, P. (Producer/Director). (1987). *Hearts and hands: 19th century women and their quilts* [Video recording]. San Francisco, CA: Ferrero Films.

Goldberg, M. (2006). *Integrating the arts: An approach to learning in multicultural and multilingual settings* (3rd ed.). Boston, MA: Pearson.

Greene, M. (1978). *Landscapes of learning.* New York, NY: Teachers College Press.

National Art Education Association. (2009). Professional standards for visual arts educators. Retrieved from www.d64.org/learning/documents/naeaprofessional standards.pdf

President's Committee on the Arts and the Humanities. (2011). *Reinvesting in arts education: Winning America's future through creative schools.* Washington, DC: Author.

Reitz, C. (2000). *Art, alienation, and the humanities: A critical engagement with Herbert Marcuse.* Albany: State University of New York Press.

Riedelsheimer, T. (Director). (2001). *Rivers and tides: Andy Goldsworthy working with time* [Motion picture]. Germany: Mediopolis Film-und Fernsehproduktion, Skyline Productions, Westdeutscher Rundfunk (WDR).

Robinson, K. (2011) *Out of our minds: Learning to be creative* (2nd ed.). West Sussex, UK: Capstone Publishing.

Arts Integration and Standards Alignment

Amy Charleroy and Pamela Paulson

Arts educators, researchers, and advocates are accustomed to the task of describing the value of their work on its own terms, but they are also accustomed to relating arts study to student engagement and performance in other academic subjects. Recent research studies have linked arts participation to increases in student literacy skills, critical thinking abilities, and capacities for communication and problem solving. This naturally has implications in all subject areas (Arts Education Partnership, 2013). The strength of an arts-integration approach is that it allows educators to highlight the ways in which the arts can naturally lend themselves to deepening learning experiences across the curriculum.

At the core of arts integration is the notion of *alignment*: that arts and non-arts content and practices are merged in the service of a common goal. Too often, the objective of integration creates forced connections across disciplines, making arts-based study subservient to learning in other subjects. Arts teachers are frequently pressured to bring the work of other disciplines into their classrooms in ways that do not authentically relate to or enhance their arts-based work, or they are expected to describe and defend the benefits of arts education in terms of non-arts outcomes. On the other hand, when done well, alignment has the potential to reinforce the value of the arts in their own terms—giving them a common language (shared with other subjects) to describe authentic artistic practice.

In considering best practices in arts integration, especially when educating preservice teachers, we often describe successful arts-integration models that educators might emulate, without unpacking the particular *qualities* of alignment that make these models so successful: the ways that arts and non-arts content and processes are considered in relation to one another. In the research sphere, educators and advocates may tout the results of alignment research (especially in cases where arts experiences have been shown to measurably boost student performance in other academic subjects) without considering the process by which those findings were reached or the

particular practices and skills of arts and non-arts disciplines that were practiced in the classroom in order to produce these results.

Educators need to be equipped to examine arts-integration models and examples with a critical eye, and to design arts-integration experiences that ensure deep alignment of processes and practices between disciplines. A useful step in this process may be to examine an arts–standards-alignment project in-depth.

As the Common Core State Standards have taken an increasingly central role in education reform, teachers, including arts educators, are frequently being tasked with aligning the work of their classes to the goals of the Common Core State Standards. Recognizing that few resources exist, particularly for arts teachers, to make these connections, College Board researchers conducted two phases of research examining the overlaps between Common Core State Standards and arts-based instruction. This work was completed in partnership with the National Coalition for Core Arts Standards, with the intent of informing the coalition's development of the arts standards.

In undertaking this work, researchers also had to grapple with the question of what is meant by the term *alignment*. One option for this work might have been to identify ways that English language arts (ELA) and math standards can be met by arts-based study. Conversely, the researchers could have studied the ways that arts standards can or should be met in ELA and math classrooms. In a third option, the analysis could have examined the frameworks for the arts standards and the Common Core State Standards side-by-side and looked for commonality of language or goals, whether or not these similar terms are taken to mean the same thing in the context of each discipline. After considering these and other possibilities, the Common Core study was carried out in two phases. In 2012, researchers identified direct references to arts-based study that are already present in the Common Core State Standards, with a focus on ELA in this phase. Upon the completion and release of the National Core Arts Standards in 2014, a second study was conducted, identifying connections between the habits, skills, and abilities emphasized in the Common Core State Standards and the National Core Arts Standards.

Following is an overview of each study and the highlights of key findings. This work is presented with the intent to provide a broad view of the way that arts study can relate to the Common Core State Standards, but also to provide a model of two approaches to alignment that could be adapted to other needs and situations.

IDENTIFYING ARTS REFERENCES
IN THE ELA COMMON CORE STATE STANDARDS

A brief description of the structure of the Common Core ELA Standards may be helpful at this point: The ELA Standards are divided into four

subcategories: Reading (which is further divided into reading informational texts and reading literature), Writing, Speaking and Listening, and Language. Each of these categories has a set of between six and ten College and Career Readiness Anchor Standards—overarching standards that apply across all grade levels. Each Anchor Standard connects to corresponding grade-level standards that offer more specific guidance on what it means to meet that standard in age- and grade-appropriate ways.

The first phase of research involved an examination of all four groups of Common Core ELA Anchor Standards *and* all of their corresponding grade-level standards, noting all specific references to the arts—recommendations that students read works of drama, for example, or interpret and analyze images. The information collected here highlights not only where the arts are or are not present in the Common Core State Standards, but it also identifies patterns and trends in these connections—noting, for example, which types of arts learning appear to be most heavily emphasized, and which arts disciplines and processes are emphasized at particular grade levels.

Standards for Reading

There are 220 grade-level Common Core State Standards for Reading, including standards both for reading literature and informational texts. A total of 50 of these standards contain at least one direct reference to arts-based learning, including the following:

- Reading a work of drama
- Analyzing and interpreting images and illustrations
- Comparing the same work in different media
- Using songs in the classroom

As the Reading standards naturally center on the practices of analyzing and interpreting texts, every anchor standard and corresponding grade-level standard in this category contains references to the term *text*. When considering arts-based connections to this body of standards, educators may interpret this term to include non-print texts, such as works of dance, visual or media arts, music, or theater. **If this definition of *text* is accepted, then all of the standards in this category, at every grade level, have direct references to arts-based content or investigation.**

This approach has informed teacher professional development opportunities nationwide. Arts education curriculum consultants have worked with arts educators, arts administrators, and faculty from institutions of higher education to similarly explore the arts as text. These consultants help facilitate the focus on evidence-based responses to works of art, related to the story, theme, symbols, ideas, feelings, etc., that the artwork may convey, as well as to how these specific artistic elements and processes are used to communicate through the respective arts discipline. These responses occur

naturally during the analysis of art, and they can help to address arts standards, which require students to use arts-specific vocabulary in their analyses of art. David Coleman, president of the College Board, has described "Seven Guiding Principles for the Arts" (Arts Education Partnership, 2012) that support the interpretation of art as text and provide examples of connections with principles of literacy and the arts. The principles are primarily focused on close observation and analysis, including the deep study of multiple renditions of the same work of art in the development of arts literacy.

Standards for Writing

Within the 110 grade-level standards for Writing, 8 contain arts references, most of which involve visual arts and media arts. The links to visual arts (primarily drawing) were found mostly in the standards for the lower grades. For example:

- W.K.2: Use a combination of drawing, writing, and dictating to compose informative/explanatory texts in which they name what they are writing about and supply some information about the topic (Common Core State Standards Initiative, 2010a, p. 19).

As the grade levels progress, there are fewer visual arts references in the Writing standards and more multimedia references; typically, it is recommended that multimedia tools be used to create graphics to enhance written presentations.

While the arts references in the Reading standards were greater in number, they focused primarily on the *analysis of and response to* works of art. In contrast, the Writing standards endorse the *creation of new works* as a tool for communication. Even in these cases, however, the standards recommend that these works of art be used to enhance or to aid other ideas that are presented in writing.

It is important to remember that there are specific standards for Literacy in History/Social Studies, Science, and Technical Subjects within the Common Core State Standards for English Language Arts, and that the definition of Technical Subjects specifically identifies the technical aspects of the arts: "A course devoted to a practical study, such as engineering, technology, design, business, or other workforce-related subjects; a technical aspect of a wider field of study, such as art or music" (Common Core State Standards Initiative, 2010c, p. 43).

Standards for Speaking and Listening

There are 16 arts references in the 66 standards for Speaking and Listening, most of which are related to Anchor Standard 5: "Make strategic use of

digital media and visual displays of data to express information and enhance understanding of presentations" (Common Core State Standards Initiative, 2010a, p. 48). In a trend similar to the Writing standards, arts references in the standards for Speaking and Listening favored different arts disciplines at different grade levels; from kindergarten to 2nd grade, the standards recommend using drawing as a tool for communication, and in later grades the use of digital media is more heavily referenced.

ALIGNMENT BETWEEN THE SKILLS AND HABITS IN THE NATIONAL CORE ARTS STANDARDS AND THE COMMON CORE STATE STANDARDS

While it is certainly useful to note the areas where the Common Core State Standards explicitly recommend arts-based study, opportunities for more complex and richer alignment arise when we consider philosophies, goals, and habits of mind that are present in both the Common Core State Standards and in the National Core Arts Standards (NCAS).

The NCAS Anchor Standards apply to all five arts disciplines (dance, media arts, music, theater, and visual arts) and are divided into four categories: Creating, Performing/Presenting/Producing, Responding, and Connecting. The eleven NCAS Anchor Standards are outlined in Figure 2.1.

These eleven NCAS Anchor Standards were compared to the Common Core's College and Career Readiness Anchor Standards for Reading, Writing, Speaking and Listening, and Language, as well as to the Standards for Mathematical Practice. The researchers made these comparisons in order to determine whether the standards across content areas addressed similar skills and habits, even if the terms used to describe these abilities were not identical. Findings indicate that the potential connections between arts learning and the goals of the Common Core are rich and varied.

Creating

Among the comparisons of the English Language Arts Standards, the NCAS Anchor Standards for Creating were most strongly aligned with the Common Core Anchor Standards for Writing. Of the 30 comparisons that were made between standards, 26 instances of alignment were found. This is perhaps not surprising, because both sets of standards deal with planning and producing original communication or personal expression.

The third NCAS Anchor Standard for Creating—*refine and complete artistic ideas and work*—had interesting (and somewhat unexpected) similarities to the Common Core Anchor Standards for Reading; it was found to positively align with eight out of ten of these standards.

Figure 2.1. National Core Arts Standards: Anchor Standards

Creating	Performing/Presenting/Producing	Responding	Connecting
Conceiving and developing new artistic ideas and work	*Realizing artistic ideas and work through interpretation and presentation; interpreting and sharing artistic work; realizing and presenting artistic ideas and work*	*Understanding and evaluating how the arts convey meaning*	*Relating artistic ideas and work with personal meaning and external context*
1. Generate and conceptualize artistic ideas and work	4. Analyze, interpret, and select artistic work for presentation	7. Perceive and analyze artistic work	10. Synthesize and relate knowledge and personal experiences to make art
2. Organize and develop artistic ideas and work	5. Develop and refine artistic techniques and work for presentation	8. Interpret intent and meaning in artistic work	11. Relate artistic ideas and works with societal, cultural, and historical context to deepen understanding
3. Refine and complete artistic ideas and work	6. Convey meaning through the presentation of artistic work	9. Apply criteria to evaluate artistic work	

Source: National Core Arts Standards © 2015 National Coalition for Core Arts Standards. Rights administered by State Education Agency Directors of Arts Education (SEADAE). All rights reserved. www.nationalartsstandards.org

Performing/Presenting/Producing

Positive alignment was found between the NCAS Anchor Standards for Performing/Presenting/Producing and all segments of the Common Core Anchor Standards for English Language Arts. The connections varied in the areas of focus and types of skills they described. Following are some of these connections:

- The first Performing/Presenting/Producing Anchor Standard— *Analyze, interpret, and select artistic work for presentation*—aligns with all ten of the Common Core Anchor Standards for Reading.

Skills of analysis and/or interpretation are referenced in all of the Common Core Reading Standards, and the inclusion of these skills alongside the act of selecting a creative work for presentation accounts for the high level of alignment here.

- Among the 30 comparisons made between the NCAS Anchor Standards and the Common Core Anchor Standards for Writing, there were 16 instances of positive alignment. Some of these alignments are described below:
 » The ability to convey meaning through the presentation of artistic work related to the Common Core language of "writing to convey complex ideas, produce coherent writing, and develop and strengthen writing" (Common Core State Standards Initiative, 2010a, p. 18).
 » The ability to develop and refine artistic techniques and work for presentation relates to five of the ten Common Core Anchor Standards for Writing, specifically to those that reference the ability to organize and develop ideas as well as to plan, revise, and edit one's work.
 » The ability to analyze, interpret, and select work for presentation relates to Writing as well as Reading; positive alignment was found in four out of ten comparisons, particularly involving Common Core Anchor Standards for Writing that referenced the act of writing in support of an argument or analysis of a source.

Responding

The Common Core Anchor Standards for Reading were a natural fit for alignment with the NCAS Standards for Responding, as all of these standards emphasize skills related to the analysis and interpretation of a work's meaning. Alignments here were clear and strong: 29 of 30 comparisons yielded positive alignment decisions.

Connecting

The two NCAS Anchor Standards for Connecting are largely concerned with the role that context plays in both the creation of and response to works of art—in relating arts-learning to one's own knowledge and personal experience as well as to broader societal, cultural, and historical contexts.

The NCAS Anchor Standards for Connecting related to about one-third of the Common Core Anchor Standards for Reading. In most of these cases, skills of analysis, assessment, and evaluation of text were connected to the ability (noted in NCAS Anchor Standard 11) to relate artistic works to societal, cultural, and historical context to deepen understanding.

Just over half (11 out of 20) of the comparisons between the Common Core Anchor Standards for Writing and the NCAS Anchor Standards for Connecting resulted in positive alignments. In general, abilities like analyzing substantive topics, relating writing style to audience and task, and demonstrating understanding of a subject under investigation all require the kind of contextual knowledge referenced in the NCAS anchors. This kind of contextual knowledge related the NCAS Connecting Anchors to two-thirds of the Common Core Anchor Standards for Speaking and Listening and just under half of comparisons to the Common Core Anchor Standards for Language.

It is a typical misperception to assume that literacy only occurs through reading and writing about the arts. The study of the arts naturally uses fundamental literacy skills such as observing closely, including the repeated observation and careful examination of art to study the choices the artist has made and to understand the interaction of artistic elements and the creation of the arts. The arts allow multiple interpretations of the same score, script, or content. The creative process itself allows students to discover how the choices they make affect their abilities to communicate through their arts discipline.

Alignment with the Standards for Mathematical Practice

The Common Core State Standards for Mathematics describe three overarching shifts in instruction and practice:

1. **Focus:** Greater focus on fewer topics.
2. **Coherence:** Linking topics and thinking across grades.
3. **Rigor:** Pursuing conceptual understanding, procedural skills and fluency, and application with equal intensity.

The Standards for Mathematical Practice are a series of eight paragraph-long descriptions of what it means for students to think mathematically, using process-oriented language to describe the steps students may follow while doing their work. The Standards for Mathematical Practice describe varieties of expertise that mathematics educators at all levels should seek to develop in their students. These practices rest on important "processes and proficiencies" that have longstanding importance in mathematics education.

At first glance, it may seem that these standards would have little in common with arts objectives, as methods of working in art and in math are widely believed to be almost completely unrelated. However, in comparing the language of the Common Core Standards for Mathematical Practice and the National Core Arts Standards, it was found that the process-oriented approach toward standard creation was a powerful unifier; both

sets of standards spoke in terms of planning for one's work, analyzing the task or idea at hand, and considering the role of context as it relates to a particular problem or idea. The 11 National Core Arts Anchor Standards were each compared to all 8 Common Core Standards for Mathematical Practice, for a total of 88 comparisons. Of these, 63 resulted in at least one instance of alignment, and many produced multiple areas of connection within a single standard.

GUIDING PRINCIPLES FOR ARTS ALIGNMENT AND INTEGRATION

Riding the wave of change represented by the Common Core State Standards provides an ideal opportunity to enrich subject area instruction through the arts. The arts are a natural fit for educators who pay close attention to the plethora of arts-related references in the Common Core State Standards.

Many states are finding ways to help arts educators at all levels, including faculty from higher education, understand and integrate key connections with the standards. Some states, such as Oklahoma and Washington, have created model programs for inservice learning in the arts for principals and teachers, as described in Chapters 4 and 7.

In Minnesota, the Perpich Center for Arts Education is working with the statewide Arts Integration Network of Teachers to provide professional development on how to navigate the plentiful choices for connections that are embedded in the Common Core State Standards as well as in the Minnesota Academic Standards in a variety of subjects. Teachers learn how to deconstruct individual benchmarks, identify active verbs, name the types of learning called for in the benchmarks, and develop integrated curriculum and aligned assessments.

In the Duluth, MN, school district, for example, the school board, as well as administration and teachers, have embraced a multi-literacies approach that honors the contributions of the arts to 21st-century literacy. The district has a vision that the arts have a role to play in developing the skills of close reading. Teachers worked with an arts coordinator from the Perpich Center for Arts Education to tie the close reading expectations in the Common Core State Standards to "close reading" of arts images. They mapped their current curriculum to the National Core Arts Standards processes of Responding and Connecting. Next they will work with the Create and Present processes. Teachers have developed draft rubrics to assess student learning in Respond and Connect.

Higher education has a vital role to play in this process. Colleges and universities are in a unique position to prepare teachers to think holistically about the arts in education—as a core subject and as a way to build skills that apply across the curriculum. Higher education can unpack and interpret the latest research that clearly points to the value of high-quality,

sequential arts programming as a fundamental element of basic education. In addition, higher education can prepare preservice teachers to recognize the hallmarks of quality cross-disciplinary alignment, and equip them to undertake alignment work of their own.

To that end, we offer a series of guiding principles for arts alignment and integration, which grow from the Common Core standards research but which may be applicable to art education planning and practice more broadly:

- When comparing arts and non-arts standards and requirements, begin by looking for verbs and other terms that clearly describe the *action* that students are undertaking. What are the processes involved in each subject: Planning? Researching? Presenting? Reflecting? Analyzing? In many cases, more authentic alignment is made possible when educators focus on connecting *practice* across subject areas, rather than connecting specific *content knowledge* in different domains.
- Consider how practices across subjects can *parallel* or *complement* one another. In some cases, processes in different subjects—for example, the acts of interpreting works of art versus interpreting written texts—share many similar qualities, and it may be useful to help students to draw those connections between subjects that they may have thought were unrelated. In other cases, the same term—*research*, for example—could relate to very different practices across disciplines. Work with colleagues to consider how you may borrow approaches and practices from one another across disciplines.
- Remember that arts practice encompasses more than creating and performing. Habits of responding, analyzing, and reflecting are also authentic artistic processes, and including these in arts-integration plans may allow for deeper cross-disciplinary investigations.
- Consider where arts-based methods may provide models for other subjects. As has been demonstrated here, the purpose of arts integration or standards alignment is not always for arts educators to support the activities and objectives of other disciplines. The revised Bloom's taxonomy cites creating as the most complex activity because it merges knowledge and cognitive processes; how might art educators' scaffolding of creative processes be adapted and reinterpreted to facilitate creation in other domains?

CONCLUSIONS

After taking a look at this analysis of points of connection between the Common Core State Standards and the National Core Arts Standards, it is

clear that there are many ways to authentically integrate the arts with reading and math. There are similar ways to connect the arts to the standards of other subject areas, because one of the common goals of educating students across the curriculum is to increase their knowledge and skills so that they can engage deeply and thoughtfully with the content and processes of various fields of learning.

By joining together different disciplines and looking at an issue or idea from multiple perspectives, a new understanding or new level of creativity is often developed. When integrated-learning experiences are designed to focus on standards and processes across the subject areas, teachers know that they are teaching to the learning expectations of the discipline and grade level—they are not being pulled off-task by implementing integrated-learning opportunities that may be perceived as a waste of time. Planning arts-integrated curriculum may be time-consuming, but when designed with a focus on standards alignment, these learning opportunities increase student focus and move the student toward the goals of thinking, linking, and coherence in their learning, as highlighted in the Common Core Standards for Mathematics. Making connections is inspiring for both students and teachers and points to a vibrant education that will prepare students for the multi-literacies in their future.

REFERENCES

Arts Education Partnership. (2012). Seven guiding principles for the arts. Retrieved from www.aep-arts.org/?s=Seven+Guiding+Principles+for+the+Arts

Arts Education Partnership. (2013). Preparing students for the next America: The benefits of an arts education. Retrieved from www.aep-arts.org/wp-content/uploads/2013/04/Preparing-Students-for-the-Next-America-FINAL.pdf

The College Board. (2012). *The arts and the Common Core: A review of connections between the Common Core State Standards and the National Core Arts Standards Conceptual Framework*. New York, NY: Author. Retrieved from www.nationalartsstandards.org/sites/default/files/College%20Board%20Research%20-%20Arts%20and%20Common%20Core%20-%20final%20report1.pdf

Common Core State Standards Initiative. (2010a). Common Core State Standards for English language arts & literacy in history/social studies, science, and technical subjects. Retrieved from www.corestandards.org/wp-content/uploads/ELA_Standards1.pdf

Common Core State Standards Initiative. (2010b). Common Core State Standards for English language arts & literacy in history/social studies, science, and technical subjects, Appendix A: Research supporting key elements of the standards and glossary of key terms. Retrieved from www.corestandards.org/assets/Appendix_A.pdf

Common Core State Standards Initiative. (2010c). Common Core State Standards for mathematics. Retrieved from www.corestandards.org/wp-content/uploads/Math_Standards1.pdf

NAEP 2008 trends in academic progress. (2009). Washington, DC: National Center for Education Statistics, Institute of Education Sciences, U.S. Department of Education. Retrieved from nces.ed.gov/nationsreportcard/pdf/main2008/2009479_1.pdf

National Coalition for Core Arts Standards. (2014). National core arts standards. Retrieved from www.nationalartsstandards.org.

National Coalition for Core Arts Standards. (2012). National core arts standards: A conceptual framework for arts learning. Unpublished manuscript.

Using Curriculum Design Frameworks for Arts Integration

Don Glass and Lisa Donovan

Despite a wide range of claims around the uniqueness and impact of arts integration in particular contexts, arts-integrated curricula can have varying degrees of (1) alignment and coherence with big ideas and enduring understandings, (2) assessment and formative feedback, (3) grounding in the learning sciences, and/or (4) accessibility and flexibility to address wide cognitive variability and cultural diversity. The purpose of this chapter is to make a case for the use of practical curriculum design frameworks in professional development to improve the quality of arts-integrated curriculum by focusing our learning design in thoughtful, purposeful, and systematic ways. In other words, how can we improve arts-integrated curricula to make it more meaningful, flexible, and engaging for a wide range of learners?

In 2007, the Arts Education Partnership commissioned Burnaford (with Brown, Doherty, & McLaughlin, 2007) to conduct a thorough review of literature and supporting research to define the use of *arts integration* as a cross-curricular design strategy. Defining our terms is useful for making concepts operational and making sure that there is a common understanding of what we are trying to do. Defining what we mean by *arts integration* is necessary for any curriculum- and assessment-design projects. Are we integrating arts content around big ideas, enduring understandings (Wiggins & McTighe, 2005), or fundamental concepts (Scripp & Reider, 2007)? Are we using arts content and processes as strategies or options for comprehension, communication, and engagement (Glass, Meyer, & Rose, 2013)? Are we using the arts to cultivate particular thinking routines, habits, and dispositions (Burton, Horowitz, & Abeles, 1999; Hetland, Winner, Veenema, & Sheridan 2007; Perkins, 1994)?

In this chapter, we move beyond defining the *what* and *why* of arts integration to the work of how to support the design of high-quality, inclusive,

and flexible arts-integrated curriculum and assessments. We examine two curriculum design frameworks that support the first two forms of arts integration: those designed around big ideas and concepts, and those designed as learning strategies. Elsewhere, Hetland and associates (2007) discuss how they are using the Studio Thinking Framework to design and review curriculum and assessments for thinking habits and dispositions found in visual arts studio settings.

We mainly explore how curriculum design frameworks and their related tools are an approach for supporting high-quality curriculum design. We build on the theoretical literature, as well as on the design elements and evaluation evidence from two professional development programs that used the same frameworks but worked with different educator audiences. We develop the hypothesis that curriculum design frameworks can help focus design-thinking to be more meaningful, purposeful, and systematic.

USING CURRICULUM DESIGN FRAMEWORKS

Protocols have been designed to provide purposeful, timed, and structured professional conversations to better understand teaching and learning, and to provide useful, timely feedback (MacDonald, Mohr, Dichter, & McDonald, 2003). Checklists have been designed to support attention, focus, and working memory in complex situations (Gawande, 2009). Similarly, curriculum design frameworks provide ways to review curriculum and opportunities to learn that are more systematic and manageable. Curriculum design frameworks can be made operational in a set of tools and protocols that embed, integrate, and "offload" the details of theories and supporting evidence, so that educators can focus on the actual learning design. These tools optimize the complexity of the frameworks to the usable level of a heuristic device for efficient and informed curricular-design decisionmaking. The tools can also be used as reflective devices to focus more deeply on areas of improvement. Novices may rely more heavily on the use of the tools to guide their information organization and use. More expert users will be able to reliably apply the embedded design principles and draw upon a wider range of curricular strategies and options generated from their earlier use of these tools.

The two curriculum design frameworks that we will discuss, Understanding by Design (UbD) and Universal Design for Learning (UDL), are often presented for the up-front design of curriculum. However, many educators, arts specialists, and teaching artists already have some level of existing curriculum or instructional activities that could be evaluated and improved using these design frameworks. Consequently, the process may be more accurately described as applying the design principles to curriculum

in a systematic, dialogic, and iterative way. The frameworks are used as developmental, reflective, and evaluative tools to guide ongoing curricular decisionmaking toward the principles embedded in the frameworks.

In the following sections, we will feature some evaluation evidence from two professional development programs: VSA's Communities of Practice (COP), and Lesley University's Creative Arts in Learning's Integrated Teaching through the Arts (ITA). Both programs use curriculum design frameworks that focus on worthwhile content, educative assessment, and expert learning strategies. These programs provide opportunities for using curriculum design frameworks in professional development with a range of educators: teaching artists, program staff, general educators, arts specialists, and arts administrators. Both programs experimented with hybrid forms of professional learning communities using interactive digital tools that support collaborative practitioner inquiry and knowledge-sharing about curriculum-design thinking and practice.

Understanding by Design: Meaningful, Aligned, and Coherent Curriculum

Understanding by Design (UbD) is a curriculum design framework that focuses first on the selection of meaningful and worthwhile content and goals, and then on the alignment and coherence of those learning goals with assessment evidence and instructional activities (Tomlinson & McTighe, 2006; Wiggins & McTighe, 2005). As a framework supported by the Association for Supervision and Curriculum Development (ASCD), UbD has strong currency in curriculum design at the classroom and district levels. Often referred to as "backward design," UbD prompts educators to plan with the desired results or the end in mind. By linking outcomes with assessment in the initial stages of planning, the activities and procedures used in teaching are more likely to support the learning goals. Teachers begin by thinking about the big ideas and meaningful enduring understandings that can serve as the conceptual foundation for a unit of study. These are then operationalized into essential questions to guide the exploration of content, spark student curiosity, and unpack the meaning of content standards. The next step is to identify the assessment evidence and the criteria of what understanding and ability look like based on the desired results. Once the assessment evidence is established, then the learning activities can be designed to support the assessments and learning outcomes.

The UbD template and related curriculum mapping tool were used in the VSA program and in a curriculum course in the Lesley University arts-integrated M.Ed. program to prompt design-thinking around worthwhile content, curricular alignment and coherence, and educative assessment. Similar to an outcome-based logic model, these tools visually organize the essential curricular elements and highlight the particular design principles

of UbD. A curriculum map may be a valuable tool for focusing arts integration, particularly around big ideas and concepts.

For VSA, a UbD-based curriculum map was first introduced as a design tool. Soon, however, it was used to document and then to report various iterations of teaching artists' design-thinking. The tool prompted teaching artists to be more explicit, clear, and accurate about the learning outcomes and the arts standards that were the goals of their arts activities. The structure helped them to see the alignment between these goals and the supporting activities, and then prompted them to figure out how they could collect relevant assessment evidence. The one-page visual map became a useful source of curricular information to communicate with school collaborators, VSA staff, and peers. Versions of the curriculum map provided coaches and staff with evidence of design-thinking around the principles of worthwhile content, alignment, and coherence.

In the ITA curriculum course, UbD allowed teachers to consider how they documented learning throughout the creative process. "Planning with assessment in mind assures that a full picture of student learning emerges throughout the learning process" (Donovan & Pascale, 2012, p. 179). Teachers explored how the arts may provide more information than traditional pencil-and-paper assessments about how a student has understood or translated a concept. Although the backward-design process may differ from how many teachers had previously designed curriculum, they quickly saw how planning for clear learning goals and assessment criteria allows for increased flexibility in methods. One teacher reflected:

> when I put the [UbD guided] unit together, I found my lesson plans were actually easier to create and write because I already knew the assessment(s) that I was going to use. (L.B., 2012)

She found that planning the assessment before the methods clarifies what needs to be taught for students to succeed on the performance assessments. She continues:

> For instance, if my assessment for a concept was going to be to create a sculpture that represents a stage of pumpkin growth, then my plan had to be the steps on how to facilitate the use of clay, how to teach the children the use of the art medium to represent their thoughts, and to make sure that the concept or subject matter was taught. (L.B., 2012)

These types of revelations by educators provided the bridge to explore and to use the second curriculum design framework: Universal Design for Learning.

Universal Design for Learning:
Addressing Student Variability and Expert Learning

Universal Design for Learning (UDL) is a translational framework for guiding the design and evaluation of accessible and flexible curriculum, programs, and materials (Rose & Meyer, 2002). The key design principles of UDL address curricular accessibility and flexibility, and they scaffold support for expert learning strategies. UDL is operationalized through a set of UDL Guidelines for providing multiple, flexible options for student Representation, Action and Expression, and Engagement (CAST, 2011). The UDL Guidelines are organized around their support of three neural networks that are associated with learning: recognition—the *what* of learning, strategic—the *how* of learning, and the affective—the *why* of learning. Representation supports learning in the recognition neural networks that deal with the processing of perceptual information, language and symbols, and comprehension. Action and Expression supports learning in the strategic neural networks that focus on physical action, expression and communication, and executive functions like planning and progress monitoring. Engagement supports the affective neural networks that support attention, motivation, persistence, and emotional self-regulation.

From a practitioner's perspective, UDL addresses the problem of how to design curriculum to support a wide variety of learners in and across educational settings. Because neuroscience is showing us that learning variability is the norm, UDL provides a well-structured and researched set of guidelines with strong explanatory power to help educators understand and design learning opportunities to support multiple, flexible learning pathways (see Figure 3.1). The framework is grounded in evidence from the learning sciences, focused ultimately on the goal of expert learning—or learning how to learn, and translated through a set of guidelines and checkpoints to prompt curricular design and evaluation decisionmaking. For arts integration, the UDL framework may be most effective in thinking about using arts content and processes as learning strategies and options for comprehension, communication, and engagement.

For VSA staff and teaching artists who work with young people with disabilities in inclusive and self-contained settings, UDL provides a system for thinking about accessibility and learning supports for a wide range of learners (Glass, 2010; Glass, Blair, & Ganley, 2012). It provides a framework to identify curricular barriers to learning, and then to design multiple, flexible supports to address the learning variability. What teaching-artists learn about supporting young people with disabilities can be made an option available to everyone. For example, captioning and transcriptions for digital media provide students who are deaf with access to spoken content, as well as provide a text version for English learners who may need some

Figure 3.1. UDL Guidelines Address Variability and Support Expert Learning

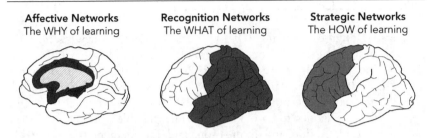

Engagement	Representation	Action and Expression
Provide options for self-regulation	Provide options for comprehension	Provide options for executive function
Provide options for sustaining effort and persistence	Provide options for mathematical expressions, and symbols	Provide options for expression and communication
Provide options for recruiting interest	Provide options for perception	Provide options for physical action

Source: CAST, *Universal Design for Learning guidelines* (2011, Version 2.0); Reprinted by permission of CAST, Inc. © CAST, 2015.

language supports, or to other students who may have a hard time focusing attention. In other words, UDL can be used as a design and reflection tool in an ongoing process of expanding educator knowledge of learning options and opportunities for everyone, as evidenced in the reflective case narratives by Jenkins and Agois-Hurel (2010) and Kronenberg and Blair (2010).

In the ITA program, teachers see UDL as a frame that points to what arts integration may do naturally—provide many pathways to learning. A study conducted with alumni of the ITA program found that teachers discovered deep relevance in arts integration because it provided multiple, flexible options for student learning and assessment. The data suggest that the arts provided multiple means for students to connect with curricular ideas and to demonstrate their understanding in ways that led to deeper learning (Bellisario, Donovan, & Prendergast, 2012).

The UDL framework is used to guide arts-integrated curriculum design to meet the needs of diverse learners. Teachers feel that designing curriculum with UDL in mind "is a new way of thinking" that prompts a focusing process leading to "three dimensional" approaches to teaching and developing "textured," well-rounded options. A trend in the evaluation responses

is highlighted by this quote from a teacher on how the arts-learning options and assessments address learner variability for demonstrating what they understand, know, and are able to do:

> This framework provided me a very clear focus, and I was able to concentrate even more deeply on the needs of my diverse students. Even though I subconsciously acknowledged that my students were highly diverse, I did not fully grasp the totality of their differences until I was introduced to the research supported in UDL—how students gather facts, organize ideas and engage in learning is uniquely individual. Upon reflection of what my assessments have been in the past, I realized that they are often times an afterthought. They are not connected to essential understandings that I hope my students will carry with them for a lifetime, but are merely focused on a resource or activity. (S.F., 2013)

Another ITA teacher noted how this more universal approach to curriculum design is efficient and works for both students and for teachers:

> I found that adding additional options provides me with a variety of choices for differentiating instruction so that when the demographics in my classroom change, all learning needs will still be met. Such rich planning also supports the teacher by having those options in place so that all information necessary is located in one lesson, rather than having to create different lessons, thus saving time and energy. (M.A., 2012)

As students begin to express their learning in different ways, translating the content into new forms, they develop what scientists and mathematicians refer to as *representational fluency*—the ability to use different symbolic systems to represent meaning. This fluency allows students to communicate effectively and responsively to applications of content. The arts provide languages that afford students a variety of ways to express understanding. Providing choices for students to express understanding not only bolsters a student's ability to communicate, but also provides additional ways for students to be successful in communicating what they know.

FOSTERING AN IMPROVEMENT MINDSET IN EDUCATORS

In this final section we touch on how the use of curriculum design frameworks for preservice and inservice educators may provide the frameworks and tools for improved design and refinement of curricula, as well as contribute to a more meaningful implementation of standards. In teacher preservice

coursework, these frameworks may provide structure and guidance for initial curriculum design by teaching the embedded design principles through their practice and use. For inservice teachers, the frameworks can provide focus for professional learning communities who are tasked with implementing new standards, as well as generate rich, qualitative documentation that can be used as additional supportive evidence of effort, improvement, and impact in teacher evaluations. For both preservice and inservice educators, the systematic use of the frameworks may foster an improvement mindset and set of routines.

Designing for Elegant Fit and Optimal Impact

Understanding by Design helps to make curricular connections explicit, fair, and formative through aligned goals, assessment, and activities. Universal Design for Learning makes this curriculum increasingly goal-oriented, varied, and flexible to address the variability of learners and to support expert learning strategies. Not only are UDL and UbD powerful thinking frames for curriculum design; educators can use the tools for design and evaluation, as well as for planning and reporting. The tools provide documentation from which educators can build professional portfolios and reflective narratives about how they have improved their practice. Collecting educator responses to the frameworks via the tools at multiple points in the design, implementation, and reflection on curriculum can provide evidence of the educators' design thinking, their application of design principles, and the scope of learning opportunities they provide for students. Equally important (or perhaps more), when consistently used over time, these documentation tools provide rich and layered documentation for a robust feedback loop for teachers to investigate and understand their teaching and learning, and for students to reflect upon and identify patterns in their work that can serve to sharpen their skills over time. In short, these tools keep teaching focused and relevant, and they document professional learning for coaching feedback and more qualitative evaluation purposes.

This can be beneficial in all learning, but for arts integration it serves to illuminate the "elegant fit" that well-designed arts-integrated and interdisciplinary work can yield. The tools provide structures and guidance for thinking, planning, and evaluating, and they reveal the "how" of the learning process. Teachers report becoming more intentional as arts-integrated curriculum designers, more aware of the power of being a reflective practitioner, and they are often amazed at how this kind of careful, intentional documentation process unearths a wealth of information about teaching and learning. The initial reaction from teachers is often: "Is this one more thing for me to do?" In reality, the process of working through UDL opens up choices in representation and expression for teachers. We believe that the use of these frameworks has the potential to align the curriculum process so

that extraneous elements fall to the side, and the true core is deepened and documented in ways that can be shared for optimal impact.

Putting Standards into Practice

Although arts integration has long been a key feature of many arts education programs, cross-curricular design is a growing strategy in general education as the Common Core State Standards (CCSS) and Next Generation Science Standards (NGSS) are being implemented. These new sets of standards demand curricular design where literacy, numeracy, and cross-cutting concepts and practices are used across subject areas. This expansion of what it means to read, write, communicate, and reason demands that curricular connections across subject areas are conceptually coherent, appropriate for, and relevant to disciplinary knowledge, and that they are flexible enough to support the general transfer of knowledge and practices to other contexts.

In their 2014 report on the alignment of the National Core Arts Standards and the Common Core State Standards, the College Board (2014) notes the "similarities in habits and processes described in standards across subject areas, and consider[s] the ways that they may relate to one another in practice." They recognize the potential curricular connections and recommend that, "in order for these research findings to be most useful, they need to be clearly and concretely connected with classroom practice" (p. 12). The National Coalition for Core Arts Standards began this process by using Understanding by Design to guide the development of the anchor standards and related model cornerstone assessments. They also explain how UbD is supported by the learning sciences:

> Enduring understandings and essential questions focus on what are often called "big ideas." Current brain research suggests that, by organizing information (in the arts and other subjects) into a conceptual framework, greater "transfer" is facilitated—a key aspect of planning and delivering big ideas in curricula. (National Coalition for Core Arts Standards, 2014, p. 14)

We recognize that the CCSS, the NGSS, and the National Core Arts Standards demand developing cross-curricular connections. Implementing standards is not just aligning what you do now with statements in a new document; implementing standards well can provide opportunities to engage with the disciplinary content and cross-curricular connections of concepts and practices. Alignment with standards needs to be a process of evaluating, reconsidering, and improving educational opportunities for a wide range of students with clear learning goals and expectations in mind (see Chapter 2).

Using curriculum design frameworks as both design and reflection tools fosters a mindset of goal-oriented improvement and continual reflection for educators. UbD and UDL set this up with a cross-curricular design process,

by providing guidance for how to unpack standards into enduring under-
standings and essential questions; select worthwhile and engaging content;
plan for collecting assessment evidence; and organize a range of supportive
instructional activities, resources, and supports. Together, the curriculum
design frameworks support systematic curriculum design that is inclusive,
goal-directed, flexible, and engaging for a wide range of learners.

REFERENCES

Bellisario, K., & Donovan, L., with Prendergast, M. (2012). *Voices from the field:
 Investigating teachers' perspectives on the relevance of arts integration in their
 classrooms.* Cambridge, MA: Lesley University.
Burnaford, G., with Brown, S., Doherty, J., & McLaughlin, H. J. (2007). *Arts integra-
 tion frameworks, research, and practice: A literature review.* Washington, DC:
 Arts Education Partnership. Retrieved from 209.59.135.52/files/publications
 /arts_integration_book_final.pdf
Burton, J., Horowitz, R., & Abeles, H. (1999). Learning in and through the arts:
 Curriculum implications. In E. B. Fiske (Ed.), *Champions of change: The im-
 pact of the arts on learning* (pp. 35–46). Washington, DC: The Arts Education
 Partnership
CAST. (2011). *Universal Design for Learning guidelines* (Version 2.0). Wakefield,
 MA: Author.
The College Board. (2014). *The arts and the Common Core: A comparison of the
 National Core Arts Standards and the Common Core State Standards.* New
 York, NY: The College Board.
Donovan, L., & Pascale, L. (2012). *Integrating the arts across the content areas.*
 Huntington Beach, CA: Shell Education.
Gawande, A. (2009). *The checklist manifesto: How to get things right.* New York,
 NY: Metropolitan Books.
Glass, D. (2010). The design and evaluation of inclusive arts teaching and learn-
 ing. In *Contours of inclusion: Inclusive arts teaching and learning* (pp. 1–11).
 Washington, DC: VSA. Retrieved from www.eric.ed.gov/ERICWebPortal/detail
 ?accno=ED522677
Glass, D., Blair, K., & Ganley, P. (2012). The arts option. In T. Hall (Ed.), *Universal
 design for learning and technology in the classroom* (pp. 106–119). New York,
 NY: Guilford Press.
Glass, D., Rose, D., & Meyer, A. (2013). Universal design for learning and the arts.
 *Harvard Educational Review, Special Issue: Expanding Our Vision for the Arts
 in Education, 83*(1), 98–119. Retrieved from hepg.org/her/abstract/1229
Hetland, L., Winner, E., Veenema S., & Sheridan, K. M. (2007). *Studio thinking: The
 real benefits of visual arts education.* New York, NY: Teachers College Press.
Jenkins, R., & Agois-Hurel, N. (2010). Engaging culturally diverse learners through
 comics and improvisation. In *Contours of inclusion: Inclusive arts teaching and
 learning* (pp. 36–46). Washington, DC: VSA.

Kronenberg, D., & Blair, K. (2010). Sixth-graders bring ancient civilizations to life through drama. In *Contours of inclusion: Inclusive arts teaching and learning* (pp. 26–35). Washington, DC: VSA.

MacDonald, J. P., Mohr, N., Dichter, A., & McDonald, E. C. (2003). *The power of protocols: An educator's guide to better practice.* New York, NY: Teachers College Press.

National Coalition for Core Arts Standards. (2014). National Core Arts Standards: A conceptual framework for arts learning. Retrieved from www.nationalarts-standards.org/content/conceptual-framework

Perkins, D. A. (1994). *The intelligent eye: Learning to think by looking at art.* Santa Monica, CA: The J. Paul Getty Trust.

Rose, D. H., & Meyer, A. (2002). *Teaching every student in the digital age: Universal Design for Learning.* Alexandria, VA: Association for Supervision and Curriculum Development.

Scripp, L., & Reider, D. (2007). New ventures in integrated teaching and learning: Working toward a model of general symbolic literacy based on the growing understanding of fundamental literacy skills shared between music and language in grades K–2. In *Journal for Music-in-Education* (pp. 337–380). Boston, MA: New England Conservatory & the Music-In-Education National Consortium.

Tomlinson, C., & McTighe, J. (2006). *Integrating differentiated instruction and Understanding by Design: Connecting content and kids.* Alexandria, VA: ASCD.

Wiggins, G., & McTighe, J. (2005). *Understanding by design* (expanded 2nd ed.). Alexandria, VA: ASCD.

STATEWIDE MODELS
OF ARTS INTEGRATION

The two chapters in this Part present the experiences and challenges of two statewide efforts to implement specific arts integration approaches across whole schools. The two examples here are from Oklahoma and Maryland. Since whole-school reform requires participation from all stakeholders, along with resources and support at the district level and frequently the state level, an infrastructure is needed to move forward from planning and design to implementation. The approaches presented here rely on collaborative partnerships among institutions of higher education, arts advisory panels, arts advocacy groups, and the USDOE for grant funding, as well as support from policymakers at the state level.

In Chapter 4, Jean Hendrickson discusses the Oklahoma A+ Schools (OKA+) approach of arts-integrated professional development that enhances the capacity of teachers to offer arts-integrated curricula. Hendrickson describes the Oklahoma approach to school reform based upon the eight A+ Essentials framework model, originally developed in North Carolina and used throughout Oklahoma and in several other states across the nation. With "Arts" as one of the eight essentials, the OKA+ Schools commit to art every day for every child, through both integration of the arts into other disciplines and through direct instruction in art forms. Because teachers need hands-on experiences in the arts if they are to be expected to use the arts in their teaching, much attention is paid to ongoing professional development provided by experienced arts and education facilitators, to build arts-rich schools. The effective strategies, lessons, and partnerships that the schools develop over time are shared through a sustained and vibrant network of A+ programs.

In Chapter 5, Mears, O'Dell, Rotkovitz, and Snyder examine the work of a unique statewide consortium of PK–12 schools, higher education, state education leaders, and arts and cultural organizations that came together in 1992 to support professional development in arts integration for all of the Maryland arts-teaching workforce. The Arts Education in Maryland Schools Alliance (AEMS) supports an approach for fostering high-quality arts integration programs supported by professional development for teachers. The

alliance has instituted changes in policy, regulation, teacher training, professional development, funding, communication, and advocacy in support of quality arts-integrated education for all children across the state. Based upon the lessons learned from the challenges and opportunities of this expansive partnership, the authors recommend guidelines for designing statewide initiatives in arts integration.

Whole-School Models of Arts Integration

Oklahoma A+ Schools

Jean Hendrickson

Oklahoma A+ Schools (OKA+) is a research-based whole-school network with a mission to nurture creativity in every learner in Oklahoma. It is a systematic approach to whole-school reform that takes into account the complex nature of the work of schools so that the arts, with all of their benefits, can become part of the fabric of each school and be sustained over time. OKA+ is a department at the University of Central Oklahoma (UCO) and provides ongoing professional development, an intricate network of support, and an active research component for feedback to schools. The research conducted on OKA+ over a five-year period, from 2002 through 2007, has documented the effectiveness of the approach when compared to schools in the state on average by showing that OKA+ Schools have higher scores on the state's Academic Performance Index, have happier and more engaged students and teachers, and experience a more joyful learning climate (Barry, 2010).

There are active A+ Schools networks in North Carolina, Oklahoma, Arkansas, and Louisiana. The four states work together in the National A+ Schools' Consortium (www.nationalaplusschools.org/), where they regularly share updates, research, and stories of successful practices. There are other hot spots that also utilize the A+ Schools' methodology in Iowa, Kansas, Texas, Michigan, and Cape Town, South Africa. Additional states and individual inquiries come to the members of the national consortium regularly, and while stand-alone whole schools or smaller groups of schools are regularly served by one of the four states in the consortium, new states' teams are accepted into the consortium only if they show the capacity to maintain a statewide home base and presence and enter into a 3- to 4-year mentoring relationship with an existing state member. This provides a level of quality control and fidelity to the tenets of the model that is crucial to its consistency.

OKA+ coordinates a diverse network of schools from early childhood through high school, in urban, suburban, and rural communities. Since its inception in 2002, and through a four-year apprenticeship with North Carolina, OKA+ has grown from 14 schools to over 70 schools, thereby comprising the largest of the four states' networks.

OKA+ uses arts-based professional development to systematically build the capacity of teachers over time to integrate the arts into their teaching so that students can learn in and through the arts. Teachers need hands-on experiences in the arts if they are to be expected to use them in their teaching, which puts arts into the context of whole-school transformation. These professional development experiences support adult learning by fostering creative personal realization and well-being as well as by building the basis for communication and connections that are relevant to the teachers and to their students. A culture of continuous learning is nurtured in a safe environment where teachers from different disciplines, grade levels, school communities, and life experiences are trained by practitioners of the same disciplines and learn strategies to implement in their classrooms.

A+ ESSENTIALS

What binds this diverse network of A+ Schools together is their use of the organizing framework of the A+ Essentials. The eight A+ Essentials were developed in 2001 by North Carolina A+ Schools. In these schools, the teachers, principals, and A+ staff worked to define what it is that sets the initiative apart. It has never been a top-down approach that tells schools what to do; rather, it is a bottom-up approach that captures what the group is commonly committed to as defined within the Essentials. Hence, the A+ Essentials framework unites schools across diverse communities with a way to communicate and learn from one another about the effective use of arts-based strategies. The Essentials systematically support the school, putting the needs of the school into a cohesive whole with common language and understanding of the areas in which the school must operate. The framework provides a nonnegotiable "home" for the arts in schools so that they are not addressed in isolation. The framework protects the arts from elimination in times of change such as lean budget years, key staff changes, and other such changes in schools over time.

Because no two schools are the same, each school must determine how it will practice each Essential. Briefly, when schools commit to the eight A+ Essentials, they commit to the following practices:

Arts. Value the arts as essential to learning, teach them daily, and include them in planning.

Curriculum. Link core classes to promote meaningful experiences and spark enthusiasm for learning.

Experiential Learning. Put learners in an environment in which they actively participate in acquiring knowledge.

Multiple Learning Pathways. Acknowledge that people learn in many ways and provide opportunities for information to be presented and shared in a variety of ways. This practice includes attention to Howard Gardner's theory of multiple intelligences and arts disciplines as means of expression.

Enriched Assessment. Evaluate achievement by allowing students to demonstrate mastery through multiple measures.

Collaboration. Strengthen ownership across the school community while promoting broad-based leadership and intentional connections.

Infrastructure. Organize time, space, technology, and resources to support transformative learning and protect space for arts instruction.

Climate. Establish an environment where teachers and students are respected and the creative process is highly valued.

With Arts as one of the eight essentials, OKA+ Schools commit to art every day for every child, through both integration of the arts into other disciplines and through direct instruction in various art forms. Committing to both arts instruction and arts integration reduces the tendency of these two approaches to compete in schools, especially as schools experience the positive impact that the two-pronged approach for arts instruction has on both teaching and learning. This combined approach enables students to more regularly engage with arts-based practices because they experience them in multiple forms as they learn. We expect every student to have an authentic encounter with the arts each day. By putting the arts into the broader set of commitments that are part of the everyday practices of the school, we ensure that they become embedded in multiple ways and are less vulnerable to elimination when changes occur in schools, communities, the economy, or government.

OKA+ SCHOOLS

To ensure that the arts are a part of everyday learning, Oklahoma schools work with three components, which they refer to as a three-legged stool. These components are ongoing professional development, networking, and research. Experience has shown that without the continued support of the network and ongoing professional development that follows a school's

initial training, arts-based initiatives may fall prey to competing interests and fail to be sustained over time. Too often efforts fall apart in schools when the primary initiator (a strong principal, teacher, or parent) leaves the school. Change is a way of life, and it is important that the arts are not negatively affected when things change. The OKA+ Schools organization serves as the sustaining hub for the network by providing site-specific professional development, regular networking events for participants, and feedback through research on the effectiveness of the implementation of the program. The research informs practice through incorporation of research recommendations and periodic observations, surveys, and focus groups.

Central to the A+ Schools approach is the leadership of a group of about 70 artists and master teachers who provide professional development in the arts for teachers in the network. These OKA+ Fellows are independent contractors who represent every subject area, grade level, and art discipline in the school system. The OKA+ Fellows work in an ongoing way with schools and are invited to join the group on the basis of their level of expertise and reputation in their respective fields. OKA+ Fellows bring credibility to the teachers because they hold similar positions to the teachers they support. OKA+ Fellows also participate in their own professional growth through regular retreats hosted by the OKA+ Schools staff. These gatherings allow the Fellows to share current projects, strategies, and workshop ideas that cross disciplines while focusing on the A+ Essentials. This model is similar to other state models of A+ Schools.

OKA+ has found that hands-on, whole-school experiences in arts content and arts integration awaken teachers' creative instincts and provide the group with shared experiences that bring learning to life in memorable, personal, and long-lasting ways. Using the arts in teacher training and connecting the arts to other disciplines helps to break the mold of what teachers have grown to expect from their "professional development" sessions. Although more than 90% of teachers take part in professional development, the training they receive is "often meaningless," according to Darling-Hammond, Chung Wei, Andree, Richardson, and Orphanos (2009). In contrast, in OKA+ Schools, teachers report a high level of satisfaction and increased confidence in their ability to use the arts in their classroom, as measured by the Teacher Opinion Survey that was administered following the arts-integration teacher-training sessions in the initial training provided by OKA+ Schools (Raiber, 2010).

In short, OKA+ Schools have found that using the arts in schools invigorates teachers, brings joy to the students, and equips both with tools of expression and exploration that are otherwise left out of the quest for school improvement. Arts learning and ongoing support build teacher capacity to authentically teach through the arts. Some of the arguments for the use of arts and arts integration for teacher training are found in the responses from the teachers themselves. In *Volume One: Composite Narratives*,

documentation of the 5-year research study of OKA+ Schools, Bryan Duke quotes from a teacher, "I've tried to incorporate lots of arts. I've tried before, but not as intensively. I feel much better about this integration after the training I have heard about many of the teachers utilizing more creative approaches than just color sheets!" (p. 19).

To combat the top-down approach that school reform typically takes, A+ Schools use a systematic approach to building school staff's understanding and ownership of the decision to become a school in the network. Schools learn about the OKA+ Schools' approach by attending half-day pre-application sessions where school teams of from five to seven people, one of whom must be the principal, learn about the A+ Essentials and the role of the arts in student learning. One team member must be the principal because the OKA+ research shows that principal leadership is one of the three key "drivers" of successful implementation. The other two drivers are faculty engagement and quality professional development. After two such workshops with two teams from the school, and with invitations from network schools to visit or inquire about the model, each school faculty must determine that 85% of the school is in agreement to apply to become an OKA+ school. It is only then that the school will apply to the network and include its responses to questions about its predisposition to use the arts, its agreement to participate in research, and its commitment to fully participate and share in network offerings.

BUILDING THE CAPACITY OF THE WHOLE SCHOOL

Starting with a five-day summer institute, each new school will have sequential interactions designed to incrementally build capacity. The entire school community, from the principal to the school secretary, participates in a series of workshops that guide the school's understanding of how the eight A+ Essentials can help each of them meet their goals for their students. Led by teams of OKA+ Fellows, the collaborative nature of the interdisciplinary approach is modeled and valued. The team then maps the curriculum to find natural connections to the arts and other disciplines, and identifies community resources that could assist the implementation process in the community.

This approach merges nicely with a school's need to connect to the larger set of goals and standards set out for them in such documents as the Common Core State Standards, which many states have adopted, as well as in the National Core Arts Standards. It does this in two ways: first, by helping teachers identify direct references to arts-based study that already exist within the standards, and second, by facilitating the search for connections to other skills and abilities being emphasized.

One of the most pervasive challenges of any initiative is to sustain the relationship and the impact after the initial introduction and orientation. In

addressing this challenge, OKA+ provides ongoing support once the school has completed its initial five-day summer institute. There is a three-year implementation process for new schools and ongoing development and support of all member schools, regardless of their time in the network. OKA+ Schools provides site-based professional development, an annual leadership retreat for the principal and the school's OKA+ Advocate (a teacher or other staff member who serves as a staff liaison in addition to the principal), and regular arts integration workshops in conjunction with cultural partners. Schools also have access to online learning and networking with video-ready workshops developed by OKA+ Fellows, and they are invited to an annual statewide OKA+ conference.

No amount of professional development can sustain effective arts-based practices without the ownership and participation of the school itself. OKA+, in conjunction with its research team, has created a suite of self-assessment tools to enable staff members to take stock of the goals and objectives that the school itself has set and to measure progress over time. OKA+ calls this set of instruments its Tools for Schools. Tools for Schools helps all parties to be clear about what their OKA+ School "looks like," and how the school knows when it is advancing effectively toward self-identified goals and objectives. It clarifies how professional development over time contributes to building teachers' capacity to manage the arts in their classrooms and to see the impact on student learning. In many ways, using the Tools for Schools suite provides teachers and administrators the confidence and opportunity to be more creative, since they are not restricted to filling in a checklist for compliance. Schools use one such tool, the *OKA+ Implementation Guide,* to assess where they are in the process of integrating the arts and how they are doing with the other A+ Essentials commitments and to determine how to take their learning into their own classrooms. Often used as the basis for requesting next-step professional development, the *Implementation Guide* helps schools chart a path toward full, effective, and rich educational experiences for all students, and it allows schools to establish benchmarks for their implementation process.

The OKA+ research report contains evidence of successful implementation of the A+ Schools' philosophy and practice from teachers, such as the following response: "Kids come to school excited about new challenges. They know they can be successful at something and often ask, 'What are we learning today?'" And here is a response from a principal who recognizes the importance of sustaining the initiative: "Another important thing that A+ has given us is a sustainable program. . . . So many things in education come and go. They are here one year, and then the next year they rename it. A+ is not 'different programs.' It's a systematic structure for school (student) achievement. A set of principles" (Barry, Raiber, Dell, Duke, & Jackson, 2006, p. 16.).

THE ROLE OF THE ARTS EDUCATOR

While every A+ School commits to providing arts-based experiences every day for every child, the reality is that some schools have a full arts staff and some have no arts staff. The arts have been a continuous part of the Oklahoma State Department of Education's definition of core curriculum for years. The issue is that the arts in schools are not standardized nor equitably available. Many schools, legislators, community leaders, and others see the OKA+ Schools approach as an effective way to ensure that the arts are central and sustainable in schools so that all students can benefit.

However, some educators fear that an OKA+ approach can displace rather than support arts educators in the school. They assume that the demand for arts specialists will decline as classroom teachers learn to integrate arts into their curriculum. What actually occurs is the opposite. By showing the value of the arts disciplines in learning and by enabling true collaboration in designing learning goals and objectives, OKA+ Schools report that the value and need for arts specialists are enhanced, both in direct instruction and as collaborators in arts integration (Raiber, 2010). Teachers in other core subjects come to appreciate the arts disciplines because of their own increased comfort and knowledge gained through the professional development. Arts specialists often see their role expanding in designing the student learning outcomes through the collaborative planning that is facilitated through the school's commitment to the A+ Essentials of Infrastructure and Collaboration.

However, the fluctuation of the amount of financial resources available to schools in Oklahoma as the state's budget rises and falls on the price of oil and gas creates a barrier to consistency of staffing. In the state's fiscal year beginning July 2015 through June 2016, for example, Oklahoma experienced "revenue failure," where the costs of government exceeded the funds taken in by the state through taxes. Budget cuts happen fairly regularly, leading to cuts in school district budgets that often lead to a reduction of staff that hits arts staff disproportionately. For example, the state's largest school district and the one with the highest number of OKA+ Schools cut arts staff by 50% in elementary schools to begin the 2016–2017 school year.

In schools without any existing arts staff or with limited staff, arts integration strategies are often the focus of the on-site professional development that is provided by OKA+ Fellows. The OKA+ office pairs Fellows who are arts specialists with grade-level teachers so that teachers without direct arts expertise receive quality instruction and support from specialists in their fields. By modeling this collaborative approach and helping teachers make connections to standards and objectives for which they are accountable in the arts, a strong sense of confidence is built in the teachers' own abilities to provide authentic, connected, and arts-rich learning opportunities for their

students. Importantly, the OKA+ Fellows become the arts specialists and collaborators who are crucial to building the school's capacity in the arts, which, in turn, leads to an understanding by the school of the need for additional arts resources. This collaboration does not, however, offer any sort of immediate relief to the stresses of budget cuts and requires strong commitment to "stay the course" for what is best for students and the community during tough economic times.

It takes time and ongoing professional development provided by experienced and creative facilitators to build arts-rich schools. The effective strategies, lessons, and partnerships that schools develop over time can then be shared with a larger community through a sustained and vibrant network. This approach demands more than simply providing arts classes for students in schools because it includes a commitment to the A+ Essentials.

Over time, this approach takes root in schools in ways that support student learning across the curriculum. As reported by one researcher observing a 5th-grade class, students were

> making Kachina dolls—masking tape bodies fashioned on a wire frame—painted and decorated with feathers, beads, construction paper and cloth. A very articulate young man approaches me, shakes my hand and introduces himself as Cody. Cody proceeds to tell me about their Kachina dolls and all that they're learning about Hopi Indians. I ask if this is a social studies or art class—Cody replies "Both." (Barry et al., 2006, p. 33)

Oklahoma A+ Schools has long partnered with higher education in their work in preservice and inservice professional development of teachers in arts integration. Oklahoma A+ Schools provides the bridge between theory and practice that has the goal of providing relevant, prepared, and excellent teachers who are predisposed to work collaboratively and creatively, with a deep understanding of the value of arts education, cross-curricular connections, multiple learning pathways, and experiential learning. Further, the research component allows higher education to engage in the initiative and provides opportunities for scholarly work in an ongoing, active endeavor. A challenge at the university level is for OKA+ offerings to be seen by professors and department heads as a support and not as a competitor for student time and interest.

For example, OKA+ Schools staff provides information to every preservice teacher at the University of Central Oklahoma through presentations in the seminar series that is part of the required coursework of all education students. Additionally, in the summer of 2012, the university began to offer a course for both graduate and undergraduate credit on A+ Essentials in Action, which explores the role of the model in individual teachers' growth and exploration.

KEEPING THE ARTS AT THE CORE

In order to ensure that schools sustain arts-based practices that honor the artist and authentically teach arts skills, disciplines, and practices, OKA+ Schools maintains that it is critical to position the arts within the larger context of the work of the school. Building a common frame and language that takes into account the many facets of schools allows the arts to be considered in the same light as all other skills, abilities, and ways of knowing that students are entitled to experience in their education.

One of the most compelling features of the A+ Schools approach is the evidence that in all statewide networks this approach works in schools that implement it with fidelity. Each state has public, private, and public charter schools. There are rich schools and poor schools, large schools and small schools, urban and suburban and rural schools. They serve students from preschool through high school. The salient factor is not any of these demographics; rather, it is that there is a framework, in this case the eight A+ Essentials, that helps provide a common language and a way to work toward building out the schools they want, inclusive of creative opportunities, so that the students have the best possible learning experience. In every A+ School the arts are a nonnegotiable part of that experience (Corbett, McKenney, Noblit, & Wilson, 2001).

Over the past decade the Oklahoma A+ Schools program has been a proving ground for exploring whole-school transformation where the arts are a key to success (Noblit, Corbett, Wilson, & McKinney, 2009). All of the lessons learned have been shared among the A+ Schools Consortium of North Carolina, Arkansas, Louisiana, and Oklahoma. Our hope is that as more schools and organizations grow in their understanding of the power of the A+ approach, more communities will partner with higher education to develop A+ Schools in their state.

REFERENCES

Barry, N. H. (2010). *Oklahoma A+ Schools: What the research tells us 2002–2007. Volume three: Quantitative measures.* Edmond, OK: Oklahoma A+ Schools/ University of Central Oklahoma.

Barry, N. H., Raiber, M., Dell, C., Duke, B., & Jackson, D. (2006). *Oklahoma A+ Schools research report: Year four: 2005–2006.* Edmond, OK: University of Central Oklahoma, Oklahoma A+ Schools®.

Corbett, D., McKenney, M., Noblit, G., & Wilson, B. (2001). *The A+ schools program: School, community, teacher, and student effects* (Report #6 in a series of seven policy reports summarizing the four-year pilot of A+ Schools in North Carolina). Winston-Salem, NC: Thomas S. Kenan Institute for the Arts.

Darling-Hammond, L., Chung Wei, R., Andree, A., Richardson, N. & Orphanos, S. (2009). *Professional learning in the learning profession: A status report on*

teacher development in the United States and abroad. Stanford, CA: The School Redesign Network at Stanford University, and Dallas, TX: National Staff Development Council.

Duke, B. (2010) *Oklahoma A+ Schools: What the research tells us 2002–2007. Volume one: Composite narratives.* Edmond, OK: Oklahoma A+ Schools/University of Central Oklahoma.

Noblit, G. W., Corbett, H. D., Wilson, B. L., & McKinney, M. B. (2009). *Creating and sustaining arts-based school reform: The A+ Schools Program.* New York, NY: Routledge.

Raiber, M. (2010). *Oklahoma A+ Schools: What the research tells us 2002–2007. Volume four: Qualitative measures.* Edmond, OK: Oklahoma A+ Schools/University of Central Oklahoma. Retrieved from http://okaplus.org

Sternberg, R. J., & Williams, W. (2003, January 1). Teaching for creativity: Two dozen tips [Web log post]. The Center for Development and Learning. Retrieved from www.cdl.org/articles/teaching-for-creativity-two-dozen-tips/

The Evolution of Arts Integration in Maryland

Working in Consortium

Mary Ann Mears, Kathy O'Dell,
Susan J. Rotkovitz, and Lori Snyder

Maryland has a long history of progressive education that includes strong arts education programs. The Arts Education in Maryland Schools Alliance (AEMS, 2014), founded in 1992, has been an important contributor to this history by accelerating the pace, volume, and quality of such programs. Today, just like 25 years ago, AEMS is fueled by the power of working in consortium. This chapter tells the story of this collaborative approach— its successes, failures, trip wires, and lessons learned—and of the partnerships forged along the way. Working together, these partners have instituted changes in policy, regulation, teacher training, professional development, funding, communication, and advocacy, all toward a shared goal: Assuring equity and access to high-quality arts and arts-integrated education for all students in Maryland.

Conceptually, this is a story of coming full circle, beginning in the 1990s, by introducing the educational necessity of arts-integrated teaching and learning in balance with discipline-specific teaching and learning; then, by the late 1990s and 2000s, focusing more exclusively on arts integration (AI); and back again, in the 2010s, to presenting AI and the five arts disciplines (dance, media arts, music, theater, and visual arts) in a more pedagogically complementary manner. But "full" circle should not be construed as "closed." Rather, the form of this evolution more closely resembles a spiral, the inherent dynamism of which charts a path upward and outward, tracking past accomplishments and directing partners' future pursuits in arts education and integration.

Because of recent advances at the state level, the story begins in the current moment, winds back to the past, moves forward, and rounds back again, highlighting significant moments in the ever-spiraling evolution of educational work in the arts in Maryland and the partners who make it

happen. The chapter ends with a look at the practices that have made the consortium approach successful and an overview of current challenges and opportunities.

NOW—MAKING INFRASTRUCTURAL CHANGE

True change often cannot take place without regulation, and the best regulatory change is seeded by experts in the field. By the time this book is published (early 2017), major changes in the Fine Arts segments of the Code of Maryland Regulations (COMAR)—the official document articulating administrative regulations for all state agencies, including the Maryland State Department of Education (MSDE)—will have been adopted. These changes require that

- all local education agencies (LEAs) provide fine arts instruction encompassing dance, media arts, music, theater, and visual arts each year and at all grade levels;
- certification processes be established to ensure annual reporting on the implementation of fine arts instructional programming and methods for measuring progress; and
- the State Superintendent of Schools maintain the MSDE Fine Arts Education Advisory Panel (FAEAP, described below) to advise on issues, best practices, and accountability measures relevant to fine arts education.

These anticipated changes constitute only one result of a set of 10 recommendations put forth in the 2014 report of the P-20 Leadership Council Task Force on Arts Education in Maryland Schools (hereafter, Task Force), which Governor Martin O'Malley formed in 2013. (For the full report, go to aemsedu.org/keyIssues/GovernorsTaskForce/FinalReport.html.) The Task Force's primary goal was to pose recommendations for infrastructural change that would support equity and access, as noted above. Recommendations were clustered in four categories: policy and regulation, curriculum and instruction, professional development, and allocation of resources. Changes in COMAR fall under the first category; their approval in 2017 will mark a landmark success in the story of the evolution of arts education in Maryland. Other Task Force recommendations resulted in success almost immediately. For example, one recommendation, also tied to COMAR, entails state collection of school-by-school arts education program data through the Maryland Longitudinal Data System (MLDS), which has already been launched. And in the second category, the Maryland Fine Arts Standards were expanded in 2015 to include media arts, thereby aligning with the National Core Arts Standards.

The implementation of the recommendations of the Governor's Task Force currently drives arts education reform in Maryland. But what's more important is that this success builds on years of collaboration—questioning, revising, engaging, expanding, and convening, then and now—as we will explore in the following sections.

THEN—QUESTIONING THE QUALITY OF AI

The early 1990s saw significant progress in Maryland toward determining best practices for standards-based instruction within arts-related disciplines. At the same time, interest in AI was growing rapidly in Maryland, as it was across the nation, fueled by theories such as Gardner's research on multiple intelligences (1983). Increasingly, however, concerns grew over the quality with which classroom teachers were incorporating AI, the effectiveness of AI instruction in relation to discrete arts content, the skills acquired by students upon which successful AI depends, and the critical thinking employed in both creating AI lessons and evaluating their outcomes. The newly formed AEMS convened partners from MSDE, school systems, and institutions of higher education (IHEs) to discuss these issues and take action.

Participants in these convenings were propelled by parallel interests: one, a strong belief in the potential power of effective AI instruction to ignite learning; and two, a concern that in practice, much so-called AI instruction, while enthusiastic, was at that time simplistic and did not assure advancement in student learning in the arts or in other subject areas. Why? Most classroom teachers lacked sufficient relevant personal experience and training in the arts. Recognizing this trip wire led to collaborative efforts to enhance the training of teachers before they entered the classroom, as well as professional development (PD) for those already there (Rotkovitz, 2006).

Such convenings also prompted MSDE to establish its Fine Arts Education Advisory Panel (FAEAP) in 1995. The group, which has met twice yearly since its inception, currently includes some 30 representatives of many of the same constituencies comprising the more recent Task Force: PK–12, IHEs, arts organizations (such as the Walters Art Museum, Baltimore Museum of Art, and Wolf Trap), and organizations and agencies that train teaching-artists (such as Young Audiences/Arts for Learning Maryland [YAMD] and the Maryland State Arts Council [MSAC]). These organizations inform the work of MSDE as they work in consortium, day-to-day, to implement standards-based arts education in the five disciplines and also to build capacity among classroom teachers and other educators for using AI as an effective instructional strategy. Fundamental to their activities is this premise: When executed well, AI not only enhances pedagogical methodologies across the curriculum, but it also supports education in discrete art forms and contributes to education reform that changes school

culture. As noted above, one proposed COMAR amendment will assure the maintenance of this advisory panel into the future.

THEN & NOW

Revising Professional Development

To enhance professional development (PD), AEMS and MSDE joined forces in 1994 to initiate the Maryland Artistry in Teaching Institute (MATI), which is still functioning in a revised format today. An intensive summer program for teams of teachers, arts specialists, and administrators from elementary, middle, and high schools, MATI has, from the beginning, been conducted by master teachers, artists, and artist-educators, with follow-up throughout the academic year. Lectures, seminars, and hands-on workshops have allowed cross-disciplinary team members to

- immerse themselves in creative processes that breed understanding of the interactions possible among the arts, as well as between the arts and other content areas;
- learn specific ways the arts can be used to integrate curriculum, content, processes, and skills;
- examine institutional models for integrating the arts into the school curriculum; and
- make concrete plans for integrating the arts into instruction at their home sites.

Then, as now, participants may opt to receive MSDE certification credits or graduate credit from the University of Maryland, College Park (UMCP).

As of 2016, MATI's format was revised in response to an in-depth analysis of AI on the part of MSDE's Coordinator of Fine Arts, who identified areas in MATI's original format that were narrowing, rather than broadening, PD potential. With the support of the FAEAP, MATI was redesigned to

- offer two tracks: one in AI, as before, plus an additional one in arts education in the five disciplines of dance, media arts, music, theater, and visual arts;
- offer arts educators additional studio time, collaborative working sessions, and unit planning, while also offering AI teachers the opportunity to focus on pedagogy, inquiry-based learning practices, arts assessments, and unit planning;
- facilitate teams of administrators and teachers in exploring and developing personal creative habits, and in gaining discipline-

specific arts instruction led by master teachers in studio environments, thus awakening the artist in themselves, while investigating the latest artistic techniques;

- serve over 200 participants—twice the previous cap of 100; and
- take place in four regions across the state, rather than only the more populated Baltimore–Washington, D.C., area, where MATI had heretofore been held (at UMCP).

Engaging Higher Education Leaders at Statewide Roundtables

In 1999, AEMS worked with its IHE partners to organize two statewide meetings of college and university administrators to address the relationship between PK–12 and higher education in providing teacher training and PD. Called the Deans' Roundtables, these gatherings were co-hosted by the state superintendent of schools and attended by nearly all deans of education and of arts and sciences across Maryland. The Roundtables focused on disseminating information about current Fine Arts Standards and brainstorming how IHEs might help meet them. There was an immediate outcome: At the conclusion of the second Roundtable, Towson University announced the creation of the Arts Integration Institute (AII).

In 2009, AEMS convened another Roundtable focusing on 21st-century skills for learning and innovation. Plenary speakers and participants discussed such topics as preparing teachers for 21st-century teaching and learning; AI in the context of education reform; metrics for assessing student achievement; linking learning, arts, and the brain through research in neuroscience; relationships of the arts to STEM initiatives; and PK–20 partnerships. Another Deans' Roundtable is being organized for 2017 to address the results of the 2014 Task Force.

Engaging Higher Education in Work Groups

Another result of the initial roundtables was AEMS's convening of the Higher Education in the Arts Task Force (HEAT Force) in 2002 with representatives from several IHEs, as well as MSDE and AEMS. Discussions led to forming a number of work groups, one of which spent five years developing a multi-institutional Post-Baccalaureate Certificate in Arts Integration (PBC-AI). The design of the PBC-AI benefited from lessons learned through the AII's programming, as well as the implementation, starting in 2004, of a U.S. Department of Education Arts in Education Model Development and Dissemination grant awarded to AEMS and the Montgomery County Public School System for a three-year project (Rotkovitz, 2006). The research and evaluation component of the grant provided opportunities to vet and improve courses being proposed for the PBC-AI—the latter gained approval

from the four participating IHEs' presidents, AEMS, and the Maryland Higher Education Commission and was launched in 2007.

Despite this significant achievement, by 2009 the HEAT Force determined it was not proactive enough in gaining input from all IHEs across the state, and decided to increase engagement with institutions in their work. That same year the HEAT Force created a work group to research the training of arts teachers at the undergraduate level. The chair of the HEAT Force then reached out to key administrators at each higher education institution in Maryland that offers a path toward certification in arts education, asking them to recommend representatives from their institutions to serve on the HEAT Force. The effort was successful, because 13 IHEs are currently represented in HEAT. Membership also expanded to include representatives from community colleges, museum education departments, and teaching-artist organizations.

The lesson learned was that personal touch can make a difference: Colleagues often want to participate in broader discussions in their disciplines but need to know where and how to find them. This lesson proved important not only to the work group but to the Task Force, which charged the HEAT Force with creating a set of IHE-specific recommendations to incorporate into its report for the governor in 2014. With wider representation from IHEs across the state, HEAT was able to respond to this charge in a more fully informed and expedient fashion.

Expanding Professional Development and Teacher Training

The Arts Integration Institute (AII) now has an 18-year history of working with PK–12 educators, MSDE, and AEMS to facilitate student growth and development in and through the arts. AII provides courses and workshops tailored to teachers' and administrators' expressed needs. In addition to exploring the philosophies and techniques of AI, each course includes pedagogy, methodology, hands-on practice, and collaborative strategies for visiting artists, their classroom counterparts, and subject-area teachers.

The PBC-AI generated the development of two master's degree programs in the state, one at Towson University (TU) and one at UMCP. Through UMCP's Teacher Leadership Program, launched in 2012, a student can pursue a Master of Education (M.Ed.) degree with a specialization in Arts Integration. The program offers PK–12 teachers the opportunity to develop their scholarly, artistic, and leadership capabilities. Focusing on the integration of arts education, pedagogy, research, and theory, the program builds on teachers' strengths, addresses their needs, places emphasis on individual growth, and facilitates new approaches to researching, creating, teaching, and assessing AI content and processes. At TU, the Master of Arts in Interdisciplinary Arts Infusion (MAIAI), launched in 2015, offers two distinct pathways.

Convening Partners

As the examples of events discussed above indicate, AEMS has consistently engaged key decisionmakers—including governors, Maryland's general assembly, state and local superintendents, school board members, principals, civic leaders, and the broader community—in convenings at which high-stakes arts education issues are discussed and acted upon. Since 1998, AEMS and MSDE have periodically hosted Superintendents' Summits for Maryland's 24 school system superintendents to discuss topics ranging from the status of the state board's fine arts education policy to best practices for developing high-quality arts programs and new models for comprehensive systemic arts programs, innovative AI schools, and arts magnet schools.

Additionally, AEMS holds multiple Maryland Arts Integration Network (MAIN) events each year in different school districts throughout the state where PK–16 educators come together to explore challenges and benefits associated with AI schools and effective AI strategies. Annually, since 1999, AEMS has convened the Cultural Arts for Education (CAFE) Conference—a statewide networking and PD event for PK–16 educators, featuring plenary sessions and workshops on pressing state and national issues and effective instructional practices.

The annual Arts Education Leadership Awards ceremony, begun in 2012, highlights the key role that principals play in creating effective arts education and AI programs, and provides a forum for principals to share successful arts leadership approaches to staffing, scheduling, and budgeting. Since 2006, AEMS, MSAC, and YAMD have run the Teaching Artist Institute (TAI), providing participants a strong foundation for structuring AI lessons aligned with the Maryland State Curriculum, thereby empowering teaching-artists and the classroom teachers with whom they partner to engage PK–12 students in rigorous learning.

Practical Lessons Learned

Based on the history of consortium-driven activities and practices in Maryland that have led to significant achievements in arts-integrated teaching, we make the following recommendations for policymakers and educators in other states:

- Meet regularly and act jointly with key state-level partners, such as the State Department of Education and the State Arts Council. Doing so can lead to unified values, strategic planning, enhanced policy recommendations, and joint sponsorships.
- Continually—and inclusively—analyze programs, refine thinking, and make relevant change. Bring together stakeholders across PK–20, as well as cultural organizations and teaching artist

representatives, so that best practices in teacher training in the arts and AI may arise, be vetted, and be shared effectively.

- Strategically leverage policy and practice at the state and local level. State-level decision makers typically defer to local systems. In order for a state policy to take hold, there needs to be substantive work within local school systems to demonstrate that the arts deliver high-value outcomes and can be evaluated for effectiveness, and, moreover, that effective programs are within reach. State-to-local collaborations can be powerful in advancing access to resources.

NOW—CHALLENGES & OPPORTUNITIES

As Maryland works toward the goal of assuring equity and access to high-quality arts education for all students in Maryland, AEMS and its partners face three important challenges/opportunities:

First, that the stated goal is still a goal, proves that it is still a need. AI plays a role in addressing this need, but it is only one part of the story—a part that requires sustained observation, analysis, critique, and action. These practices are especially important in trying to understand and position AI in the multiple and interlocking contexts of arts education, including Maryland's Fine Arts Standards, Maryland's Bridge to Excellence (a 2002 legislative act addressing budget inequities among Maryland schools), Common Core/College and Career Readiness Standards, Race to the Top (described in Maryland as the Third Wave of Reform), and now, since December 2015, the Every Student Succeeds Act (ESSA), the reauthorization of the Elementary and Secondary Education Act (ESEA).

Second, whether making the case for arts education or AI, demonstrating efficacy is essential. Accountability and assessment of student learning have cycled through changes in federal and state policy, and arts educators are challenged by the diversion of resources due to high-stakes standardized testing in reading and math, which drives decisionmaking on funding and class schedules. At the same time, the opportunity exists for the arts, as untested subject areas, to demonstrate thoughtful approaches—for example, using actual student artwork as evidence of growth and creating rubrics for qualitative evaluations. In 2012, AEMS fostered a collaboration among five state school systems, piloting e-portfolio technology for teachers and other evaluators to look at student work, using video, audio, photo, and other digital documentation. Through the multiple changes in testing policy, Maryland arts educators have forged ahead with arts assessments embracing multiple measures of student growth while maintaining the primacy of looking at student work. This best practice is essential for preserving the integrity of the arts, and is ideal for supporting interdisciplinary teaching

and learning. The use of technology for assessment is now integrated into many of Maryland's PD initiatives.

The implications of technology-enabled assessments based on student work for program accountability and equity of access to high-quality arts and arts-integrated instruction are being examined closely in the policy context. Interestingly, the pushback on standardized testing as having gone too far—narrowing the curriculum and measuring neither the most important "21st-century skills" nor the skills and content embodied in the Common Core—opens an opportunity for the arts to lead the development of assessments that measure student growth in high-value skills such as creativity, collaboration, and critical thinking. Now is the time: Public opinion and the views of educational leaders are open to new thinking. The opportunity and challenge: To influence policy through amending regulation in ways that honor what is understood as best practice in Maryland.

Third, the importance of scholarly research to the mission and vision of AI cannot be overestimated. Central to such endeavors are Johns Hopkins University's (JHU) Brain Science Institute, School of Education, and other departments focusing on cognitive science research. One example is the use of MRI technology to explore cognition and creativity as reflected in brain activity in subjects performing jazz and rap.

Similarly, Dr. Mariale Hardiman, co-founder of JHU's School of Education's Neuro-Education Initiative, led a highly controlled study in which research and curriculum-writing teams designed arts-integrated 5th-grade science units and matched control units to test the effects of AI on long-term retention of academic content. While results from the preliminary study showed no differences between conditions in initial learning, there was significantly better retention under the arts-integrated condition, and increases in retention were greatest for students at the lowest levels of reading achievement (Hardiman, Rinne, & Yarmolinskaya, 2014). More research is needed to determine the effects of AI on memory and on other important learning outcomes, such as creative thinking and problem solving. Still, this encouraging study suggests that AI has the potential to transform educational practices and policies in unique and substantial ways. In addition to studying the effects of AI on memory for content, the next planned study will also look at its effects on creative problem solving. Researchers will also measure the extent to which students meet arts standards within an AI context.

Further, the new use of the MLDS to collect school-by-school programmatic data promises opportunities to assess equity of access to arts education. Cross-referencing MLDS data with other kinds of data, including student, teacher, program, and institutional evaluations conducted internally and externally by state and national accreditation entities, will help researchers test the hypothesis that learning in and through the arts is transformative for students, teachers, and schools.

In the work to expand and deepen learning in and through the arts, partners in Maryland are buffeted by, and must constantly adjust to, swings and cycles in education policy and funding. At the same time, it remains critical to expand knowledge and understanding at the intersection of content and creativity, and, above all, to hold true to the values of equity, access, and quality. Sustaining collective strength through partnerships forged and fostered by AEMS, plus being nimble through changing times, enable progress to spiral upward and outward.

REFERENCES

Arts Education in Maryland Schools Alliance. (2014). *The governor's P-20 Leadership Council Task Force on Arts Education in Maryland schools.* Final Report September 2014. Retrieved from aems-edu.org

Gardner, H. (1983). *Frames of mind: The theory of multiple intelligences.* New York, NY: Basic Books.

Hardiman, M., Rinne, L., & Yarmolinskaya, J. (2014). The effects of arts integration on long-term retention of academic content. *Mind, Brain, and Education, 8*(3), 144–148.

Rotkovitz, S. J. (2006). Dramaturg as educator <=> Educator as dramaturg: The expanded role of the dramaturg, as modeled by the Arts Integration Institute at Towson University (Unpublished master of fine arts thesis). Towson University, Towson, MD.

Suggested Readings

Arts Education Partnership. (2003). *Creating quality integrated and interdisciplinary arts programs.* (2003). Washington, DC: Author Arts Education Partnership.

Burnaford, G., Aprill, A., & Weiss, C. (2001). *Renaissance in the classroom: Arts integration and meaningful learning.* Mahwah, NJ: Lawrence Erlbaum Associates, 2001.

Catterall, J. (2002). The arts and the transfer of learning. In R. Deasy (Ed.), *Critical links: Learning in the arts and student academic and social development.* Washington, DC: Arts Education Partnership.

Hardiman, M. (2009, May 12). *Commentary: The arts will help school accountability.* New York, NY: The Dana Foundation. Retrieved from www.dana.org/news/features/detail.aspx?id=21768.

Hardiman, M. (2010). The creative-artistic brain: Education in the 21st century. In D. Sousa (Ed.), *Mind, brain, and education: Neuroscience implications for the classroom* (pp. 227–246). New York, NY: Solution Tree Press.

Hardiman, M. (2012). Informing pedagogy through the brain-targeted teaching model. *Journal of Microbiology & Biology Education, 13*(1), 11–16.

Hardiman, M., Magsamen, S., McKhann, G., & Eilber, J. (2009). *Neuroeducation: Learning, arts, and the brain—Findings and challenges for educators and researchers from the 2009 Johns Hopkins University Summit.* New York, NY: Dana Press.

Limb, C. (2010). Your brain on improv [TED Talk]. Available from www.ted.com/talks/charles_limb_your_brain_on_improv

Limb, C. J., & Braun, A. R. (2008). Neural substrates of spontaneous musical performance: An fMRI study of jazz improvisation. *PLoS ONE, 3*(2). doi:10.1371/journal.pone.0001679.

Richerme, L. K., Shuler, S. C., & McCaffrey, M. (2012). *Roles of certified arts educators, certified non-arts educators, and providers of supplemental arts instruction*. A SEADAE Arts Education White Paper. Dover, DE: State Education Agency Directors of Arts Education.

Robinson, K. (2011). *Out of our minds: Learning to be creative* (2nd ed.). Chichester, West Sussex, England: Capstone Publishing Ltd.

Siedel, S., Tishman, S., Winner, E., Hetland, L., & Palmer, P. (2009). *The qualities of quality: Understanding excellence in arts education.* Cambridge, MA: Project Zero, Harvard Graduate School of Education.

Whitesitt, L., Franklin, E., & Lentczner, B. (Consultants) & Walcott, N. (Ed.). (2007). *Montgomery County Arts Integration Model Schools Program 2004–2007: Final Evaluation Report June 2007.* Prepared by RealVisions.

EDUCATION OF LEADERS IN ARTS INTEGRATION

In this Part the authors explore the important role that school leaders play in promoting awareness of, and implementation strategies for, art integration. Through experience and research, the authors have found that a critical element in transforming teaching and learning through arts integration is the involvement of the principal as visionary academic leader of the process. Building an awareness of the potential of the arts in student learning that begins in the preservice training of educational administrators or that can be addressed by district inservice training for administrators are both avenues to consider for reaching school leaders. Ideally, the role of arts-integration leader needs to begin in preservice education and be maintained through ongoing professional development and program support, in addition to being informed through research at the university.

In Chapter 6, Engdahl and Winkelman suggest a unique approach for creating supportive environments for integrating the arts into schools by engaging preservice teachers and school leaders in arts-integrated experiences while pursuing their professional certification at the university. This professional development approach was created through the collaboration of Engdahl, in the Department of Teacher Education and Winkelman, in the Department of Educational Leadership, at California State University–East Bay, as they offered opportunities for their students to work together to build a common understanding and support for arts integration. In their professional development model, preservice teachers provided presentations followed by workshops for the preservice educational leaders and principals. Through these teacher-led workshops, the preservice teachers were able to demonstrate their knowledge and passion for the arts and arts integration as well as develop their advocacy skills in addressing administrators. The school administrators gained deeper understanding of how arts integration supports learning and cognitive development, and therefore they became more supportive of teachers engaging in the arts and arts integration in their schools.

In Chapter 7, McAlinden suggests that principals as school leaders play a central role in providing better, more robust, and sustainable arts education for their students. The Principals Arts Leadership (PAL) program, founded in Washington State in 2006, was designed to support the school principal in building a team made up of teachers, art specialists, and community

partners who would work collaboratively to write and implement an arts plan for their school. Recognizing that principals have multiple, competing priorities and limited resources, PAL supported them in designing a road map for bringing more arts into the school day and building the infrastructure to support and sustain arts learning. Critical to the success of the programs were five elements: engagement of the principal, creation of a school arts team, design of a school arts plan, identification of financial resources, and development of a peer network of principals to support and mentor one another. PAL identified four stages of effective implementation of this approach. These include igniting a catalytic spark in school leadership, engaging a team within the school to advance the arts, implementing the arts plan with effective systems and tools, and, finally, establishing a cycle of renewing and expanding interest and knowledge that will build the strongest base for sustainability.

Hallmark, in Chapter 8, maintains that transforming high-quality arts integration training into common school practice calls for higher education leadership and scholarship that can provide evidence-based road maps toward that practice. Hallmark has found in her research that principals can play a critical role in creating arts-integrated schools when they collaborate with teachers on designing curriculum, staffing, scheduling, and school culture in which the arts are integral to teaching and learning. In this chapter Hallmark writes about how one principal has transformed her school into an arts-central community. Hallmark suggests that higher education has much to learn from field research on models of successful schools in which principals and teachers collaboratively design arts-integrated curriculum and pedagogy that can inform how we prepare teachers and leaders for K–12 schools. For Hallmark, the work must begin in the university, where faculty in the arts and other disciplines, most importantly education, are called upon to model this collaboration in their own work.

Preservice Teachers Advocating for the Arts

Eric Engdahl and Peg Winkelman

> To think effectively in terms of relations of qualities is as severe a demand on thought as to think in terms of symbols, verbal and mathematical. Indeed, since words are easily manipulated in mechanical ways, the production of genuine art probably demands more intelligence than does the so-called thinking that goes on among those who pride themselves in being "intellectuals." (Dewey, 1934, p. 48)

Teachers who want to integrate the arts in their classrooms face many challenges. Even if they are possessed with enthusiasm and energy, have had good arts methods coursework during their teaching training, come to the classroom with arts experience, and/or have received high-quality professional development, teachers can face a lack of administrative support and/or a school culture that does not support the arts. In this chapter we discuss one approach to creating a supportive environment for integrating the arts.

A COLLABORATIVE APPROACH

In 2010 two faculty members at California State University (CSU)–East Bay, Eric, from the Department of Teacher Education, and Peg, from the Department of Educational Leadership, wondered if there were a way to construct administrative support for the arts preemptively. Initially, Peg asked Eric to visit her class and teach administrative candidates about arts integration. As we considered a possible collaboration, Eric came up with the idea of having the preservice classroom teacher candidates present arts integration to the educational leadership candidates.

CSU East Bay is a medium-sized urban public university located in the greater San Francisco Bay Area. We educate between 70% and 80% of the

teachers and administrators for the San Francisco area, an area that is rich in the arts and has strong ongoing professional development for educators in arts education. The student population reflects the region with its extremely diverse campus—culturally, linguistically, economically, and academically.

Having preservice teacher candidates present arts integration to experienced teachers and counselors studying to become administrators offered the teachers an opportunity to demonstrate their knowledge and build their capacity to advocate. In considering this approach, three questions emerged: How can preservice teachers develop their advocacy and collaboration capacities? How will administrative candidates respond to sessions led by preservice teachers? Most importantly, how can administrative structures and school cultures that support the arts be fostered in preservice education programs?

In order to create a framework for developing school cultures that are supportive of the arts in the CSU–East Bay education training programs, the faculty members simply opened a space for professional learning to occur. The teachers and the administrators were all working on their state education credentials in separate departments without any previous contact. The faculty considered that bringing them together in this project would ultimately benefit pre-K–12 students.

PRESERVICE TEACHERS ADVOCATING FOR THE ARTS

For three years teacher candidates at CSU–East Bay made presentations on the importance of arts education to administrative candidates. Their directions were intentionally vague: They were to practice advocacy as teacher-leaders in effectively communicating with various constituencies including administrators, parents, and the community. They were told that effective presentations often include the following: (1) data about the power of the arts, (2) personal or student stories of success through the arts, and (3) participatory arts experiences. They could choose whatever data they thought would be most relevant and compelling. They had the freedom to select activities in whatever art form they were most comfortable presenting.

The annual sessions, although presented quite differently over the years, have always included these three elements and have been effective in their advocacy, according to written responses to questions following the sessions. In the first year, candidates from the elementary teaching track program who were also enrolled in an arts methods course presented a session that was divided into four parts focusing on "Mythbusters." The students selected topics in arts education that were discussed in their arts education coursework and that they felt were important to address with administrators. They emphasized the following strengths of the arts:

- Teaching arts improves academic performance!
- Teaching arts does not take away time from regular, "more relevant" core curriculum!
- You do not need to spend a lot of money to have a successful art lesson!
- Learning arts can improve students' test scores!

Debriefings after the presentations were important to help the teachers understand advocacy. They went into the presentation with the assumption that administrators would be unreceptive to the arts, and that they would prefer not to participate in the activities. To their surprise the audience was friendly, aware of the importance of the arts, and eager to learn more through experiential activities. The teacher candidates began to understand that, in fact, many people support the arts. While "culture wars" occur on the fringes of the arts, generally both liberals and conservatives support the arts (Lakoff, 2002). The teachers also learned that data need to be specific to the audience and not generic, and that more data are not preferable to targeted data.

Presenters were at their most compelling in their personal stories about how the arts affected their educational experience. Their stories demonstrated the power of the arts and were communicated with truth, humor, and emotion. One presenter divulged that she stayed in middle school only so she could keep going to band class. Another shared how participating in the arts kept her in school despite an unwanted pregnancy.

In the second year, specialists in music and visual arts led the presentations, and they were markedly different from the previous year. The arts specialists presented little data. Confident in their content knowledge and in their teaching abilities, they felt more comfortable with hands-on activities. The visual arts teacher began by leading the administrators in a well-structured, standards-based middle school basic skills lesson. He tackled head-on the assumption that "I can't teach art, I am not an artist because I can't <u>DRAW</u>" by teaching some basic drawing skills. He pointed out that drawing is directly related to good observation skills, to putting on paper what you actually see and not what you think you see. The key skill of observation, he said, transfers to many other subject areas: science, math, language arts, and physical education, as well as to interpersonal relations.

At the end of the activity the administrators were still somewhat uncomfortable with drawing. However, a gallery walk and a discussion helped them understand how the arts work in a classroom. Through reflection, a necessary component of every good arts lesson, they practiced their skills in critical thinking, aesthetic valuing, and cooperative learning as they came to understand the complex cognitive and creative processes that had occurred.

The student who created the portrait shown in Figure 6.1 stated before the exercise that he was not an artist. At the conclusion of the exercise he

Figure 6.1. Student Portrait

Reprinted by permission of Gary Peterson.

restated this conviction. The presenters were unable to dissuade him of his ideas, but his peers were able to get him to understand the value and artistry in his work. It was at that point he added the confident signature.

They also discussed how these skills might transfer to other subject areas. It was noted that as much time was spent analyzing as doing, and how necessary that practice was to reinforce learning. By the end of the reflection, the administrators' attitudes toward the arts were much more positive, as evidenced in their written responses highlighted in the next section.

Another presenter was a veteran teacher with over 20 years of middle school experience that included teaching chorus. She was a storyteller and possessed a keen understanding of how to communicate the importance of the arts. Her presentation began with simple remarks about the power of the arts in her own life, about the power of music, and about how she was able to engage her students artistically. Through her stories she addressed issues of access and equity (should all students be allowed in music programs despite a lack of talent?), graduation requirements, and student motivation. Then she moved quickly into a simple singing exercise. Singing, like drawing, is an activity that inspires fear in some people. But she did this masterfully, all the while demonstrating strong teaching skills such as engaging the whole body, asking questions, reteaching when needed, and leading the administrators to a successful outcome.

In the third year the presenter was a visual arts specialist. Unlike the arts specialists of year two, who presented basic middle school lessons, this

teacher chose to present a sophisticated secondary art lesson. Administrators had to create models of a piece of installation art that represented their views on a pressing social issue. This assignment immediately engaged them, and they eagerly went to work. The follow-up reflection was rich and engaging. The group focused on the social issues raised, how groups work together, creative problem solving, and the surprising complexity and depth of high school art assignments.

In all three years it was the reflection and following discussion that were vitally important. Each year the presentations had a different emphasis and tone, but each engaged the administrators in talking about what had happened in the lessons, and from this discussion they began to understand the importance of the arts.

The relatively unstructured nature of the presentation assignment provided an advantage for the preservice teachers in allowing them to explore, discover, and grow as teachers and advocates for the arts. This open-ended structure reflects the nature of the artistic process and demonstrates that there can be many "correct" responses to the same problem.

ADMINISTRATIVE STUDENTS' RESPONSES

After the first year's session the administrative candidates were asked to write anonymous reflections on the following prompts: I learned . . . I like . . . I wonder . . . :

> I learned that art activities can be incorporated into a variety of content areas very cheaply and are great for diversifying teaching strategies. [*Note:* Uncited quotations appearing in this chapter are from interviews with Administrative Candidates, 2008–2010.]

This statement is representative of the overwhelmingly positive responses to the session led by the teacher candidates. Throughout the session the administrative candidates were actively engaged in the activities and seemed persuaded by the research presented. They wrote that they "learned" new arts activities that they "liked" very much and planned to incorporate:

> I liked the PowerPoint backdrop, the examples, the visuals and the passion that the presenters have for the subject.

This response reflects the influence of participating in the activities, combined with the presentation of facts, on participants' perspective on arts integration. Many of the administrative candidates wrote responses such as, "I learned that an amazing number (almost 90%) of students do not have access to visual and performing arts curriculum, and it is an important

equity issue." This session made them think about expanding arts activities beyond their own teaching repertoire. Several stated that they appreciated that data exist on the importance of arts integration, and they found the "Mythbusters" exercise to be a compelling centerpiece of the session.

The "I wonder . . ." responses of the administrators fell largely into two categories. First, they "wondered" how to get more training and more resources to support arts integration in their classrooms. Second, they raised the concern about their abilities as leaders to implement arts integration at their sites. "I wonder how to convince the many people who don't see and/or appreciate the connection and positive influence the arts have on the other curriculum areas." It was unclear from their responses whether their concerns about having to face reluctant teachers, skeptical community members, and perhaps even adversarial school board members will prevent these emerging school leaders from advocating for arts integration. As one administrative candidate wrote:

> Please be aware we teach at high-risk, low-income schools. The arts are great, I'm on your side, however you need to get over making things fair, but to just do your best with what you have.

Though this statement was the only "do the best with what you have" response, it was difficult to predict what leadership actions the administrative candidates might or might not take to their schools based on one session. Unfortunately, this arts-integration session occurred at the end of spring quarter; thus, there was no time for the educational leadership professor to adequately pursue the questions and concerns about how to take leadership actions on behalf of arts integration.

Based on the questions raised and the favorable responses to the visual and performing arts sessions, we moved the session to the beginning of the quarter in the following years. Peg planned to gather more detailed responses from the administrative candidates to inform her instruction throughout the quarter. After the presentations and discussion, Peg asked the administrative candidates to write responses to the following questions: What are the benefits of teaching/integrating the arts? What are the burdens or barriers to teaching/integrating the arts? What are you "taking away" from this session on the arts? What questions do you have? What support do you as a leader need to further implement arts integration at your site? Their responses provide some direction for education programs as well as perspective(s) on the current state of arts education in PK–12 schools.

Benefits

The administrative credential candidates' grasped the benefits of teaching the arts. "(They provide) . . . a powerful way to get a student involved in

school who may not otherwise be interested," they help young people "find their niche," and they enable students to make cross-curricular connections, as "no subject is truly on its own, skills must be integrated." They stated that the arts can be used to reinforce subject-area knowledge and support the kids "who may not connect with 'core' subjects." "We learn more about our students, their talents, and how they learn." They see that through the arts, students "discover 'hidden' talents" and are provided with opportunities for success and recognition. They believe the arts can foster positive socialization and build a supportive community environment as performances and showings are powerful experiences for students to be seen (by themselves and others) in "a different light."

The administrative candidates were also convinced that arts integration increases and enhances learning and is "something to look forward to!" Their responses about the benefits of arts integration included the development of cognitive skills, the support of literacy development, the stimulation of different areas of the brain, and the activation and creation of schema. They discussed the concept of multiple intelligences and elaborated on how the arts provide ways to differentiate and diversify instruction by allowing students to learn information through different modalities.

The administrative candidates noted that they appreciated how teaching in and through the arts promotes creativity and demonstrates its value. As one candidate stated, "[Arts integration] shows that education is also about creativity!" Others referred to arts education as providing a more holistic approach to learning, and some observed that arts integration allows students to develop a more complete formation and construction of knowledge. A few offered examples, such as the exploration of culture and diversity that can be fostered through arts education, as well as the visual representation of ideas through art.

Burdens

While administrative candidates appreciated the benefits of the arts in learning, they acknowledged the burden of implementation in their schools. They described how the arts are not viewed as part of the "core" curriculum and bemoaned the lack of community understanding about the arts connection across subject areas. "Many times it [arts integration] seems frivolous and not overtly necessary to be a productive member of society." They assumed that many school boards and district leaders were not aware of the need for, and the importance of, the arts. They further stated that many teachers and leaders are neither knowledgeable about nor comfortable with the teaching of the arts. In fact, they felt that many educators were completely unaware of the arts standards.

LESSONS LEARNED

> The session . . . engaged me, saddened me and motivated me. It further
> committed me to my beliefs that the arts are a critical component of
> equitable education.

A sense of advocacy was clearly demonstrated by these administrative can-
didates as they realized their potential roles in promoting, maintaining, and
sustaining arts education. They felt compelled to find ways to incorporate
the arts at the school level. As one of them declared, "Even I (or almost
every student) can be successful in the arts."

In writing about their personal experiences following the art activities,
they commented on the high level of teaching skills required in the arts,
such as the importance of providing clear expectations and outcomes while
providing "room for individualism." They stressed the role of the teacher
to encourage, not "crush," students' artistic attempts and how the right
amount of coaching allows the student to "flourish." They discussed how
the group connections were deepened because they had all taken risks to
express themselves. In the sessions with preservice teacher candidates, they
had all experienced the growth and learning that are inherent in the arts.

Questions

The questions that some administrators posed reflected the lack of knowl-
edge regarding the arts in many schools and districts. For instance, "I know
multiple subject candidates have to take a physical education methods class,
do they also take art, music, etc.?" Several were unaware that there are
frameworks and standards in the visual and performing arts. Others did not
know that high school arts classes are required for entrance to the University
of California and the California State University systems.

> Every department has their arguments as to why they are the most
> important. How can we bring back arts into the curriculum as leaders? How
> do we have time, support, influence?

This statement is indicative of the questions raised as administrative
candidates wrestled with issues of advocacy and implementation of arts in-
tegration. The statement reflects the burdens they feel; however, it is inter-
esting to note that this question began with "how can we," not "should
we." The administrators talked about presenting data on the power of arts
integration and posed questions on how decisions are made around policies,
budgets, courses, and programs.

How can we use arts classes to make connections across curriculum at my site?

These candidates eagerly requested more examples of arts integration at a school site and/or the district level. They viewed themselves as instructional leaders who needed to further develop their own teaching repertoire and curricular knowledge. They wanted to know not only how to better integrate the arts in the teaching of "core" curricular areas, but more importantly, how to support the development of students' creative and critical thinking through arts integration.

Support

> I wonder about how I, as an administrator, can push for change, seek out opportunities to build this learning . . . whether through before- and after-school learning, charter school ideas, summer school, etc. How can I use financial resources, or what grants are available to assist with this and coordinate with regular/core curricular demands?

This administrative candidate's statement illustrates the tension between a desire to "push" for change, coupled with a concern about available resources and the need to coordinate with "regular" curricular demands. These administrative candidates realized that, as leaders, they will need to make time for professional development and teacher collaboration. They expressed the need for research to persuade their teachers and communities of the benefits of arts integration. They realized that they will need resources to fund interdisciplinary arts projects and performances, and that they will want to hire creative, effective, versatile teachers who connect with students. They would need district support, and "at a minimum [districts must] give site leaders the freedom to pursue creative ideas."

Equity

> It's a money issue. We have quality programs. Parents need and want these programs, so they pay.

These words from an administrative candidate who leads a pre-K program "rich" with arts integration resonated with other students in the cohort. While the preservice teachers presented lessons that would cost little to implement, the socioeconomic issue is frequently cited by administrative candidates as an issue for community perception and awareness. Privilege plays out in public schools because higher-income communities view arts curriculum as part of a well-rounded education, while many teachers in

low-income and often low-performing schools believe that they have no time for the arts. The school communities in lower socioeconomic areas do not possess the social capital or perhaps the sense of entitlement to demand an arts education for their students.

The issues of equity in arts education remain troubling. The lack of arts integration, particularly in low-income schools, limits students' options for artistic expression, the integration of conceptual understanding across curricular content areas, and the development of creativity. Why is creativity an equity issue? Definitions of creativity include references to originality, inspiration, imagination, resourcefulness, and invention. Denying access to the arts goes beyond the possibility that we will lose a generation of artists, musicians, dancers, etc. Students who are not provided a space for creativity are denied opportunities to develop the very skills that will not only make them successful as individuals, but will also serve to solve the problems of an increasingly complex society.

CONCLUSION

We began this work with three questions: How can preservice teachers develop their advocacy and collaboration capacities? How will administrative candidates respond to sessions led by preservice teachers? Most importantly, how can administrative support and school cultures that support the arts be fostered in preservice education programs? In reflecting on this approach, we recognized the multiple levels of arts integration that needed to be addressed. While the approach began with changes at a program level and an intention of modeling collaboration among leaders and teachers, through implementation there emerged an appreciation of arts integration on a personal level. The preservice teachers demonstrated not only knowledge of arts and arts integration but a passion that evoked a sense of urgency and commitment in the administrative candidates. This was an unintended but welcome outcome. We hope that preservice teachers will take this sense of competency and confidence into their classroom practice and advocate for the arts/arts integration at their sites and that these administrative candidates will be empowering teachers in arts/arts integration.

When school administrators are aware of how arts integration supports learning and cognitive development, and when they are aware that arts integration adds value to the learning environment, they are more likely to support teacher leadership in integrating the arts. Principals, faced with an overwhelming set of tasks (Darling-Hammond, 1997), in fact need to rely on teacher leadership to accomplish this. The relationship between principals and teacher leadership is symbiotic, however, and the teacher leadership needs support from the principals to become effective instructional leaders (Mangin, 2007).

This approach is suggested for institutions of higher education that have programs in teacher education and administration. However, it can easily be adapted to schools, districts, county offices, and alternate certification programs. As long as space is provided so that practitioners can demonstrate their expertise/knowledge and practice their advocacy to leaders, the approach has the potential to open dialog, create collaborations, change minds, and improve learning for all students. In terms of policy, especially with the implementation of new curricula where collaboration is defined as an essential proficiency, teachers, administrators, and students need to be taught the skills of integrating the arts throughout the educational pipeline.

The challenge in this approach is how to embed the process in growing administrator and teacher education programs. While it worked for us as faculty members, we have not yet been able to get other faculty who teach other sections of these courses to use the approach, partially because of the logistics of scheduling and multiple sections. While time is a challenge among competing priorities, fortunately funding is not. This approach of collaboration among departments, faculty, and their students requires no extra funding.

This poem, created by a preservice teacher, best captures the sense of advocacy that must continue if arts integration is be successful in pre-K–12 schools.

Not Enough Money

By Malinda Hopkins, Teacher

Do schools have enough money to teach Arts?
You don't need money to integrate arts!
What does it cost to act out a story?
What does it cost to create your own dance?
What does it cost to sketch a picture?
What does it cost to make crayon rubbings?
What does it cost to sing a song?
What does it cost if you don't do any of these things?

REFERENCES

Darling-Hammond, L. (1997). *The right to learn: A blueprint for creating schools that work*. San Francisco, CA: Jossey-Bass.

Dewey, J. (1934). *Art as experience*. New York, NY: G.P. Putnam.

Lakoff, G. (2002). *Moral politics: How liberals and conservatives think* (2nd ed.). Chicago, IL: The University of Chicago Press.

Mangin, M. (2007). Facilitating elementary principals' support for instructional teacher leadership. *Educational Administration Quarterly, 43*, 319–358.

Principals Arts Leadership Program

Una McAlinden

The Elementary and Secondary Education Act, reauthorized in 2015 as the Every Student Succeeds Act, lists the arts in the definition of a "well-rounded education," and in many states the local education law also specifically includes the arts in the definition of basic education (Arts Education Partnership, 2014). In Washington State, this has been the case since 1993, followed by the development of arts learning standards in 1994, the adoption of a graduation requirement in 2004, and the implementation of classroom-based assessments in the arts in 2008. However, the reality of *provision* of arts-learning belied these clear expectations. Opportunities for learning in and through the arts varied from district to district, school to school, and even classroom to classroom, with **no equity of access** to this core subject area. For example, a Washington State study published in 2009 found that 33% of elementary students were getting an average of less than one hour of arts instruction per week, and 9% of schools offered no formal arts instruction at all (Baker, Gratama, Freed, & Watts, 2009).

In 2004, having just been appointed executive director of a small not-for-profit with limited resources but a statewide arts education mission, the board and I struggled to identify our role in the ecosystem to advance arts education. We decided that our best approach was to focus on working with school principals, and we called our project the Principals Arts Leadership program (PAL).

THE NEED FOR PAL: PRINCIPALS AS A CRITICAL LINK

In 2006 the Washington State Arts Commission published its first Arts Education Research Initiative (AERI), and in setting out the action agenda for collective focus, it identified professional development for principals and school leaders in arts education implementation as an area that needed attention (Washington State Arts Commission, 2006). We knew we were on the right track. Their second report in 2009 showed that 63% of principals

were dissatisfied with the quantity of arts education in their schools (Baker, et al., 2009). There was a lot of ground for us to cover.

The approach of the PAL program grew from the vision of a small group of arts and education leaders who realized that while most school administrators understand that the arts are an essential element of a well-rounded education, they struggle with competing and ever-increasing requirements and expectations and are at a loss about how to create infrastructure for the arts. This is compounded by the fact that since the 1980s, there's been a steady decline in the provision of arts education within the school day (Rabkin & Hedberg, 2011), so many principals have not personally experienced, or seen the impact of, a robust arts-learning environment. Yet, it's been clear through the PAL work over the past decade that principals seek effective ways to provide the arts.

In creating the PAL program to support school leaders with better provision of the arts, our approach was to offer a framework within which a school could develop a shared vision and co-owned action plan. PAL sought to support all schools, regardless of where they were on the arts education continuum, and then to catalyze positive forward momentum in a collaborative way. In all of this, we placed a central focus on the principal's role. These key leaders, struggling with competing priorities and a shortage of resources, needed road maps to help incorporate more arts into the school day and to tackle the building of infrastructure to support and sustain arts learning.

Evolution of the PAL Program

The original concept of PAL was to support the school principal in building a team that would collectively write an arts plan. We encouraged the team to include both primary and secondary teachers, at least one arts specialist and community partner, and, of course, the principal was a nonnegotiable member. We met with several arts-friendly principals to float the approach, received specific and critical feedback to refine it, and launched our first cadre.

Principals were interviewed, teams were formed, baseline data were collected, and the whole group was brought together for a preplanning workshop to expand their thinking and learn what other schools were doing. As a nonprofit executive director, I did not have a formal background in education; however, the concepts of peer networks and communities of practice were instinctive ways to share ideas and propagate arts leadership effectively. After that, teams went back to their school sites and were supposed to write a plan with some topic areas to guide them.

In reality, this was much more difficult than it seemed, and the plans were as varied as the homework might be in any classroom! We tried providing a template, but this didn't assist particularly. As the primary contact

with the schools, I was often asked for suggestions, and while I could certainly share approaches that I'd seen elsewhere, this never sat well with me. The truth was that this Johnny Appleseed approach made it more my plan than theirs. Over the first few years, this was something that I struggled to address, and it was compounded by the challenge of getting the teams to work on plans back at school. Often, the principal ended up writing the plan largely solo, undermining our team-based approach.

The program time frame also evolved rapidly. The initial idea was a one-year program to simply help schools create an arts plan. But at the pre-planning workshop, team members asked about ongoing support, expressing concern that the plan could not be implemented without this. Listening to our constituents was key to being effective, and in follow-up calls, several of the principals told me what they needed: occasional visits and check-ins, some seed money, and ongoing opportunities to meet and exchange ideas. With this guidance, we rapidly moved to a three-year approach: the first year focusing on data and planning, then two years of supported implementation that we hoped would lead to sustainability.

The Principal: Instructional Leader for the Arts

> With the myriad demands on administrative time, PAL functions as the lifeline that keeps the initiative to integrate the arts afloat. Without leadership support for implementing and sustaining the teaching of the arts, nothing lasting can be achieved. —*Susan Arbury, Southwood Elementary, Enumclaw School District*

The PAL program highlights the principal's role right in its name: *Principals Arts Leadership*. The school principal is the most important point of leverage in creating a sustainable impact on a school's arts education status.

In 1999, the report *Gaining the Arts Advantage: Lessons from School Districts That Value Arts Education* identified "the principal as the primary instructional leader at the individual school level" and confirmed that "principals create the expectations and climate in the school building and their support for arts education is essential" (Arts Education Partnership, 1999). This seminal research was the original catalyst for the development of the PAL program. From this understanding, we launched PAL to meet the needs of principals who wanted to provide better, more robust, and sustainable arts education to their students.

According to the Washington State Arts Commission's 2006 *AERI* report, "principals are uniquely positioned to influence the culture of the school, to ensure that the arts are built into school staffing and budgets and to articulate the value of the arts to parents, school district, and school boards" (Washington State Arts Commission, 2006). Looking at their role more broadly, and beyond the context of the arts, principals create the

conditions for staff to make changes by providing a balance of external pressure and internal support. The principal is the first line of defense to buffer staff from interruptions and factors that compete for staff time and attention (Hallinger & Heck, 1998; Hargreaves & Fink, 2004).

We know that principals face many challenges all while juggling evolving standards and expectations and ever more onerous processes of evaluation both their staff and themselves. Extensive research demonstrates that high-quality, sequential arts education can help meet these goals, but the data alone are not enough (President's Committee on the Arts and the Humanities, 2011). Principals have indicated that they listen best when their peers show them examples that have improved school achievement in educational climates similar to their own. This is why the peer-to-peer aspect of the PAL program is so important.

Gaining the Arts Advantage singled out a cadre of principals as one of the critical success factors for achieving districtwide arts education, and we put this at the heart of our approach. As PAL continued to evolve, it became clear that those who have experienced success in arts education, especially in similar circumstances, do more to influence other principals than anything else. This peer approach became more and more foundational to PAL.

PAL Stages of Effective Implementation

After approximately three years of implementation of the PAL program, we saw significant impact in many PAL schools' arts capacity, so we enlisted independent evaluators to examine PAL and help us further refine our approach. The evaluators' 2009 report, *Anchoring Arts Education,* set out PAL's four stages of effective implementation (Bach & de Soto, 2009):

> *Stage 1: Catalytic Spark.* PAL begins by connecting with or igniting
> a catalytic spark in the school's leadership. This is a critical
> component present in all successful PAL schools. Often principals
> and key staff have a personal passion for or experience in the
> arts. Many principals have stories about how the arts kept them
> in school. Catalytic spark is also a belief in the arts as an effective
> learning tool. PAL takes root most effectively in schools where this
> is present. This was exemplified by one of our principals, who,
> through PAL, had the courage to fulfill a lifelong desire to learn
> violin and joined the school's 5th-graders in orchestra class.
> *Stage 2: Dynamic Shared Leadership.* Although the role of the principal
> is pivotal, the second stage of PAL empowers engagement and
> participation by a team within the school community whose
> members take individual and collective responsibility for advancing
> the arts. Our research confirmed that the leadership of the principal
> in "giving permission" for the arts was essential, and that arts

teams that met regularly with authority and resource support could then drive implementation and spread the "spark" to others, advancing incremental growth with the strongest impact and potential for sustainability.

Stage 3: Effective Systems and Tools. With a principal-led team creating a vision and action plan, what a school then puts in place has a major impact on capacity to provide the arts equitably. Professional learning opportunities that improved technical teaching skills and lesson plan development were cited by all schools as fundamental to their success, because they build teacher confidence and expand the catalytic spark.

Stage 4: Sustainability. Like anything worthwhile, PAL needs continued effort and engagement to sustain it. An annual review of the arts plan and the setting of new goals helps maintain focus and recognizes progress. Over time, schoolwide cultural change takes place to continue this commitment beyond the principal's tenure. Schools that established a cycle of renewing and expanding interest and knowledge built the strongest base for sustainability.

One major finding from the research was feedback from principals recognizing that although the plan was considered their most valuable component (see the key features of PAL, below), it was challenging to create. This didn't come as a surprise.

The Principal as a Peer Coach

Our coach encouraged us to create goals that were meaningful for our school. She helped direct our focus and create a realistic time line. She also shared past experiences which helped us to better understand the process.
—*Anonymous survey response from PAL participant*

Following our evaluation process and report, a 2009 visit to the Arts for All program in Los Angeles County helped us learn how to make the planning process easier while also supporting principals in creating plans in which they and their teams were strongly invested. The facilitation method around which the Arts for All district planning model had been crafted provided a process within which the school team could articulate their knowledge and wisdom into an arts vision and action plan (California Alliance for Arts Education, 2009). We completely redesigned our PAL program to center around two facilitated sessions in which each school team would create a unique road map for their specific school's circumstances and opportunities. This approach was transformational, as the evaluation feedback of one participant showed: "Just having a coach to guide us through is huge. The plan is tailored to our school. We have no need to question or doubt it because we wrote it."

Serendipity intervened further when a staff departure challenged our capacity. I turned to our PAL alumni and decided to train them in the facilitation process and deploy them as coaches. Their insights and experience as principals helped to establish trust and built on the peer network aspect of PAL, and their independent facilitation freed up the host principal to be a full participant who contributes ideas as a member of the team.

PAL IMPACTS

During the first 10 years, the PAL approach was implemented in 64 schools to create School Arts Plans that would guide the improvement of arts instruction for nearly 30,000 students. No two PAL plans look alike. Each plan reflects the individual school's characteristics, community, and opportunities for growth; each plan identifies a unique pathway for that school to offer high-quality arts instruction to their students using existing and new resources. The individual nature of each plan helps to ensure that each school's goals and action steps are relevant and realistic within their environment. PAL is not about short-term, patchwork fixes. The PAL program seeks to develop real and lasting change by focusing on and growing school capacity to teach the arts.

The PAL Approach: Five Structural Pillars

As schools wend their way through the four stages of implementation, the PAL program intentionally develops five structural pillars. *Gaining the Arts Advantage* (Arts Education Partnership, 1999) and *The School Principal as Leader* (Wallace Foundation, 2013) are representative of substantive research in the context of both arts learning and general education leadership that underscores the importance of these foundational pillars.

In 2010, *Principals Arts Leadership: Program Key Features* outlined these five pillars of successful and sustainable implementation of arts education in schools (ArtsEd Washington, 2010). These descriptions are adapted from that report.

1. The Principal. The foremost and nonnegotiable tenet of the PAL approach is its requirement of direct principal involvement. As we knew at the outset, principals create the expectations and climate within the school building, and their support for arts education is essential (Arts Education Partnership, 1999). The principal, as the instructional leader in the arts at the school level, is thus the program's key constituent and the central figure in advancement of arts learning.

2. The School Arts Team. For the most effective outcomes, the School Arts Team should include both school and community leaders. This means

teachers, who bring a classroom-based perspective to the table, as well as family members, local artists, and business and civic leaders, all working together with the principal. Teacher participation in the planning process is essential. And research has found community involvement to be a key factor in the success of school-based arts programs (Arts Education Partnership, 1999).

3. The School Arts Plan. Principals identified the School Arts Plan as the PAL component that is most valuable to them as instructional leaders. A School Arts Plan lays out the school's expectations for both the leadership and the staff, and it formally establishes an agenda for positioning the arts as a core content area in the school's curriculum (Bach & de Soto, 2009). An Arts Plan is a living document: To be sustainable, it must be revisited and revised yearly.

4. Financial Resources. In the early years of the direct service model, seed money was provided to each participating school, helping them launch their plans. This money was targeted to early investments that would lead to sustainability; for example, teacher training or consultations with teaching artists, as opposed to consumable goods such as classroom art supplies. Principals reported that the seed money helped clarify their schools' arts priorities. In many cases, it also helped leverage additional funding to support schools' growing arts programs. As the program later shifted to a district-level approach, this pillar also shifted to highlight the role of central office staff in helping PAL principals identify available resources, include the arts in their school budgets, and work with district leaders to access additional funding for arts education.

5. Peer Networks. In peer networks, leaders share experiences, stimulate one another's ideas, and renew their energy and commitment. As our evaluation report showed, PAL principals placed a high value on the program's ability to create and support networking among peers. The principals' desire to gather as a peer group, learn about best practices, and connect with other principals who are on the same path remained a key feature as the program evolved. The system of PAL coaches, in which trained facilitators, usually principals themselves, provide PAL principals and school arts teams with the ongoing support needed to develop sustainability in school-based arts programming, also broadens and deepens peer relationships.

The Ongoing Evolution of PAL

The PAL program was initially developed as a direct service approach provided to interested principals and schools. Certainly, we intentionally recruited principals from the same districts, endeavoring to build district-

level clusters of committed principals. In two small districts of four or five schools, we were able to have all elementary school principals participate in PAL over the course of a few years. We also sought to enlist district leaders in school teams, inviting them to team workshops and keeping them apprised of their schools' progress. But this was challenging to do with any consistency.

As an external program without a district central-office liaison, we often found ourselves—or our workshops and forums—conflicting with the district calendar. Clearly, when the district called a meeting, it didn't matter whether we'd flown in a speaker or arranged a special training; the principals had to attend to district priorities.

Data collected in a variety of districts over the 10 years of direct service implementation confirmed the need for district-level ownership, engagement, and leadership that would support and sustain the work of individual schools and principals and sustain plans and teams when the principals moved on. This change of school leadership happened frequently, and while we focused resources on supporting the new leader, PAL and the arts plan didn't always continue under a new principal. On the other hand, we knew that when PAL principals moved to new schools and districts, they brought what they'd learned with them. For example, when one principal was assigned as a planning principal for a new building, she applied PAL knowledge by working with the architect to include a dance studio in the new building. She also focused teacher recruitment around an arts-integration approach. Such successes notwithstanding, we sought a more systematic and sustainable approach.

The inequities in arts learning that had initially inspired the PAL approach now underscored the need for a shift to a districtwide approach. Without this, PAL would not be able to catalyze leadership in the arts and develop the necessary capacity and infrastructure in a systemwide and sustainable way.

With approximately 2,400 schools in Washington State, PAL could not directly serve all the schools that needed or could benefit from the program. This understanding was part of my drive toward a district-implemented model. With thoughtful support and partnership across the educational system, the PAL approach could potentially be expanded to benefit many thousands of students in Washington State and beyond, thereby increasing the provision of sequential arts learning and its impact on student learning.

PAL as a Regional Model

Meanwhile, in the state's largest district, Seattle Public Schools (SPS), a major district-level arts plan, guided by a citywide partnership, The Creative Advantage, was under development. Having taken note of the impact PAL

had on several Seattle schools, and having identified principal leadership development as a core goal for school arts improvement, SPS turned to PAL to assist. Schools within student assignment pathways or service areas would first develop a collective, regional vision and then, using an adapted PAL model, each building within the pathway would also develop their piece of the big picture, through a PAL arts vision and action plan.

To this end, PAL was adapted and retooled into a scalable, replicable arts planning model to be implemented not by an external organization but by staff of the school district central office, as an internal program of the district. By shifting program implementation directly to districts, it was anticipated that district-level support for the arts would increase, and the PAL approach could be implemented in more schools with greater impact for more students.

Working on a district level offers numerous advantages over working on a building-only level: consistency of curriculum framework, evaluation systems, planning templates, and School Improvement Plan expectations, for example. It presented the opportunity to shift thinking from individual buildings to the bigger picture of sequential and equitable arts provision.

Focusing effectively on the supports and infrastructure the district could provide offered a supportive launching pad for the subsequent building-level plans. When PAL was implemented at the building level without full district engagement, there were many times when teams were hampered and plans were limited by things not within their control. In this district-level approach, the pre-existence of the pathways vision and plan, and the overarching umbrella of the Creative Advantage K–12 arts plan, could guide the individual schools' visions and help expand their thinking (Seattle Public Schools, 2013).

The anticipated impact of shifting the PAL approach to a district level has been borne out by the Seattle implementation, now across two pathways, affecting 26 schools, with significant gains in arts learning for all students. In each pathway, unique plans have been developed, both at the regional and building levels, creating intentional focus, with diverse and varied implementation strategies that have always been pivotal to PAL (Baker, Gratama, Peterson, Ford, Jones, Chighizola, & Mehlberg, 2015).

The shift to the district-implemented approach in PAL's evolution makes the arts planning work more visible to the central office leadership. It can thus be better integrated and coordinated with the delivery of other district professional development and academic resources.

District Arts Planning: An Essential Prerequisite

Having seen the impact on schools and principals over 12 years of the evolution and continuous improvement of PAL, I feel continued hope for its efficacy and potential. The PAL research and data from our years of direct provision

confirmed this, and the reports from the Creative Advantage in Seattle Public Schools show the exponential impact of an internally implemented district approach that has the PAL facilitation protocols at the center of pathway- and building-based arts planning.

This whole experience confirms for me that starting with a district arts plan is essential for a sequential and sustainable approach that can lead to long-term, equitable provision of the arts. A recent countywide research study of all 19 school districts in King County, Washington, which collectively serve approximately 280,000 students—a quarter of the state's public school population—verifies this. *Cornerstones of Creative Capacity* (ArtsEd Washington, 2010) examines the current arts infrastructure in school districts ranging in size from 53,000 to under 40 students, through in-person interviews with district leaders. Six key features for equity in arts education emerged from the findings, including the need for intentional, district-level arts planning to set expectations and design strategies. No sustainable, system-wide change happens in any context or content area within a district without a plan. The arts are no exception to this. Within such a framework that addresses capacity and sustainability, the PAL approach could continue to help principals build purposefully toward a reality where the arts are an integral part of the well-rounded education, defined by federal law, that all students deserve.

REFERENCES

Arts Education Partnership. (1999). Gaining the arts advantage: Lessons from school districts that value arts education. Retrieved from www.aep-arts.org/wp-content/uploads/2013/01/Gaining-the-Arts-Advantage-Part-1-FINAL.pdf

Arts Education Partnership. (2014). ArtScan state profiles. Retrieved from www.aep-arts.org/research-policy/artscan/

ArtsEd Washington. (2010). Cornerstones of creative capacity: Administrative perspectives on arts education. Retrieved from artsedwashington.org/C3

ArtsEd Washington. (2010, updated 2012). Principals arts leadership: Program key features. Retrieved from artsedwashington.org/for-educators/principals-arts-leadership/pal-research

Bach, C., & de Soto, A. (2009). *Anchoring arts education: Principals' arts leadership: An evaluation of ArtsEd Washington's elementary school program*. Seattle, WA: ArtsEd Washington and AdvisArts Consulting. Retrieved from www.giarts.org/article/anchoring-arts-education-principals'-arts-leadership

Baker, D. B., Gratama, C., Freed, M. R., & Watts, S. (2009). *Arts education research initiative: The state of K–12 arts education in Washington State, 2008–2009 report*. Bothell, WA: The BERC Group. Retrieved from www.arts.wa.gov/media/dynamic/docs/Report-Arts-Education-Research-Initiative.pdf

Baker, D. B., Gratama, C. A., Peterson, K. M., Ford, K., Jones, M., Chighizola, B., & Mehlberg, S. (2015). *The creative advantage: Central Arts Pathway: Evaluation report year 2*. Bothell, WA: The BERC Group. Retrieved from www.

creativeadvantageseattle.org/wp-content/uploads/2014/06/Creative-Advantage
-Report-Year-2.pdf

California Alliance for Arts Education. (2009). The insider's guide to arts education
planning. Retrieved from www.artsed411.org/insidersguide

Hallinger, P., & Heck, R. H. (1998). Exploring the principal's contribution to school
effectiveness, 1980–1995. *School Effectiveness and School Improvement, 9*(2),
157–191.

Hargreaves, A., & Fink, D. (2004). The seven principles of sustainable leadership.
Educational Leadership 61(7), 8–13.

President's Committee on the Arts and the Humanities. (2011). *Reinvesting in arts
education: Winning America's future through creative schools.* Retrieved from
pcah.gov/sites/default/files/PCAH_Reinvesting_4web_0.pdf

Rabkin, N., & Hedberg, E. C. (2011). *Arts education in America: What the de-
clines mean for arts participation* (Research Report No. 52). Washington,
DC: National Endowment for the Arts. Retrieved from arts.gov/sites/default/
files/2008-SPPA-ArtsLearning.pdf

Seattle Public Schools. (2013). Seattle K–12 Arts Plan. Retrieved from seattleschools.
org/UserFiles/Servers/Server_543/File/Migration/Departments/Arts/SPS%20
Arts%20Plan%20Final.pdf

The Wallace Foundation. (2013). The school principal as leader: Guiding schools
to better teaching and learning. Retrieved from www.wallacefoundation.org/
knowledge-center/school-leadership/effective-principal-leadership/Pages/The-
School-Principal-as-Leader-Guiding-Schools-to-Better-Teaching-and-Learning.
aspx

Washington State Arts Commission. (2006). Arts for every student: Arts Education
Resources Initiative. Retrieved from www.arts.wa.gov/media/dynamic/docs/
Arts-Education-Resources-Initative-Booklet.pdf

Learning from an Arts-Savvy Charter School Principal

Elizabeth F. Hallmark

Although academia has traditionally cultivated separate disciplinary boundaries, interdisciplinary collaboration is increasingly relevant as the world becomes interconnected through globalization (Bresler, 2002). Arts-integrated teaching practices give teachers and their students the opportunity to find different ways of meaning-making across disciplinary boundaries. Practically speaking, higher education can offer experiences that increase educators' interest and capacity for collaboration through preservice training and arts-integrated professional development for inservice teachers, although this self-evident, collaborative practice across disciplinary boundaries is not widespread. At K–12 levels the organizational support for teacher collaboration across arts and other academic curricula tends to be the exception rather than the rule. Collaboration among subject-area specialists depends not simply on teachers' willingness to push beyond their comfort zones, but on leadership that establishes collaborative structures in which educators are able to renegotiate the traditional disciplinary boundaries between arts and other academic disciplines.

Transforming high-quality arts-integration training into common school practice clearly calls for additional supports such as leadership and scholarship that can provide evidence-based approaches for that practice. Higher education's role, therefore, is fundamental to providing arts-integrated training as well as research-based documentation of good models for the field. In this chapter I offer findings from an inquiry into the leadership style and curricular structures that one K–6 principal used to directly support arts and other academic collaboration in her school. The process of documenting her decisions not only illuminates key support elements of the school, but also allows me to suggest how this kind of research might be used to inform higher education's own teaching practices.

THE SCHOOL SITE

My inquiry was conducted at a 200-student K–6 charter school in the north-eastern United States that I call the River Charter School. I used qualitative methodologies and grounded theory analysis (Charmaz, 2006; Corbin & Strauss, 2008) to understand the school's design elements as well as the ped-agogical perspectives of K–6 teams of teachers and staff. I gathered informa-tion based on participant observation, fieldnotes, interviews, and document analysis over a period of four months (Hallmark, 2011).

The inquiry focused on 30 in-house teachers who practiced arts integra-tion in a form I call "arts as collaborative inquiry" (Hallmark, 2011). At this school, arts integration was a practice in which grade-level and arts-teacher teams regularly collaborated to create learning targets that would activate students' understanding of overlapping academic and arts concepts. I use the term "in-house" to distinguish this school's arts integration work from other schools whose integration work often includes teaching-artists from outside the school. The phrase "arts as collaborative inquiry" refers to arts-integrated work practiced by collaborating teachers who design lessons through inquiry methods. In this chapter, I focus on my findings about a K–6 principal who supported teacher collaboration through her vision and leadership choices in the school.

Unlike the curriculum in many of the franchise charter schools being launched today, the River Charter School's arts-oriented curriculum was developed by its own staff and grew from teachers' work at a high-poverty public school in a city neighborhood. Teachers at the original public school designed a curriculum called the River Project that was based on local his-tory. The teachers incorporated students' own questions about their neigh-borhood into the curriculum as a way to engage them with a clearer sense of local place and belonging (Wing, 1992). The River Project thrived for about a decade until curriculum funding ended, and many of the participating teachers left to teach elsewhere.

When charter schools became a new option in the late 1990s, the cur-riculum specialist from the original public school resurrected the old River Project idea. Enlisting help from teachers involved at the former school, she wrote a charter and launched a new school based on that curriculum. She became leader of the new River Charter School and persuaded some teachers from the original school to become charter staff. Among the orig-inal group that helped create the school were some charismatic arts teach-ers. Through the leader's support of these teachers' vision, the arts became central tools for implementing both social and academic curricula. The school was therefore established out of the leader's personal efforts as well as the rehired teachers whose institutional memory helped ground the cur-ricular focus of the new school. As will be further detailed, their "arts as

collaborative inquiry" approach relied on the principal's decisions around curriculum and staff scheduling.

MENDING CURRICULAR DIVISION

Integrated alignment between arts and other academic disciplines is generally the exception rather than the rule. Typically, K–12 arts education is practiced in such a way that teachers of the arts and other academic disciplines have separate and nonintersecting curricula provided by the district and aligned with state standards. One could argue that this is because few schools provide arts teachers and academic teachers with common planning time for constructive curricular integration (Carey, Kleiner, Porch, & Farris Westat, 2002, p. 90). Although, ideally, arts integration is implemented with the participation of in-house arts teachers, their time and ability to do this regularly is inhibited by their separate discipline-specific scope and sequence goals. Where arts-integrated work exists, it is often created through the help of external teaching-artists who work beyond or in complement to the standard curriculum. While teaching-artists fill many important needs in schools, deeper solutions to this curricular divide are most meaningful if they can develop from within a school.

This curricular separation of the arts and other academic disciplines was precisely what the River Charter School set out to restructure. They did not "fix" the divide by relying on outside teaching artists to bridge the gap, nor did they allow the arts to be separated from the rest of the curriculum by having arts instruction offered in isolation from grade-level teachers' work. Instead, they established a whole-school practice where, in addition to separate scope and sequence disciplinary work, teams of teachers developed regularly integrated projects that drew from both academic content and arts learning. To anchor this practice they instituted a social curriculum where students, parents, and teachers routinely participated in whole-school arts rituals (such as community circles and family nights) that bolstered an arts-friendly school climate. In this way, academic and social arts participation became customary among students and non-arts teachers alike.

Not only did the school's cross-disciplinary teacher collaboration and social curriculum stand out, the arts programming itself was also unusual. The River Charter School avoided traditional art clubs, bands, or choirs because they felt that partial student membership in arts programming subtly undermined whole-school participation in the arts. Instead of a subset of students set apart as performers, as is usual in most schools, entire grades of students performed together in all music, dance, and theater productions, thus encouraging every student to self-identify as a performer and artist. While whole-grade productions were a great responsibility placed on the

shoulders of all teachers, the productions were made tenable because of the school's small size and the principal's operational supports for the arts. The River Charter School's nontraditional programming helped to strengthen the student-as-artist vision, even though an occasional parent might not immediately understand that. Below is an excerpt from the music teacher's writings (quotes labeled with initials and year are taken from Hallmark, 2011):

> One of my greatest compliments as a teacher came to me in the form of an insult. "I wish I'd known that there was no music program at this school," wrote someone on parent satisfaction survey. Horrified, I exclaimed to my school leader, "But what about our professionally recorded CDs, plays we've put on, our weekly music-based community circles and our site seminars that bring educators from all over the country to see how we integrate the arts?" My school leader laughed and helped me realize that because the arts are so finely embedded into the life of our school, people have trouble identifying the components of a traditional music program (C.H., 2009).

As this quote vividly shows, the school leader supported the music teacher's integrated programming by affirming how it reflected the school's larger vision. At the core of the school's arts-integration design was the school leader's expectation that, just like other subjects, the arts were to be consistently implemented and meaningfully aligned across all programming. In this school, therefore, the arts and academic curricula intersected in as many ways as possible, and the traditional ways of teaching the arts separate from the larger curriculum were discontinued.

ORGANIZING TEAMS AND TIME

The principal's belief in the importance of the arts' role in student learning guided all of the principal's curriculum leadership decisions. Although it was the teams of teachers who designed the arts-integrated work, their ability to do this work was made possible by an arts-savvy principal who supported the teachers by encouraging team teaching, reliable planning time, and development of core intersecting goals.

Team Teaching

The school used grade-level teacher teams to support the process of whole-school arts integration. Each grade-level classroom was made up of a large group of students (30–32) that were led by a team of teachers (2 co-teachers and an aide). This teacher-team arrangement compelled grade-level teachers

to work together and was even jokingly referred to as a "marriage," with its attendant need for negotiation and mutual support. Not only did this structure help establish a schoolwide culture of teacher collaboration, it gave grade-level teachers much greater flexibility in working with arts teachers.

For example, every arts class (music, visual, dance/physical education) was taught twice so that half of the grade-level class (15–16 students) could participate in the sequential instruction. The two teachers split their time so that one of the grade-level teachers would stay behind to work with half the class while the other grade-level teacher would accompany students to arts classes. Then the teachers and students would switch activities. By attending arts classes with their students, grade-level teachers would learn the concepts and skills being taught in arts class, which resulted in a shared language and curricular focus between academics and arts disciplines.

Here, a 4th-grade teacher explains to the arts teachers his and his partner's decision to take turns in attending music and visual art on a biweekly basis:

> We'll trade off [to] take turns every week. One of us will be there. I know it's inconsistent but we feel like we need to be in everything to see what's really going on . . . in the first [12 weeks] I was the music person and I would go to music and [my partner] would go to art. And then the second [12 weeks] we switched, but then we both felt like we weren't getting the other arts, so we said how about if we take turns in going . . . so that we both know what we're doing [in music and visual art]. (C.D., 2011)

Grade-level teachers used their arts class visits as opportunities to be adult learners in the arts and came to depend on the arrangement to reinforce their own teaching. What could also be viewed as a peer observation and embedded professional development arrangement further strengthened teacher relationships across the arts and classroom divide.

Reliable Planning Time

The school principal served as the instructional leader of the school, creating flexibility for teachers to design their own curricula and integrate the arts. As one of the school planners, she had helped design a curriculum that aligned all subject areas toward three 12-week investigations of historical time periods and local content per year. The school used a curricular map that allowed for ongoing teacher input and innovation. Unit planning was transparent between teachers because the principal organized meeting times where they helped one another search for possible lesson plan ideas. To address collaborative planning needs, she scheduled time for every set of grade-level teachers to meet with the arts team several times per 12-week instructional

block. Their collaborative meetings were held in advance of the start and at the midpoint of each 12-week instructional block. In this way the arts were incorporated from the ground up; they were never separated from the rest of the curriculum or seen as "add-ons" to teaching and learning.

The collaborative meetings held in advance of each 12-week instructional block consisted of the three arts teachers (music, visual, dance) and three classroom teachers (two co-teachers and an aide) per grade. In these meetings teachers would brainstorm about integrated applications for music, dance, and visual arts so that no one had to work alone in generating ideas. Conversations, like the following excerpt between 4th-grade classroom teachers and a visual arts teacher, were held for every classroom in the school. Similar exchanges took place between grade-level teachers and the music and dance teachers. In the conversation below, the art and classroom teachers brainstormed about how pop-up cards in visual arts class might help students explore the idea of energy transfer for a unit on power and energy in the grade-level classroom:

> *Visual Arts Teacher:* I'm definitely going to use Alexander Calder, but in order to get them started I might have to start with pop-ups. I can start with real basic things that are action on the fold. To get movement on a free-standing kinetic paper sculpture, usually there's something the artist has to do to it [like blow air], but if we can use this energy on the fold to make the motion, I think it might make more sense . . .
>
> *4th-Grade Teacher:* Could be, because we are going to be doing an inquiry thing that's going to be the pinwheel . . . looking at how the shape of a pinwheel makes it more efficient or less efficient, like the size and shape of the blade itself. And we were going to talk about how a wind turbine works vis-a-vis the pinwheel. . . . It's not rotating on the pin, it's rotating the whole thing. So we [could deconstruct and rebuild it but] that's so complicated . . . can 4th graders really handle that?
>
> *VAT:* I can help them problem-solve . . . but trying to plan out step-by-step how to make something . . . might be too hard
>
> *4GT:* No, I want to make it realistic and beautiful. I want the kids to feel successful doing it themselves. . . .
>
> *VAT:* If it's kinetic, it does some motion or movement and it opens. . . .
>
> *4GT:* Right, because that'll fit into the whole potential energy and kinetic energy that we'll be looking at. . . . We're good with that!
>
> *VAT:* OK, nice. I'm thinking like crisp white heavy paper. . . (M.L. and C.D., 2011)

Through practice, such conversations helped both arts and academic classroom teachers learn how to design separate lessons based on complementary

learning targets. In this case, the science/math learning targets for students included examples such as "I can use models and diagrams to demonstrate how a wind turbine works," or "I can describe the different forms of energy and how they are transferred." The visual arts teacher's learning targets for students included problem solving in kinetic card construction, and, "I can show my ideas about wind energy through my paper design."

In making pop-up cards in visual arts class, a student could work toward literal construction problem solving as well as personal expression targets. For example, a student could have argued against wind turbines because they injure birds and could have decided to create an image about birds and turbines that made his concern evident. The teachers' use of arts as collaborative inquiry was a natural way to help students understand how to think conceptually by being invited to respond individually about content.

What would happen when collaborative planning meetings were not fruitful? For meetings in which brainstorming did not work out, the teachers would agree to think further, revisit ideas after a break, or simply not pursue integration for that particular unit. With the school leader's support and expectations, teachers were able to practice collaborative integrations throughout the year. The repeated collaborative planning requirement resulted in the arts and classroom teachers developing a solid understanding of how the arts could be used to facilitate teaching and learning of content and concepts. Through repeated opportunities to practice collaboration, they improved their skills for arts integration and learned not to give up—even if efforts were occasionally challenging or inelegant.

Intersecting Goals

The arts were not used as extracurricular adornment but rather were integral to student learning from within a shared curricular framework. The school accomplished this through the use of a curriculum map based on historical time periods that every grade level explored, with differences in content and pedagogy as appropriate to differences in grade levels. For example, one 12-week time period was focused on the years 1820–1865 and explored how a local village became a city. While the kindergarteners and 1st-graders might explore early occupations and agricultural economies as their first exposure to these ideas, the 4th- and 5th-graders might explore how larger concepts such as slavery and women's rights specifically influenced the local region during the same historical period. Each 12-week teaching block ended with shared "exhibition nights": public performances/exhibitions that demonstrated student learning of the arts and other academic content through spoken words, visual arts, music, and/or dance. Because exhibition nights were designed to show student learning across arts and other academic areas, these collaborations reflected the teachers' shared goals. Whenever an arts project required extra rehearsal, spacing, or polish before a public showing,

both grade-level and arts teachers were highly motivated to support whatever work or time was needed. Simply stated, successful exhibition nights reflected well on *all* teachers.

Regular collaborative opportunities for teachers led to a shared school-wide belief that student learning should reflect on arts and academic expressions of knowledge. This became the school culture. Behind all of this integrated work was a principal's effort to think creatively regarding staff clustering, master scheduling, and curriculum design. Not only did she help facilitate arts and grade-level teachers' collaboration through structured teaming, whole-staff discussions, and observation of each other's teaching, she made sure the curriculum itself was designed and approached in such a way that grade-level and arts teachers viewed it as a shared rather than a separate enterprise. Her example demonstrates how a strong arts-supportive instructional leader can support building the arts into the curriculum from beginning to end, through staffing and scheduling structures that make shared goal-setting among teachers a reality.

CONCLUSIONS: HIGHER EDUCATION'S WORK

Here I provide a glimpse into how one arts-savvy principal used her leadership to help teachers practice high-quality arts integration—what I call "arts as collaborative inquiry"—on a regular basis. While this school may offer numerous ideas for designing and leading new arts-integrated schools, readers may wonder how these structures might pertain to schools that have already been established. In other words, how are the lessons learned from this charter school relevant to other public schools whose structures are generally less tractable in the areas of curriculum, scheduling, and staffing?

The answers may point toward higher education's need to do some deeper work. Engaging in curriculum design, providing professional development for teachers and principals, and capturing high-quality arts-integration practices through more field-based research are some of the ways in which higher education can influence K–12 schools. Although the River Charter School's collaborative instructional practices may appear atypical of what are found in most schools, its most foundational elements are based on old, well-known educational practices. If schools of education make sure their teacher and leader candidates have opportunities to practice team teaching, peer observation, and required collaborative curricular planning in any number of subject areas, then once learned and valued they can apply these same skills toward cross-disciplinary arts and academic collaborative teamwork.

To realize this collaborative vision, institutions of higher education might look toward the divisions that exist within their own ranks. Whenever

higher-education schools or departments train their own candidates without consultation or collaboration across the arts/education aisle, the original curricular divide in K–12 schools is reinforced. More collaborative goals mean that the collaborative "we" should include both art professors and education professors working across the disciplines. Schools of education, art departments, and schools of fine arts all have great potential for expanding cross-disciplinary teaching, modeling, and research opportunities. To accomplish this, those who are educating teachers in higher education might consider the following:

- How do we promote collaboration between faculty at Schools of Art and Schools of Education that will increase teacher candidates' understanding and experience in arts-integrated curriculum design?
- How shall we incentivize ourselves to conduct more field research that will guide our teaching?
- Could we provide collaborative courses in which education- and arts-teacher candidates can practice working together to design high-quality arts integration *before* they begin teaching in schools?
- Could we provide professional development in interdisciplinary collaborative work for *inservice* teachers and leaders?
- Could we explore how traditional art teaching might be organized in ways that would lead toward intersecting goals with non-arts teachers?
- What are the best ways to teach our leaders-in-training how to support creative team teaching, peer observation, and interdisciplinary curricular planning?
- What are the barriers to stimulating further collaboration on arts-integrated inquiry between higher education faculty?

If higher education plans to take a leadership role in improving and transforming the arts-education workforce (as defined earlier in the Introduction), it must create more partnerships and curriculum discussions that are informed by field-based research. Also key is the development of education policy that motivates and rewards thoughtful collaboration. School leaders, like the principal described in this study, are living models for how high-quality arts-integrated curricular design can be accomplished. I challenge higher education to learn from those in the field who are committed to collaboration so that they can more effectively prepare leaders who understand the elements of curriculum design, staffing, professional development, and organizational structures in schools—all of which are required to achieve high-quality arts integration. The future of arts education may well depend on it.

REFERENCES

Bresler, L. (2002). Out of the trenches: The joys (and risks) of cross-disciplinary collaborations. *Bulletin of the Council for Research in Music Education, 152,* 17–39.

Carey, N., Kleiner, B., Porch, R., & Farris Westat, E. (Project Officer: Shelley, B.). (2002). *Arts education in public elementary and secondary schools: 1999–2000* (Report No. NCES 2002–131). Washington, DC: U.S. Department of Education, National Center for Education Statistics.

Charmaz, K. (2006). *Constructing grounded theory: A practical guide through qualitative analysis.* Los Angeles, CA: Sage.

Corbin, J., & Strauss, A. (2008). *Basics of qualitative research: Techniques and procedures for developing grounded theory* (3rd ed.). Los Angeles, CA: Sage.

Hallmark, E. (2011). Arts as collaborative inquiry: Re-defining and re-centering quality arts practice in schools (Doctoral dissertation). Retrieved from urresearch. rochester.edu/institutionalPublicationPublicView.action;jsessionid=2588BC-5864D8375CC13104EC63E84469?institutionalItemId=13697

Wing, L. (1992). The interesting questions approach. *Childhood Education, 69*(2), 78–81.

ARTS SPECIALISTS IN ARTS INTEGRATION

The authors in this Part illustrate the benefits and challenges of collaboration among teaching artists, arts specialists (dance, drama, music, and visual), and classroom teachers. Tensions among the different artists in the schools over roles and responsibilities can be resolved when all those who teach in the arts, what we call "the arts-teaching workforce," recognize the power of collaboration. While there continues to be a lack of consistency in training arts specialists, teaching-artists, and classroom teachers in arts integration, the authors suggest that collaboration among schools, cultural arts organizations, and higher education institutions can lead to higher-quality training that includes all members of the arts-teaching workforce. Clear limitations of this effort are the unstable funding of cultural arts organizations and the limited access to higher education in some communities.

In Chapter 9, Huser and Hockman and their colleagues from the State Education Agency Directors of Arts Education (SEADAE) suggest several approaches for arts integration in schools where the arts specialists play a central role in designing and implementing arts-integrated teaching and learning. The authors point out that arts integration should not replace core arts education, and they suggest that comprehensive and sequential visual and performing arts education provide the foundation for arts integration across the disciplines. In this approach, the role of the arts specialist expands to include providing visual and performing arts programs as well as supporting teachers in integrating the arts in the other content areas. Huser and Hockman identify elements of successful approaches in which the arts specialist plays a central role in designing curriculum and instruction. Drawing upon approaches from across the country in Colorado (Arts Integration Leadership Model), South Carolina (Arts in Basic Curriculum project), and Pennsylvania (Art in Action program), among others, Huser and Hockman suggest a variety of leadership roles that arts specialists can play in integrating the arts across their schools. The authors highlight the roles that we all play, from community members to higher education faculty, in promoting successful full-school models of arts integration.

In Chapter 10, Barnum documents the Arts Impact approach for mentoring classroom teachers in authentic arts integration, which has been practiced for over 17 years in Washington State. Her description of this unique approach to teacher professional development in arts integration centers on four key elements: studying the arts as distinct disciplines, designing arts integration curriculum in which arts and other academic subjects are valued equally, developing pedagogical practices that apply across the disciplines, and coaching by artist mentors in the classroom. As documented in several U.S. Department of Education research studies of this program, the arts-infused approach for professional development improved teacher practice across all disciplines, resulting in positive outcomes for students. The implications for teacher preservice and inservice professional development are significant; however, there are multiple challenges to this approach because many teachers have limited experience with learning in the arts. So the policy implications include not only the importance of including arts integration training in preservice and inservice teacher preparation but also the expanded learning in the arts for K–12 students, so that future teachers will bring experience in learning in the arts to their design of curriculum and instruction and improve student outcomes.

Championing the Way to Effective Arts Integration

Joyce Huser and R. Scot Hockman

This chapter addresses the importance of building a strong community of learning for students and teachers for arts integration. Included here are the approaches to this effort from various states across the country. It is important to note that arts integration does not replace core arts education and the role of arts educators in schools. It is the job of the arts specialists to teach transferable skills so their students can apply this knowledge in the other content areas. Comprehensive and sequential visual and performing arts programs are the foundation for strong arts-integration initiatives.

Through a shared vision, a clear mission, and strong leadership, a school may benefit from the powerful potential of an arts-integration program. The State of Colorado applies the idea of common beliefs by addressing key elements that focus on fulfilling the high demands of arts-integration leadership as described on the Colorado Department of Education website (www.cde.state.co.us/coarts/plcbytesandwebinars). These elements include the following:

> *Curriculum:* As stated in *The Principal as Curriculum Leader* (Glatthorn & Jailall, 2009), "Principals can best discharge their leadership role if they develop a deep and broad knowledge base with respect to curriculum (p. 3)." A cohesive, schoolwide plan of instruction must involve informed curricular planning. It is important to involve multiple stakeholders in building arts-integrated curricula for every grade level that is standards-based and vertically connected through key concepts.
>
> *Instruction:* The primary consideration for instruction within an arts-integrative model is to ensure that all instructors have a high level of understanding in multiple disciplines and that they utilize the creative processes of perform/produce/present, create, respond, and connect. Effective integrative arts instruction relies upon a commitment to honor process *and* product.

Assessment: Meaningful assessment involves a focus on multiple forms of formative, interim, and summative evaluation centered upon schoolwide goals and objectives for student learning. Instructors in an arts-integrative environment should be well versed in conducting performance-based assessment; creating portfolios; applying knowledge and skills in a variety of content areas; practicing problem- and project-based learning; preparing exhibits; and encouraging creativity-building, including fluency, flexibility, originality, and elaboration.

Effective Practices: An arts-integrative environment engages in effective practices of data-based decisionmaking, unit design, and instructional time that are built upon strengths and needs` inventories of staff and students. It also utilizes a project-centered approach that targets creative problem-solving processes, ongoing needs-based professional learning opportunities, and technology that is embedded to meet learning needs.

Communication and Collaboration: An arts-integrative environment is highly collaborative and seeks innovative instructors who possess many areas of expertise. Often, effective arts-integrative school leaders intentionally hire teaching teams that are comprised of very different individual strengths and talents.

Climate and Culture: A common myth about arts-integrative environments is that they are loose and unplanned, with little attention given to management and behavior concerns. The truth is quite the opposite. Building a highly dynamic learning environment demands the strong planning and intentional guidance of all personnel to accommodate the diversity of student learning strengths and needs while allowing students to take control of their own learning.

Differentiation: The integrative school leader not only encourages creative problem-solving strategies for students but also employs this same model to staff. Differentiation for students based on individual learning needs requires a staff that is well versed in creative problem-solving. The ability to meet student needs on an ongoing basis exemplifies both the art and science of teaching.

Partnerships: One of the most beneficial endeavors of arts integration is the engagement of higher education, community arts partners, teaching-artists, and creative industry professionals in order to connect directly with students. These partnerships, along with feeder-school personnel and "sister" arts-focused schools, provide future opportunities for students to become actively involved in diverse real-world experiences.

Using Colorado's Arts Integration *Compass Rose*, a leadership plan and organizational design, school leaders can steer the school planning process toward success through intentional planning around these key organizational elements. The components included in the *Compass Rose* are intended to stimulate thought and are not intended to be all-inclusive. *Compass Rose* can be found at the Colorado Department of Education website (www.cde.state. co.us/coarts/artsintegrationcompassrose). Arts-integrated communities start with strong leadership that empowers instructors to ensure that all students succeed. In successful arts-integration programs, this leadership requires the expertise and experience of a certified arts specialist, what we refer to as the Building Champion. Arts specialists are highly qualified certified members of the school faculty, accountable for the ongoing artistic achievement of their students. The arts specialist is often recognized as "the artist in the building," and fittingly can assume leadership in the development and implementation of the arts-integration program. Recognizing the leadership role of the arts specialist is the first strategic step in organizing the program. In this capacity, the arts specialist becomes the school's "go-to" person. As the curricular aspects of the program unfurl, the arts specialist must act on behalf of the administrative team, participating in discussions about the school curriculum.

Robinson and Aronica (2009) write of transformative education and its needs for the 21st century in their book *The Element*. They describe the need for reliance upon the "depth and dynamism of human abilities of every sort" (p. 250). The authors argue that in the future, "education must be Elemental," and they emphasize the potential impact of building upon "educational visionaries" (p. 250). The school leader embodies the role of an educational visionary in order for the arts-integrative program to succeed. An arts-integration leader embraces the needs of such a specialized and diverse program.

COMMUNITY WIDE EFFORT

With strong leadership, relationships are formed among partnering personnel. The State Education Agency Directors of Arts Education (SEADAE) 2012 publication *Roles of Certified Arts Educators, Certified Non-Arts Educators, & Providers of Supplemental Arts Instruction* (Richerme, Shuler, McCaffrey, Hansen, & Tuttle, 2012) describes the process of fostering instructional collaborations and relationships among certified arts educators, certified educators in all disciplines across the curriculum, and authentic arts resources. Such relationships create a succinct checklist for building effective arts-integration partnerships. Key players include certified educators in all disciplines across the curriculum who are trained, who have resources to form interdisciplinary connections, and who use the arts to enhance learning. With their specialized skills and their lives as working artists,

authentic arts resources and teaching-artists help students learn. Schools need to provide opportunities for certified arts educators, certified educators in all disciplines across the curriculum, and authentic arts resources to share their expertise through collaborative planning (Richerme et al., 2012). Designated arts resource rooms in the school can provide shared resources for this purpose.

One example of a program with a strong statewide partnership is the Arts in Basic Curriculum (ABC) Project in South Carolina. ABC is a statewide collaborative initiative begun in 1987, whose goal is to ensure that every child in South Carolina, pre-K–16, has access to quality, comprehensive education in the arts, including dance, media arts, music, theater, visual arts, and creative writing. The ABC Project is administered collaboratively by the South Carolina Department of Education (SCDE), the South Carolina Arts Commission (SCAC), and the College of Visual and Performing Arts at Winthrop University.

A statewide coalition of diverse members is committed to achieving the project's goal. The ABC Steering Committee includes the SCDE, the SCAC, schools and school districts, colleges and universities, artists, educators, arts organizations, government leaders, and business leaders. Now comprised of more than 50 members, the committee meets three times a year to learn about current education legislation and programs, review project initiatives, and make recommendations for carrying out initiatives such as the Model ABC Advancement Sites program. Grant funds are used to develop innovation arts programs through a competitive process that sustains arts and arts-integration programs in schools and districts. Currently, the ABC Advancement Sites include 62 schools and 7 districts serving 159,655 students.

ABC works on the following approach, which contributes to its longstanding success. Individual schools autonomously design a comprehensive sequential arts program and an arts-integration program specific to the needs of their arts-learning community. The needs of a school and its students are determined using the Opportunity to Learn Standards (OTLS) survey. The OTLS covers issues related to curriculum and scheduling, staffing, materials and equipment, and facilities. A district or school steering committee in each ABC school includes members from the learning community at large. This steering committee, comprised of 15 to 25 members, determines school priorities and action steps, then develops a five-year strategic plan that allows the school to determine the extent and pace of the arts-integration program.

The ABC director and the field services specialist work closely with individual arts integration programs. The project "blueprint" for arts education, completed in 1988 with funds from the National Endowment for the Arts (NEA), outlines a whole-school arts curriculum founded on the premise that a quality arts education is an indispensable part of a complete

education that adds to the learning potential of all students. Arts education complements learning in other disciplines and establishes a foundation for success in school and lifelong learning. The ABC blueprint also provides a forum for the development of strategic arts initiatives and serves as the foundation for a broad advocacy coalition for arts education reform in South Carolina. South Carolina programs have garnered numerous accolades for ABC schools, including the Kennedy Center for the Performing Arts Schools of Distinction Awards and National Blue Ribbon Awards.

An example of the success of the ABC Project model can be found in Hand Middle School. Located in Richland County School District One, Hand Middle School "had not responded to the changing demographics and needs of its student population. Achievement was languishing below the 50th percentile on standardized test scores. Hand has used the arts to generate a new image of the school" (Stevenson & Deasy, 2005, p. 131). Since making the decision to become an arts-based school, Hand has seen an 85% increase in the PACT (Palmetto Achievement Challenge Test) test scores of its African American students, who make up 49% of the student population. Students test scores continue to lead schools in the district and the state on the newer Palmetto Assessment of State Standards test. In 2000, TIME magazine named Hand the National Middle School of the Year (Stevenson & Deasy, 2005). During the same year, Hand received the United States Department of Education National Blue Ribbon Award. The school received numerous Palmetto Silver Awards and the Palmetto Gold Award in 2014 and 2015 from the SCDE for overall achievement and improvement. In 2011 and 2007 Hand was recognized with the Historically Underachieving Group (HUG) Award for the increasing academic achievement of African American students (Stevenson & Deasy, 2005).

Developed to assist teachers and administrators to better understand effective practices for integrating the arts into all content areas, the ABC Arts Infusion Continuum represents a progression of standards-based arts-integration practices beyond basic connections. The continuum represents a broad spectrum of research that is consolidated into a one-page document (www2.winthrop.edu/abc/). "Varieties of Arts Integration" by the Center for Applied Research and Educational Improvement and Perpich Center for Arts Education (2002) informed the writing of this document. The ABC Arts Infusion Continuum also incorporated information from the New Hampshire Integrated Learning Project (NHILP) ("New Hampshire," 2016), guided by Ray Doughty, former director of the ABC Project.

ROLE OF HIGHER EDUCATION

Communities invested in arts integration require schoolwide participation in professional development and design implementation. As stated in *School*

Leadership That Works (Marzono, Waters, & McNulty, 2005), the first priority for second-order change leadership is "being knowledgeable about how the *innovation* will affect curricular, instructional, and assessment practices and provide conceptual guidance in these areas" (p. 70). Community leadership includes insightful arts educators that play a key role; however, knowledgeable educators across the curriculum, teaching-artists, and supportive administrators and communities also play a necessary role. All faculty members need an understanding of the value of arts integration as a potential school reform model. Teaching-artists need training in standards-based instruction and pedagogy. Administrators and the community need arts awareness to support such a program.

College and university preservice teacher education programs play a vital role in providing professional education that focuses on preparing arts educators to practice arts integration and to maintain existing pre-K–12 arts-integration programs. This education starts during the preservice years in preparation programs for both art and non-arts teachers. From there, colleges, universities, and other technical assistance providers assist in delivering ongoing professional development to participating schools as veteran educators design and implement programs.

One such example of this ongoing partnership exists through the Art in Action program in Erie, Pennsylvania. Art in Action is a partnership among Arts Erie, Union City Elementary School, First District Elementary School, Cambridge Springs Elementary School, and the Edinboro University of Pennsylvania. Funded by the partnership, Edinboro University works with Art in Action schools to provide graduate-level coursework in arts integration. Teachers in participating schools and Art in Action artists enroll in graduate courses tuition-free. The result is classroom teachers, building arts specialists, and teaching-artists who are learning side by side. They build standards-based arts-integrated curriculum using a constructivist approach that is grounded in Understanding by Design techniques (Wiggins & McTighe, 2005) and inquiry-based learning, as noted in Chapter 3. The graduate courses are taught directly after school on the campus of one of the three partnering districts. Increased teacher attendance is realized when the university comes to a location near the teachers, similar to the Lesley University programs mentioned in Chapter 1. Coursework is supplemented by professional development workshops held one evening each semester during the school year. In the summer, Arts Erie sponsors a three-day Learning Lab retreat attended by teaching-artists, building arts specialists, classroom teachers, and administrators. Workshops are planned with individualized learning tracks that can accommodate both inservice and preservice teachers. Monthly meetings are held with school administrators, content specialists, and building champions. Arts Erie and Edinboro University create a forum for sharing, monitoring program progress, and planning for the

future. The program completes a circle that lays the groundwork for long-term sustainable partnerships in arts integration.

Art in Action is committed to creating a sustainable community that is invested in arts integration. Integral to community-building is the development of strong lines of communication and ownership. An appointed building champion in each building acts as the point person during the school year. At two of the three buildings, the building champion is the visual arts teacher, thus modeling the structure of certified arts educators as leaders for arts integration. Content specialists work with each building champion to schedule and coordinate a residency and unit of instruction. Through bi-weekly meetings, staff and content specialists share information, reflect on the status of the ongoing programs, and plan ongoing professional learning opportunities.

In one example of Art in Action, a teaching-artist used storytelling, pantomime, and improvisation to teach the children how to create a character and remember details and story sequence in order to reenact the story for one another as an improvised drama. Drama classes were targeted to support language arts curriculum; in writing, the children created scripts based on the stories they were learning with the teaching-artist and his team. This taught the classroom teachers to encourage fluency and automaticity as they read the stories aloud. Dynamic Indicators of Basic Early Literacy Skills (DIBELS) tests for reading fluency and comprehension were given just before and just after the residency. Results from pre- and post-DIBELS testing showed an average increase in scores of 17.5 points in reading fluency and 8.4 points in reading recall. Several individual students increased their scores by over 40 points in reading fluency. Individual test scores in reading recall increased as much as 60 or 62 points for some students.

STATEWIDE POLICY

Statewide policy often supports arts integration programs that, in turn, support community- and relationship-building. Some states, such as North Carolina, have arts-integration programs that exist in response to state policies. For example, the North Carolina state legislature affirmed the recommendations of a report that specifically addresses professional development to support arts-standards implementation in all areas of the curriculum. The goal of this action is to better equip new teachers to integrate the arts in all disciplines and to enhance students' creativity and critical thinking skills. In June 2012, Senate Bill 724: An Act to Implement Various Education Reforms (S724) was signed into North Carolina law. This law requires that preservice elementary teachers and lateral-entry teachers be prepared to integrate arts education across the curriculum. This wide-scale

legislation directs the State Board of Education to work with the Board of Governors of the University of North Carolina and the State Board of Community Colleges to ensure that programs of study for preservice and lateral-entry teachers remain current and reflect a rigorous course of study that is aligned to state and national standards. The law addresses teacher preparation across many areas, including adequate coursework and requisite knowledge in scientifically based reading and mathematics instruction, knowledge of formative and summative assessments, knowledge of technology-based assessment systems, and preparation to integrate the arts across all areas of learning.

North Carolina's Basic Education Program, which was passed into law in 1985, defines arts education as part of a fundamentally complete program of education to be offered to every child in the public schools. This philosophy continues to be supported at the state and national levels, including the designation of the arts as a core academic subject under the Elementary and Secondary Education Act (ESEA). The S66 Vision for Arts Education considers dance, music, theater arts, and visual arts, taught by licensed arts educators and integrated throughout the curriculum, to be critical to 21st-century education in North Carolina. The state affirms the valuable role that standards-based arts education plays in the development of arts literacy within each art form, as well as the importance of integrating the arts into other areas of learning.

The *S66 Comprehensive Arts Education Task Force Report* includes recommendations that specifically address the implementation of arts education in the schools and ensures that appropriately licensed arts educators deliver all arts education classes. Recommendations for arts integration as part of a comprehensive arts education are additional to (not in place of) the specific recommendations for implementing arts education programs as defined in existing state law. These recommendations include the following: prioritizing arts integration as a primary component of education reform, requiring arts integration for teacher and administrator preparation and licensure, using the state educator evaluation system to assess teachers' use of arts integration, and using arts teachers as resources and consultants for arts integration within schools and across local education agencies.

Congressional legislation in the form of the Every Student Succeeds Act (ESSA) stipulates that the arts are included in the definition of a well-rounded education. A well-rounded education consists of courses, activities, and programming that are provided with the purpose of providing all students access to an enriched curriculum and educational experience (the legislation can be accessed at www.ed.gov/ESSA).

The Arts Education Partnership State Policy Database ("Arts Ed," 2016) shows the ways in which state policy supports quality arts integration. Quality arts integration is accomplished through requiring ongoing professional development for practicing artists and arts specialists, as well as

training on how arts specialists can be leaders in their building via arts integration. In addition, building knowledgeable classroom teachers by offering art and art-integration classes for generalists can significantly strengthen the overall program. Requiring preservice arts integration training helps prepare teachers prior to their classroom experience. Through precise focus and clear vision, a school may truly utilize the powerful potential of arts-integration programming.

FUNDING SOURCES

Existing funding sources presently support arts integration and sustainability. One such funding source is the U.S. Department of Education's Arts in Education Model Development and Dissemination Grant. As described earlier, Art in Action is a partnership that is funded by this grant, which is administered by the Arts Erie arts council of Erie, Pennsylvania. Another funding source is the National Endowment of the Arts (NEA). The NEA has funded many arts integration programs across the nation, including the ArtsPowered Schools (APS). APS fostered a coalition that has won yearly grants from the NEA and agency funds to provide a week of residential professional development in arts integration, with university credits available. This funding has allowed Idaho's APS Summer Institute to rotate between three college and university campus sites, utilizing college campus arts facilities, incorporating local and regional arts resources, teaching artists, and teams of educators from schools across the state. The coalition wrote and published *ArtsPowered Learning: An Idaho Arts Education Framework* (Idaho State Department of Education & Idaho Commission on the Arts, 2009) and developed an active website (artspoweredschools.idaho.gov/) that archives materials, lessons, documentation, photographs, and videos from every year of the program. This resource is used in preservice art education courses at the University of Idaho as a resource for arts integration.

Finally, under ESSA, Title I schools operating a schoolwide Title I program (meaning the school has a poverty rate of at least 40% and has undergone a rigorous planning and research process to select and implement whole-school reform) can use their Title I funding to implement arts integration, either as whole-school reform or part of the school's reform strategies (Title I, Section 1114).

CONCLUSION

It is an exciting time to be an integrated-arts school. The opportunities are many, the rewards for students and teachers are valuable, and the challenges can be met. With certified, experienced arts specialists and a schoolwide

community committed to a shared mission, vision, and beliefs about arts integration, professionally trained staff can create a community invested in arts integration for sustainability that will benefit every child.

Continuous conversations about how preservice teachers and existing classroom teachers are prepared to integrate the arts throughout instruction will play a key role as we focus as a country on preparing students to be college- and career-ready. The only question left to ask is, Which perspectives will the next generation arts-integration school leader bring to this endeavor? The members of SEADAE offer several existing models and funding sources in this chapter. We trust that our successors in arts-integration leadership will create, implement, fund, and champion programs beyond our current imaginations.

REFERENCES

Arts Education Partnership Database. (2016, August 3). Retrieved from www.aep-arts.org/research-policy/artscan/state-of-the-states-2015/

Center for Applied Research and Educational Improvement & Perpich Center for Arts Education. (2002). Varieties of arts integration. Regents of the University of Minnesota. Retrieved from www.cde.state.co.us/coarts/artsintegrationmodels

Glatthorn, A., & Jailall, J. (Eds.). (2009). *The principal as curriculum leader: Shaping what is taught and tested*. Thousand Oaks, CA: Corwin Press.

Idaho State Department of Education & Idaho Commission on the Arts. (2009). *ArtsPowered learning: An Idaho arts education framework*. Boise, ID: Authors. Retrieved from arts.idaho.gov/ae/framework.pdf

Marzono, R. J., Waters, T., & McNulty, B. A. (2005). *School leadership that works: From research to results*. Alexander, VA: Association for Supervision and Curriculum Development.

New Hampshire Department of Education. (2016, August 3). Arts integration. Retrieved from education.nh.gov/instruction/curriculum/arts/integration.htm.

Richerme, L. K., Shuler, S. C., McCaffrey, M., Hansen, D., & Tuttle, L. (2012, June 26). *Roles of certified arts educators, certified non-arts educators, & providers of supplemental arts instruction*. Dover, DE: SEADAE. Retrieved from www.seadae.org/Corporatesite/files/8d/8dff82c9-2e44-46e3-b180-63fa11915214.pdf

Robinson, K., & Aronica, L. (2009). *The element: How finding your passion changes everything*. New York, NY: Penguin Group USA.

Stevenson, L. M., & Deasy, R. J. (2005). *Third space: When learning matters*. Washington, DC: Arts Education Partnership.

Wiggins, G., & McTighe, J. (2005). *Understanding by design* (expanded 2nd ed.). Alexandria, VA: Association for Supervision and Curriculum Development.

Professional Learning in and Through the Arts

Sibyl Barnum

In the introduction to this book, McKenna and Diaz make a clear case for the value and benefit of arts integration for students. However, there is also a case to be made that learning in and through the arts benefits teachers and improves their practice. This chapter looks closely at a professional development approach in which learning in and through the arts has produced evidence of improved teacher practice across all disciplines, leading to positive outcomes for students.

Teachers encounter two significant challenges as they begin a professional learning program in arts integration. First, many teachers have little personal experience in the arts and feel anxiety and self-doubt about their personal artistic abilities. Most did not receive a sequential arts education growing up, and some were told they were not artistic—that they couldn't sing, dance, act, or draw. They may have had little opportunity to experience or participate in creating or performing in any of the arts disciplines. Their concerns lead to the second challenge, which is that they have not received any preservice or inservice professional development in the arts or arts integration. How, then, are these barriers to be overcome so that a teacher can develop personal artistic confidence and professional competency to integrate the arts?

A combination of factors is involved in delivering professional learning in arts integration. These factors include the following: a pedagogical foundation that is grounded in research-based educational theory, alignment with standards for professional learning (see Chapter 2 by Charleroy & Paulson), a learning design appropriate for adult learners, a standards-based curriculum, and job-embedded coaching from an artist mentor. All of these should be provided in a safe environment that allows for the development of personal artistic skills and pedagogical strategies for arts integration.

Arts Impact, as an inservice professional learning program of Puget Sound Educational Service District in Washington State, has functioned since 1999, developing and refining its approach to professional learning in arts

integration for teachers. Nearly 800 teachers in 90 schools in Washington State have completed the program. Research on the impact of its approach has been supported by seven U.S. Department of Education Arts in Education grants since 2002, with variations of the approach in each subsequent project based on findings from the previous grant projects. These projects have highlighted the characteristics of an effective professional learning approach and have provided evidence that infusing the arts improves overall teacher practice and develops teacher confidence and competence. While these research projects also showed evidence of improved student outcomes in the arts and in other subject areas, as well as a reduction in the opportunity gap for students of color, this chapter focuses specifically on the impact of learning in and through the arts on educator effectiveness.

EVIDENCE OF IMPROVED TEACHER PRACTICE
AND SUSTAINED ARTS-INTEGRATED TEACHING

In a 2006–2010 U.S. Department of Education Arts Education Model Development and Dissemination grant, Arts Impact posed the research question: Does professional development in the arts improve teacher practice across disciplines? In the experimental design, teachers in two groups from different schools were matched for similar student demographics and achievement scores. The treatment group of teachers received Arts Impact training and the control group did not. The STAR Protocol, a classroom observation tool developed by the BERC Group that measures attributes of Powerful Teaching and Learning, was used to observe classroom teachers from both groups while they were teaching a regular reading or math lesson. A three-part process is required for scoring with the STAR Protocol. It begins with scoring using 15 Indicators, then it evaluates the Five Essential Components: Skills, Knowledge, Thinking, Application, and Relationships. Finally, it gives the lesson an Overall score (BERC Group, 2014).

STAR Protocol data were collected four times: at baseline, at the end of the first and second years of Arts Impact professional development, and at the end of the third year, after direct professional learning was completed. Figure 10.1 shows that at baseline, 43% of teachers in the treatment group and 42% of teachers in the control group scored in the two highest rating levels in the overall category of the STAR Protocol. At the end of the third year, when teachers infused the arts on their own, 62% of Arts Impact teachers were in the two highest rating levels in the overall category compared to 43% of control teachers (BERC Group, 2014).

An increase in the level of teacher autonomy to teach arts-infused lessons, as measured by the Autonomy Rubric for Teachers (ART), was also demonstrated in this study. The ART is a four-point annotated rubric that was developed in 2002 by Arts Impact and vetted over multiple uses between

Figure 10.1. STAR Protocol Data on Lesson Alignment

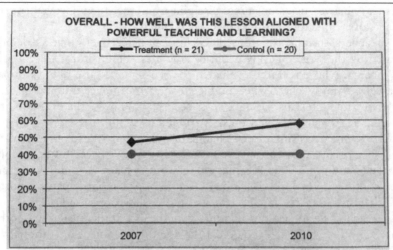

2002 and 2006. A score of a 1 or a 2 means a teacher is developing skills, and a 3 or 4 means they are proficient. Ratings were taken at the end of the first and second year of professional development. Figure 10.2 shows that at the end of the second year, teachers made significant gains in all categories.

Similar outcomes on the STAR Protocol and ART were achieved in subsequent Arts Impact studies: Math Artistic Pathways (2008–2010), Teacher Training: Arts as Literacy (2008–2011), and Arts Impact Dissemination and Expansion (2010–2014). These studies can be found at arts-impact.org/research-projects/.

Figure 10.2. Autonomy Rubric for Teachers

Teaching and Assessing Skills Measured by the ART	Percent of Teachers Receiving Arts Impact Professional Learning Rated as Proficient	
	2007–2008	2008–2009
Leading Warm-up	72	92
Sequencing Lesson Steps	56	92
Lesson Pacing	72	97
Performing Embedded Assessment	72	92
Classroom Management	78	92
Eliciting Creative Original Response	58	97
Leading Criteria Based Reflection	89	100
Focus on Criteria	91	100

Repeated positive results on the STAR and ART demonstrate that Arts Impact improved teaching across disciplines and that the improvement sustained after direct professional developed ended.

Teachers sustain arts-infused teaching practice over time as demonstrated by the work of Amy McBride, the arts administrator for the City of Tacoma, whose research evaluated the self-reported use of Arts Impact strategies from teachers who completed the Arts Impact training at three different time intervals. Using a cross-sectional analysis, she evaluated the affect that Arts Impact had on its participants within the context of best practices and transformational change in professional development in the arts. Her results showed that Arts Impact was very successful in teaching strategies and providing tools that are relevant to teachers and the arts, and they continue to be used over time. Over 85% of the participants reported that they still use Arts Impact strategies in the classroom. And over 94% of these teachers design lessons that integrate the arts authentically with other core subjects, which is a required behavior for sustained, operationalized change (Upitis, Smithrim, & Soren, 1999).

CHARACTERISTICS OF PROFESSIONAL LEARNING IN THE ARTS

As noted earlier, a combination of the features within this professional development approach produces positive change in teacher effectiveness. The factors include the following, which should all take place in a safe environment: a pedagogical foundation grounded in research-based educational theory, alignment with standards, a learning design appropriate for adult learners, a standards-based curriculum, and coaching from an artist mentor. Let's take a close look at each of these factors.

Pedagogy: Research-Based Educational Theory

To build teacher efficacy, professional learning must be grounded in research-based educational theory that spans all disciplines, not just the arts. This approach very intentionally overlays research-based teaching practices onto the artistic process. Teaching and learning in the arts is as rigorous and intentional as instruction in any other content area while engaging the learner in experiential, creative, inquiry-based learning. The instructional approaches described below complement and optimize learning that happens when teachers and students engage in the artistic process.

The foundations of the Arts Impact pedagogy are based on the educational theories and practices discussed below. During the summer institute, these theories are presented as part of the professional learning syllabus both intellectually and experientially. Teachers participate in the actual lessons they take back and teach in their classrooms, learning experientially how these instructional practices play out.

Concept-based instruction: Instruction centered on key concepts is expressed in the enduring understanding of each lesson that integrates thinking beyond the level of facts. Conceptual learning is the highest level of learning because the attributes of a concept are broad and abstract, timeless, universal, and can be represented by different examples with common attributes (Erikson, 2005).

Arts infusion: While acknowledging the multiple ways to integrate the arts into other core subject areas, Arts Impact teaches to a specific type of integration called arts infusion. An arts infused lesson is one that teaches concepts that are authentically shared between two or more disciplines. For example, symmetry is a concept in math, science, visual art, and dance. The focus of the learning is on the concept rather than the specific discipline. Arts infusion provides multiple pathways to understanding the concept ("Authentic Connections," 2002; Erikson, 2005).

Clear learning targets and criteria: Clear learning targets—what students should know, do, or be—and criteria—what the student does or says to demonstrate understanding—are articulated in every lesson so that both teacher and student understand what the expected outcomes are. Arts Impact emphasizes the importance of teachers being able to clearly articulate the learning targets and criteria for every lesson. By doing so, instruction is intentional, can be easily assessed in the moment, and is transparent for the student (Stiggins, 1997; Wiggins & McTighe, 1998). Students are asked to demonstrate the concept through multiple examples that include artistic, written, spoken, and/or kinesthetic means.

Performance-based assessments: Student outcomes are measured against clear criteria and are based on what the teacher hears and observes from the student that demonstrates understanding of the concepts. Students demonstrate what they know and can do through an artistic expression—an artwork, a piece of choreography, or a dramatic scene. This alternate way to express understanding is particularly beneficial for students who struggle with traditional paper-and-pencil forms of assessment. Teachers report that they discover abilities and capabilities, which would not have otherwise been revealed, in students who traditionally perform poorly. Success in expressing arts-infused concepts such as a balanced equation, story structure, or congruent shapes through artistic pathways can provide many students the confidence they need to continue to succeed.

Multiple forms of performance-based assessments are utilized and include criteria-based checklists, self-assessment, written reflection, peer assessment and feedback, group reflection and response, and analytic rubrics. Performance-based assessments are embedded throughout instruction to check for understanding. Data are used formatively to adjust instruction based on student responses (Moss & Brookhart, 2009; Stiggins, 1997).

Performance-based assessments play a key role in establishing a safe and creative environment for students who are novices in the arts. All performance-based assessments are criteria-based, as opposed to subjective evaluation. Student success is based on their ability to show understanding of lesson criteria, not on how "beautiful" the artwork is or how "graceful" the student is. Clear criteria establish whether the student clearly communicates symmetry in the dance, artwork, or written assignment. Taking the qualitative judgment out of the assessment sets students up for success, and encourages students to refine and revise their work, leading to discovery and creativity. Criteria-based assessment also allows teachers to confidently assess the arts when they understand they are not "judging" a students' creation or performance.

Standards-Based Instruction

All curricula must be aligned with current standards, which at the time of this writing includes the National Core Arts Standards, Common Core State Standards in mathematics and English language arts, and Washington State Early Learning Guidelines for pre-K–grade 3. The alignment must be intentional and grade-level-specific, noting specifically what a student will know and be able to do within the broader standard. In addition, the artistic process is closely aligned with the mathematical and writing processes as well as the College and Career Readiness Standards in the Common Core State Standards and the Common Anchor Standards in the National Core Arts Standards.

The professional learning approach itself needs to be aligned with what research says actually changes teacher practice. The seven standards of Learning Forward's Standards for Professional Learning serve as a guide for educator learning: learning communities, leadership, resources, data, learning designs, implementation, and outcomes (Learning Forward, 2009). When a program uses these standards to plan and evaluate professional learning, instructional practice is elevated and student outcomes improve.

Research on implementation of professional learning has shown that a significant number of hours over a sustained period of time are necessary for teachers to change their practice (Learning Forward, 2009). The Arts Impact program offers 104 hours of professional learning over the course of two years. In a recent research grant, "Teacher Training: Arts as Literacy Plus," Arts Impact (2014a) found that additional time and ongoing support increase the likelihood that arts-infusion will become part of school culture and be seen as part of a building's overall strategy for school and student improvement. Teacher feedback also revealed that even after three years of strong implementation support, opportunities for ongoing professional learning in arts-infusion are necessary, just like it is in other subject areas.

Professional Learning Activities Designed for Adult Learners

The learning activities teachers engage in as they develop new knowledge, skills, and teaching practices are critical to building confidence and competence in their ability to infuse the arts and develop personal artistic expressiveness. There must be multiple learning activities appropriate for adult learners with opportunity for reflection, sharing with colleagues, and evaluation of progress, and it must include job-embedded coaching.

The site of the learning also contributes to its influence and success. Arts Impact professional learning is held in two key locations. Summer institutes take place in regional art museums and performing arts centers, providing teachers the opportunity to access original works of art as part of the training and to gain familiarity with local venues and resources. Teachers report that spending a week in an art museum or performing arts center is engaging, more meaningful, and personally inspiring, an invigorating change from the usual professional development sites such as the school library or a hotel conference room.

The classroom is the other training location. Teachers report that the job-embedded, one-on-one coaching/mentoring from the artist mentor in the 10-hour mentorship is the most important component for building autonomy, confidence, and competence to infuse the arts. The opportunity to practice arts-infused teaching with an expert coach provides the assurance a teacher needs as new practices are tried out in the classroom.

Summer Institute

Artist mentors teach the experiential five-day, 30-hour summer institutes that build foundational content knowledge in three art forms (dance, theater, and visual arts), model best teaching practice, and develop personal artistic confidence. Teachers learn the same lessons they take back and teach in the classroom. They paint, draw, act, dance, and choreograph, just as they will be asking their students to do. This type of learning carries a significant level of risk for teachers, as they dance, act, or make art as novices alongside their peers. But the arts also provide the opportunity for personal expression. A successful learning experience that involves both risk and personal meaning-making is very powerful (Rubenson, 2011). Learning is internalized and becomes part of a person's schema.

At the institute, teachers are engaged in multiple learning experiences simultaneously: as a student—learning, creating, and performing in the arts; and as a teacher—discovering and analyzing how the artist-mentors' teaching practice makes them successful learners. Teaching, learning, and assessment processes are clearly illuminated when teachers have a transformative learning experience and the teaching practice that elicits that response is

well-articulated and modeled by expert teaching-artists. Teachers "get it" on a deep metacognitive level.

In addition to building arts knowledge and skills and arts-infused teaching practice, the institute experience immerses teachers in the artistic process, providing them the opportunity to experience the arts on a deep personal level. Throughout the institute week, not only is teaching practice refined, but teachers' artistic confidence grows as well, culminating on the final day, when teachers collaboratively create and perform for one another a dance they choreographed, a theater piece they wrote, or a completed work of art. Every year, teachers report how transformational this concluding experience is, how high the quality of the presentations are, and how it was only possible because learning was safe and accessible. Teachers are eager to provide the same experience for their students.

Professional Learning Communities (PLC)

Arts Impact facilitates professional learning communities (PLCs) that develop a community of practitioners who share common goals and visions. The PLCs engage teachers in collaborative professional learning around arts infusion to strengthen and improve their practice and to increase student results. Teachers use shared connections, experiences, and student outcomes from their classroom arts-infused lessons to build upon their learning and practice in ways that cannot happen if they remain isolated and disconnected from their community of learners (Hord, 2004).

Cultural Study Trips

Each class in the program takes a cultural study trip, an object-based learning experience that capitalizes on the idea that community resources—original works of art, live dance, theater, and musical performances—are the highest exemplars of the concepts, skills, and processes artists use to communicate. Educators at partnering community cultural organizations guide learning for students and teachers on museum tours and at dance or theater performances to complement classroom study, a much richer exposure opportunity for students than the normal field trip ("Object Based Learning," 2005). Students are active audience members as they experience artworks or performances through the lens of the same artistic concepts they use in class to create their own works.

Job-Embedded Coaching

The final component of the professional development is the classroom-based mentorship. Artist-mentors provide job-embedded coaching and mentoring in planning, teaching, and assessing arts-infused lessons. The mentorship

includes multiple visits with the artist-mentor over the course of a week, to-taling 9–12 hours. The mentorship gradually transfers teaching responsibility from the artist-mentor to the teacher, from model teaching to assessment of student work (Huling, 2001). Collaboration is a powerful teaching and learning tool, allowing the strengths of each partner to inform the other's practice. The role of the artist-mentor in the mentorship is central to the development of teacher autonomy to infuse the arts. The relationship between the artist-mentor and the classroom teacher, two practitioners with distinct areas of expertise sharing an instructional framework, is an active teaching partnership in which there is a seamless flow of instructional practice between the two "experts." This is different from artist-in-residence models that rely solely on the expertise of a teaching-artist to provide instruction. Some integrated-arts residency models include collaboration between the teaching-artist and teacher to develop the integrated content, but the expertise of each remains firmly separate. Over the course of two years, teachers and artist-mentors blend their expertise and gradually erase the border between content areas to reveal a conceptually integrated instructional approach.

The importance of the role of the artist-mentor was reinforced in the research project "Teacher Training: Arts as Literacy Plus" (Arts Impact, 2014b), funded by a U.S. Department of Education grant. Arts Impact piloted a teacher-leader model in which a small group of teachers from four elementary schools in the Seattle Public Schools received professional development to become Arts Impact arts-infused teacher-leaders in their buildings. The goal was to create an affordable model for a large urban school district to scale up arts integration across the district. In this study, individual classroom mentoring by the artist-mentor, the most costly component of the program, was significantly reduced, with teacher-leaders stepping in to fill many aspects of that role. As a result, STAR Protocol outcomes were lower than in other studies, suggesting that the artist-mentor plays a significant role in improved teacher outcomes.

IMPLICATIONS, APPLICATIONS, POLICY, AND PRACTICE

The evidence for improved teacher practice when professional development happens through the arts has implications for both preservice and inservice learning. As university students are preparing to become teachers, the lessons learned from inservice arts-integration professional learning can be applied to preservice education courses. Four key areas for implementation in teacher preparatory courses come to the forefront: inclusion of the arts as part of the core education coursework, authentic conceptual integration that validates both subject areas, emphasis on instructional practice that applies to all content as opposed to content-specific "methods," and job-embedded

coaching. Inservice teachers experience a transformation of their teaching practice that not only empowers them to use arts infusion as a way to improve student outcomes but elevates their practice across all disciplines.

Enabling teachers to embed arts infusion into their everyday teaching practice advances arts infusion in a sustainable way. It diminishes the need to rely on special programs or residencies from outside organizations as a primary source of arts education or exposure, especially at the elementary grade levels. Arts-infused learning in the classroom supports and deepens arts-learning from specialists, when schools are able to provide them, providing students the opportunity to apply arts-learning to other content and real-world problems.

The Arts Impact approach of professional learning supports the case to reform district and building policy in the way resources are allocated for professional learning. Professional learning that is sustained and intense includes job-embedded coaching and provides time for teachers to collaborate in developing arts-infused learning opportunities for students.

The evidence presented here makes a strong case that the unique aspect of learning through the arts, when combined with strong instructional theory, illuminates best teaching practice and can be as beneficial for teacher outcomes as it is for student outcomes. The arts develop qualities of effective teaching in a 21st-century world, just as the arts develop qualities for students to be successful in a global society. It is imperative for practitioners and professional development programs in arts integration to ensure that their practice stands up to the rigor of instructional best practices that apply across all of education. Engaging in that work, and aligning with the broader educational field's efforts to improve teaching and learning, is one of arts education's best advocacy tools. As educators demonstrate a serious approach to instruction, the benefits of the arts to teachers and students—dispositions for learning, 21st-century skills, habits of mind, social-emotional development, and the joy and fulfillment of participating in the arts—will gain importance. And perhaps instead of being seen as peripheral or expendable, the arts will be understood as essential.

REFERENCES

Arts Impact. (2010a). Math artistic pathways, Final Report. Retrieved from arts-impact .org/research-projects/

Arts Impact. (2010b). Sustaining arts-infused education: A study of teacher change and principal leadership. Retrieved from www.arts-impact.org/research/files/ 2006_10_AI_AL_FinalReport.pdf

Arts Impact. (2011). Teacher training: Arts as literacy, Final Report. Retrieved from arts-impact.org/research-projects/teacher-training-arts-as-literacy/

Arts Impact. (2014a). Arts Impact dissemination and expansion, Final Report. Retrieved from arts-impact.org/research-projects/

Arts Impact. (2014b). Teacher training: Arts as literacy plus, Final Report. Retrieved from arts-impact.org/research-projects/teacher-training-arts-as-literacy-plus/

Authentic connections: Interdisciplinary work in the arts. (2002). The Consortium of National Arts Education Associations. Retrieved from www.unescobkk. org/fileadmin/user_upload/culture/Arts_Education/Resource_Links/Authentic_ Connections.pdf

The BERC Group. (2014). STAR protocol. Retrieved from www.bercgroup.com/ star-protocol.html

Erikson, H. L. (2005). The integration of thinking: The key to deep understanding and the transfer of knowledge. Retrieved from creativeplaces.wikispaces.com/ file/detail/Integration_of_Thinking_Summer+2005.ppt

Hord, S. M. (Ed.). (2004). *Learning together, leading together: Changing schools through professional learning communities*. New York, NY: Teachers College Press.

Huling, L. R. (2001). *Teacher mentoring as professional development* (ERIC Digest). Washington, DC: ERIC Clearinghouse on Teaching and Teacher Education.

Learning Forward. (2009). Standards for professional learning. Retrieved from www.learningforward.org/standards

Moss, C., & Brookhart, S. (2009). *Advancing formative assessment in every classroom: A guide for instructional leaders*. Alexandria, VA: Association for Supervision and Curriculum Development.

Object based learning and inquiry projects. (2005). Retrieved from schools.cbe.ab. ca/b101/pdfs/inquirybasedlearning.pdf

Rubenson, K. (2011). *Adult learning and education*. Oxford, UK: Academic Press.

Stiggins, R. J. (1997). *Student-centered classroom assessment*. Upper Saddle River, NJ: Prentice Hall.

Upitis, R., Smithrim, K., & Soren, B. J. (1999). When teachers become musicians and artists: Teacher transformation and professional development. *Music Education Research, 1,* 23–35.

Wiggins, G., & McTighe, J. (1998) *Understanding by design*. Alexandria, VA: Association for Supervision and Curriculum Development.

ARTS INTEGRATION IN PRACTICE

In this Part the authors explore the impact of arts-integrated profession-al development approaches to curriculum and pedagogy across various art modalities and academic disciplines with examples from the perspectives of higher education professionals. While these approaches integrate disciplinary methods with arts methods to train teachers in specific art forms as they relate to other academic disciplines, each addresses a different scope of content and reaches a unique population, ranging from regional to international.

The ability to work across disciplines integrating complex and abstract ideas remains a challenge for many academics doing this work. Another challenge is that certain areas of the arts, such as folk art, have been marginalized from the mainstream conversations involving the arts in learning. As well, special student populations, those with different abilities, cultures, languages, and gender orientations, continue to suffer marginalization within schools. Thus, those seeking to engage in professional development in arts integration will most likely encounter challenges to inclusion and interdisci-plinarity. The approaches these authors have used can serve as examples of the benefits of encountering and overcoming these challenges.

In Chapter 11, Marshall describes the importance of institutional team-work in creating an arts-integrated program for the San Francisco Unified School District: Science, Literacy and Art iNtegration in the Twenty-first century (*SLANT*), an ambitious partnership among science and art museums, a school district, and a university. This partnership approach was characterized by a strong, committed, and active core team composed of education specialists from member institutions. A central component of the program was a strong theoretical foundation grounded in the concept that arts integration is *transdisciplinary*. Another component of this approach is sustained professional development over the course of a year with teachers in partnership with the artists, scientists, and educators. All of them used a research workbook modeled on scientific field journals that crossed over into the realm of visual art when, through its combination of visual and verbal expression, the journal became a work of "information

art." Since this approach to arts integration has been adopted by the school district, it has lost some of its unique qualities, an ongoing issue for sustaining arts-integration partnerships, but the work of the many educators and museum staff who were trained in the *SLANT* approach continues to grow through the partner institutions' continued teamwork.

Bradley and McGreevy-Nichols, in Chapter 12, introduce an approach for online professional development for arts integration designed by the National Dance Education Organization (NDEO) to advance dance education centered in the arts. NDEO sees dance as a core subject area in and of itself, as well as a form of literacy and area of study with rich possibilities for integration with social studies, science, and literature. To support the professional development of general classroom teachers and the dance specialists in dance integration strategies, NDEO has designed coursework offered through their Online Professional Development Institute (OPDI). By offering dance education professional development online, OPDI makes it accessible to all dance educators who might otherwise have limited exposure to quality teacher training in dance education.

In Chapter 13, Dean and Sweeting suggest that engaging students in learning folk dances of different cultures constitutes a unique approach for arts integration in pre-K–12 schools. They describe the role of folk dance in the Integrated Teacher Education Program at California State University–Northridge, in which faculty in the Departments of Kinesiology and Elementary Education, Liberal Studies, and Arts, Media and Communication collaborate to prepare teacher education students in arts integration. Aligning the visual and performing arts courses with the California Visual and Performing Arts Framework and State Academic Content prepares students to transform learning in schools through arts integration. However, the challenge remains for these teacher candidates as they enter public schools for their practical experiences and discover that principals and teachers do not share their value for arts integration.

Elaine Bernstorf, in Chapter 14, chronicles the unique evolution of arts integration in Kansas at Wichita State University and the communities they serve. She relates the history from the pioneering work of integrating the arts in programs designed to meet the special needs of young children to adults in the 1950s to the current movement integrating the arts across various education and therapeutic professional education programs. Focusing on students and clients with specials needs, professional artists, arts educators, and arts therapists collaborated with community agencies to develop programs to serve this special population. Their efforts have resulted in creative approaches to arts integration that work for all learners and clients. Implications for policy include support for the development of public and private partnerships in education and health services that draw upon the expertise of artists in designing programs that integrate the arts in education and health services.

SLANT

Professional Development
in Science and Arts Integration

Julia Marshall

How do we integrate art and academic disciplines in a way that builds deep understanding of all domains? How do we educate teachers to practice a more substantive approach to arts integration? These are questions that the Art Education Department at San Francisco State University grapples with as part of its ongoing effort to clarify, deepen, and implement its approach to arts integration. One strategy for addressing these questions is to link up with outside experts. In our case, our department regularly partners with local school districts and cultural institutions to expand our knowledge and practices, and to develop arts-integrated programs. In the collaboration discussed here, we came together with the San Francisco Unified School District (SFUSD) to work with the California Academy of Sciences and the de Young Museum, two premier museums in San Francisco, one of the natural sciences and the other of the visual arts. The result of this collaboration was Science, Literacy and Art iNtegration in the Twenty-first century (*SLANT*), a professional development program that was a platform for exploring the connections between contemporary art and science and creating innovative ways to integrate and teach them. Sited in these two museums, *SLANT* employed museum collections as catalysts and resources for curriculum, and contemporary visual and performing art as models for creative strategies for arts integration.

We started *SLANT* with this basic premise: The arts and sciences are continuously evolving. Therefore, to understand them and to teach them in a viable, integrated, and substantive way, we must develop in teachers a disposition of curiosity and openness to new information and changing perspectives and practices. We must also consider the arts and sciences as areas of inquiry that have much in common but are also quite different. Last, we

must develop teaching strategies that foster and embody openness, flexibility, and curiosity in students. This is why *SLANT* drew on experienced scholars associated with the museums while helping teachers to conduct their own cross-disciplinary research, encouraging them to explore current horizons of science and art, and preparing them to generate their own ways of teaching the two domains in integrated and innovative ways.

SLANT also addressed the goals of the SFUSD by doing three things: (1) making explicit connections to the Core Academic Curriculum Content Standards, (2) promoting equity and access by providing teacher-created models for Special Education (SPED) Inclusion and English language learners, and (3) offering support for professional learning communities. This increased educator confidence and ability to teach science and art content, processes, and skills, enabling them to make science and the arts accessible to all learners. These direct connections to school priorities made *SLANT* particularly valuable for teachers and school administrators.

SLANT TEAM ACTIVITIES

SLANT programming consisted of a weeklong summer institute for cohorts of up to 40 teachers followed by four workshops during the academic year, ongoing in-class coaching and support, and a year-end symposium for sharing ideas, research, and curriculum. Venues for these workshops and symposia rotated among the California Academy of Sciences, the de Young Museum, and various schools and facilities of the San Francisco Unified School District. Symposia took place in summer and late spring. Workshops were held on weekends and school districtwide professional development days. Coaching was carried out by SFUSD curriculum specialists and occurred throughout the school year. Evaluation of the program was conducted yearly through teacher questionnaires and reflections. This yearly evaluation, along with continuous contact with, and feedback from, teachers, allowed the *SLANT* team to monitor teacher progress and address their needs and challenges on an ongoing basis.

As for our department's contribution, San Francisco State University faculty led a team of professional development specialists from the collaborating institutions to develop *SLANT*'s conceptual framework, content, and programs. Our faculty also contributed the theoretical grounding, program ideas, and examples of contemporary art, and models for integrated curricula to symposia and workshops throughout the year.

The program was sustained by grants from various foundations and institutions, education programming funds of the de Young Museum and the California Academy of Sciences, and the San Francisco Unified School District, which also provided one full-time and one half-time position.

ATTRIBUTES OF *SLANT*

Organization and Outreach

SLANT was a model of institutional teamwork; it represented an ambitious partnership among science and art museums, a school district, and a university. This model was characterized by a strong, committed, and active core team composed of education specialists from member institutions. Beyond the core team, *SLANT* also engaged education specialists and resources from a wide range of Bay Area cultural institutions, such as the San Francisco Museum of Modern Art, the Oakland Museum of California, the Institute for the Study of Knowledge Management in Education (ISKME), and the Hearst Museum of Anthropology at the University of California–Berkeley. *SLANT* also sponsored a series of meetings of these organizations, and, therefore, was the catalyst and hub of a Bay Area–wide initiative to promote and strengthen arts integration in schools and museums.

Theoretical Foundation and Framework

SLANT also provided an example for developing practical, innovative arts-integrated curricula based on the significant ideas and issues underlying current art and science. This attention to what matters aligned *SLANT* curriculum with the Next Generation Science Standards, which emphasize cross-cutting concepts and big ideas, and it also directly linked *SLANT* to the conceptual orientation and social engagement of much contemporary art. Furthermore, the program had a strong theoretical foundation grounded in the concept that arts integration is *transdisciplinary*. Designating integration as transdisciplinary connotes four important characteristics of arts integration: (1) it has an overarching conceptual framework that gives it coherence, (2) it emphasizes research, (3) it has a singular epistemology, and (4) it works through interstitial practices (Klein, 2000). In the case of science/art integration at *SLANT*, the overarching conceptual framework emphasized thinking systemically to promote complex thinking and deep understanding of all disciplines. Also, the framework characterized the sciences and the arts as modes of inquiry: ways of learning content in an exploratory, open-ended way while developing thinking, creativity, and research skills. Moreover, research in *SLANT* meant exploration of significant ideas and information through the critical, imaginative, and playful lenses of art and science. In regard to epistemology, *SLANT* aimed to construct knowledge through inquiry-based integrative projects and thinking, and this knowledge covered discipline-specific knowledge as well as concepts, practices, and creative strategies that science and the arts have in common. That is to say, *SLANT* emphasized creative thinking, experimentation,

exploration, play, and making as ways to build understandings of academic topics and ideas. Invention and fantasy based on observation and analysis were encouraged as vehicles for going deeper into the meaning of things being studied. This creative inquiry was carried out through interstitial practices, which in *SLANT* were methods and processes from art and science that were hybridized and adapted to teaching and learning.

Content, Procedures, and Tools

SLANT also identified and highlighted creative strategies used by scientists and artists. These strategies include making associations and metaphors; juxtaposing, re-contextualizing, and re-framing content and ideas; presenting ideas and content through art and scientific formats and tropes; and envisioning what is possible or projecting beyond the given (Marshall & Donahue, 2014). These strategies are often most overtly visible in contemporary visual art, which openly crosses disciplinary borders by addressing topics and using methods and forms usually associated with the academic disciplines. These integrative artworks provided models of making meaning for integrated classroom projects in *SLANT*. Artists such as Mark Dion, Amy Youngs, Nathalie Miebach, and Do Ho Suh were introduced as exemplars, not for their styles, techniques, materials, or subject matter, but primarily for the creative strategies they use to make meaning or change perspectives on topics. With this emphasis on strategy, students did not mimic the formal qualities or techniques of artworks, but employed the conceptual strategies artists use to generate and convey ideas. Teachers were also encouraged to use these creative conceptual strategies in developing their own integrated curricula and teaching methods. Here *SLANT* touched on pedagogy as creative practice with strategies and forms inspired by arts and science.

Innovative procedures for educating teachers were also a core component of *SLANT*. In *SLANT*'s third year, teachers made and used research workbooks that chronicled their inquiry into academic content, contemporary art, new pedagogical practices in arts integration; their teaching and art-making experiments and projects; and student learning and responses to integrated lessons. The research workbook is a learning tool taken from visual-art-based research in fields such as education, psychology, and the social sciences that is now being adapted to classrooms (Marshall & D'Adamo, 2011). In *SLANT*, the research workbook was modeled on scientific field journals and crossed over into the realm of visual art when, through its combination of visual and verbal expression, the journal became a work of "information art."

Students in *SLANT* classrooms also made research workbooks as tools for learning across the curriculum. With their combination of visual imagery and written explanations, reflections, project plans, and projections,

these workbooks were used to promote learning of art and science while fostering language acquisition and development. They also became chronicles of learning and thinking over time that allowed teachers and students alike to reflect on what and how they learned and how it all fit together.

MULTIDIMENSIONAL LEARNING

We believe that *SLANT* was significant in the depth of integration it cultivated. Students and teachers explored, compared, and contrasted the arts and science on four levels. These levels align with the four dimensions of understanding delineated by Veronica Boix Mansilla and Howard Gardner (1998). They include the purposes (motives and rationales) of art and science, the knowledge (topics and concepts) that the domains share, the methods (thinking, modes of inquiry and interpretation) employed, and the forms they construct to demonstrate and communicate their understandings. That is to say, students and teachers explored science and the arts on all four levels: they addressed essential questions and motives behind art and science; they explored and compared content of the fields; they compared, contrasted, and used methods of the arts and science to do science and create artworks; and they employed forms from the arts and science to convey meaning. This *multidimensional* approach generated *substantive* integrated curriculum that built both understanding of academic content and comprehensive learning about disciplinary intent and practices.

One primary goal of *SLANT* was for students to become aware of their thinking and learning and for teachers to formulate a metacognitive approach to developing curriculum. The other primary goal of *SLANT* was to have both groups understand themselves as researchers who cross over disciplinary boundaries to acquire deep and broad knowledge of the arts and science, and to develop imaginative ways to express and use that knowledge. We believe that the outcomes of these paired goals comprise the core of literacy in science and the arts, and, therefore, should be the aim of art and science integration for both students and teachers. In the four years of *SLANT*, we found these to be ambitious but worthy goals that take time, practice, and institutionalization to fully realize.

AN EXAMPLE OF PROFESSIONAL DEVELOPMENT CURRICULUM

What did a typical *SLANT* curriculum look like? *SLANT* projects were often extended investigations of a concept through multiple art forms using scientific and artistic methods and reflective writing. One example was the Islands Project, which was done over a four-day period at one of *SLANT*'s summer institutes. In this project, teachers invented islands and explored

their islands through the lenses of art and science, and they followed a trail of inquiry that built learning of academic content upon a base of invention and fantasy.

The work began at the California Academy of Sciences with an exercise in scientific process: an inquiry activity of guessing, investigating, and mapping the contents of "mystery tubes"—tubes full of unknown items from the academy collection. Teachers then moved outside to explore earth and life science through interpreting geological forces, weather patterns, and living systems through movement and dance. From there, at the de Young Museum, participants investigated how visual artists respond to landscapes and landforms by looking at three-dimensional topography sculptures by Maya Lin and various illustrated maps from the de Young collection. Returning to the Academy of Sciences, teachers investigated real models for their fantasy islands: the Galapagos Islands and Madagascar. Prepared with lots of background knowledge of island geology, climate, flora, and fauna, teachers then divided into groups and created fantasy islands. This involved construction of island landscapes in clay and then writing short narratives about the climate and topography of the islands and their ecosystems. In this phase of the project, teachers practiced the creative strategies of projection and elaboration, spinning new information based on scientific facts in the context of something imaginary.

The concept of migration was the next topic of study. For this, teachers viewed a video of bird migrations to and from the Farallon Islands, two landforms off the coast of San Francisco. A study of animal adaptation followed, and teachers were encouraged to make connections between animal migration and adaptation to new environments and human immigration and adjustment to new cultures. Analogy is creative strategy used in both art and science. Taking the association further, migrant birds became metaphors for immigrants who not only adapt to new environments but also change those environments. Metaphor is a premier creative strategy in the arts, and scientists often use metaphor to conceptualize and make sense of their findings and theories (Derry, 1999). Metaphor in science, describing a phenomenon in terms of something previously known, helps both laypeople and scientists understand what would otherwise be incomprehensible. Picturing atoms as tiny solar systems is one example of this. Metaphor in art has a similar function: It anchors abstract concepts and feelings to something known and tangible. Metaphor is, therefore, a powerful cross-disciplinary strategy for developing understanding.

In the final phase of the project, teachers moved into the realm of the social sciences when they developed a civilization for their islands and constructed cities, roads, and other infrastructure on their clay landscapes. The project ended with teams mapping their islands, further developing and illustrating the culture they invented. In this phase, they designed cities,

developed architecture, designated a belief system, developed an economy, and otherwise created a human ecosystem for their islands. Here, teacher teams used the creative strategy of mapping, a version of formatting, to develop ideas and stories. Mapping is a principal strategy in art and science that both domains use to make concepts, relationships, and information visible. This last phase of the project also involved descriptive ethnographic writing about the island cultures. In this final step, teachers once again elaborated and projected to create new information and ideas.

The islands project was one of many examples of *SLANT* curriculum that demonstrated seamless integration of scientific and artistic inquiry, thinking, and interpretation. Perhaps its most salient qualities were the way fantasy was intertwined with facts and became the platform on which further investigation was conducted, how multiple art forms (dance and visual art) facilitated learning, and how learning was reinforced and extended through creative strategies and means such as creative descriptive writing. Above all, this project was an example of how one investigation leads to another to allow ideas, methods, and information to build on one another. Teachers wholeheartedly embraced it, and it provided a template for their curriculum trail development in other content areas.

WHAT WE LEARNED FROM *SLANT*

Over the four-year lifespan of *SLANT*, we gathered valuable insights. First, a yearlong program with multiple sequential workshops works well. Program strength depends on well-spaced meetings that build upon one another; this generates momentum and progress. Second, the program benefits from organizing participants into cohorts of 30 to 40 teachers who work together over an entire year. This ongoing engagement helps teachers to weather the inevitable challenges to arts integration, such as making time for art-making and inquiry-based projects, and justify this approach to administrators. It also allows for the sharing of ideas, problems, and solutions. This keeps teachers inspired and engaged.

Third, it is advisable to maintain close relationships with "graduates" by inviting them to coach new cohort members and present their post-program work at institutes. When graduates return with their latest work, current participants see how what they learn in *SLANT* can grow and develop after they graduate. Above all, yearlong cohorts and graduate participation help to construct a vital, sustainable community of learners, which again promotes teacher engagement and resilience. Fourth, it is essential to have a strong unified core team of "consultant collaborators" that works together on a regular basis, continually pushes the program to innovate and dig deeper into content and practice, and takes responsibility for implementing the program. One or

two people, who organize and choreograph institutes and workshops, should anchor this team.

Finally, program success depends on consistency and coherence, which are a consequence of having a solid theoretical foundation and a guiding pedagogical framework. For our pedagogical frame, we used a modified version of the Teaching for Understanding Framework (Wiske, 1998). This provided a common vocabulary and a practical, coherent structure within which to develop curriculum ideas, procedures, and assessment. Our theoretical basis described above brought conceptual coherence to the program. We believe that *SLANT's* focus on substantive, multidimensional art integration that is grounded in the contemporary arts, creativity, and scientific thinking and practices; its emphasis on the arts and science as related areas of inquiry; and its vision of students and teacher as researchers together provided the conceptual grounding that not only gave coherence to the program, but also made *SLANT* an exemplary professional development program.

TRANSITION

Sustaining a program such as *SLANT* is a challenge. Perhaps the biggest hazard for *SLANT* and programs like it is change in school district personnel and priorities. A couple years ago *SLANT* was folded into the San Francisco School District STEAM program. With this merger, many of the qualities that made *SLANT* distinctive and noteworthy are no longer officially part of the district's professional development programs. However, they are still alive in the work of *SLANT* graduates and the community they established through *SLANT.*

SLANT's influence is also evident in another of San Francisco State University's community outreach projects: our collaboration with the Integrated Learning Specialist Program (ILSP) of the Alameda County Office of Education (ACOE). The ILSP provides certification in integrated learning through the arts with a series of professional development courses for teachers, teaching-artists, administrators, and other educators across the San Francisco Bay Area. This program represents a broadening of the *SLANT* approach. It merges the ideas, practices, depth, and quality of *SLANT's* model of arts integration with a focus on culturally responsive teaching and learning. In ILSP, *SLANT's* example has found a supportive and stable home where it is enthusiastically supported by school administrators and buttressed by a Bay Area–wide network of arts and educational organizations and institutions, including science and art museums. This support, we find, is key to growing and sustaining innovative programs in arts integration.

CONCLUSIONS

Why should colleges and institutions reach out to their communities and constituents? What is to be learned? What is to be accomplished? We find at San Francisco State University that collaborating with local cultural institutions and school districts is critical for all involved. For San Francisco State University, our collaborations including *SLANT* have influenced our teacher preparation programs and made them credible. From science museums, such as the California Academy of Sciences and the Exploratorium, our program continually learns about contemporary practices and understandings in the natural sciences; from art museums, such as the de Young and the San Francisco Museum of Modern Art, we learn about new art and how it is showcased and theorized; from schools in San Francisco and the East Bay, we get direct experience with the needs and practices of teachers. All of this directly shapes our teacher preparation curriculum, keeping it current, realistic, viable, and relevant.

Our collaboration with outside institutions is a two-way street, of course. In return, our San Francisco State faculty provides theoretical and pedagogical guidance to schools and museums. We also help to bring a theoretical framework to our collaborations. While programs such as *SLANT* may come and go, the understandings developed in them remain. The San Francisco State Art Education program promotes and builds on the *SLANT* experience and, in that way, we act as stewards of its legacy. Ultimately, *SLANT* provided a laboratory for the cornerstone of arts integration across the Bay Area. Our goal is to expand its influence and make sure its wisdom makes a difference.

REFERENCES

Derry, G. (1999). *What science is and how it works*. Princeton, NJ: Princeton University Press.

Klein, J. T. (2000). Voices of Royaumont. In M. Somerville & D. Rapport (Eds.), *Transdisciplinarity: Recreating integrated knowledge* (pp. 3–13). Oxford, UK: EOLSS.

Mansilla, V. B., & Gardner, H. (1998). What are the qualities of understanding? In M. Wiske (Ed.), *Teaching for understanding: Linking theory to practice* (pp. 161–196). San Francisco, CA: Jossey Bass.

Marshall, J., & D'Adamo, K. (2011). Art practice as research in the classroom: A new paradigm in art education. *Art Education, 64*(5), 12–18.

Marshall, J., & Donahue, D. (2014). *Art-centered learning across the curriculum: Integrating contemporary art into secondary school classroom*. New York, NY: Teachers College Press.

Wiske, M. (1998). What is teaching for understanding? In M. Wiske (Ed.), *Teaching for understanding: Linking theory to practice* (pp. 61–86). San Francisco, CA: Jossey Bass.

Dance Literacy
A Pathway to Arts Integration

Karen Bradley and Susan McGreevy-Nichols

The very word *literacy* has been expanded in both meaning and context in recent years. Artistic literacy is defined in the Conceptual Framework for the National Core Arts Standards as

> the knowledge and understanding required to participate authentically in the arts. Fluency in the language(s) of the arts is the ability to create, perform/produce/ present, respond, and connect through symbolic and metaphoric forms that are unique to the arts; it is embodied in specific philosophical foundations and life-long goals that enable an artistically literate person to transfer arts knowledge, skills, and capacities to other subjects, settings, and contexts. (National Coalition for Core Arts Standards, 2014)

This document goes on to explain that

> While individuals can learn *about* dance, media, music, theatre, and visual arts through reading print texts, artistic *literacy* requires that they engage in artistic creation processes directly through the use of appropriate materials (such as charcoal or paint or clay, musical instruments and scores, digital and mechanical apparatuses, light boards, and the actual human body) and in appropriate spaces (concert halls, stages, dance rehearsal spaces, arts studios and computer labs). For authentic practice to occur in arts classrooms, teachers and students must participate fully and jointly in activities where they can exercise the creative practices of imagine, investigate, construct, and reflect as unique beings committed to giving meaning to their experiences. In our increasingly multi-media age, where information is communicated less through numeracy and the written word, these meta-cognitive activities are critical to student learning and achievement across the arts and other academic disciplines. (National Coalition for Core Arts Standards, 2014)

In the field of dance, in addition to the many written texts and articles on the subject, the expansion has included designations such as notation, analysis, reflections on practices, qualitative research, advocacy materials, video with commentary and markup, motion capture and analysis, and more that is yet to come. Being articulate *about* dance, in addition to being articulate *in* dance, has become increasingly important. Such skills have been bolstered by interactive technological developments. Online access through the Internet has contributed to the evolution of what is considered the literature of dance as much as it has contributed to the dissemination of dance. It is now possible to teach dance history, for example, using YouTube to access previously inaccessible historical works. It is possible to show dance students critical reviews of early dance works from the front of the classroom. And it is possible to find online interviews with experts and demonstrations of cultural dances from previously unavailable areas around the globe.

These developments have contributed to educators seeing dance as a core subject area in and of itself, and to seeing dance within the context of human endeavors: as social studies, as science, as literature, and as a form of literacy.

THE PRIMACY OF MOVEMENT

We learn to walk by falling. We learn to think by acting. Human processes, indeed human intelligence, derive from enacting and interacting with the world through movement.

The cognitive scientist Daniel Wolpert (2011) understands that the purpose of our brains is not mere cognition, but to "produce adaptable and complex movements." In a TED Talk he states: "Movement is the only way you have to affect the world around you—except for sweating—everything else involves the contraction of muscles." Sensory memory and cognitive processes are brain-based, but according to Wolpert, these only exist to "drive or suppress future movement" (Wolpert, 2011).

All children, no matter what their circumstances, are resilient and voracious learners. They do not think categorically, or even in a linear cause-and-effect mindset.

Recent research, such as that of Grabmeier (2014), suggests that children do not categorize information, observations, or objects in the same way that adults do. They are far more likely to observe salient characteristics, especially movement, for example, in a dog or a toy, and to interact with the movement than they are to label the object and interact with it as an adult would. Observe any child watching a miniature train set, or meeting a new pet, and the above is obvious. Objects are to be played with, not named. Objects are to be learned from, not categorized.

The role of viscera—of organs, muscles, blood, bones, and the rest—in movement and therefore, subsequently, thinking and communicating, is not simple, is not merely functional, nor is it merely expressive. Movement is integrative of all human functioning, and it is also generative of those functions. And so dance is both generative of itself, as creative and physical practice, as it becomes a specialized modality for embodied learning. In this way, dance is essential arts integration and a necessary component for learning across disciplines, modalities, and developmental stages.

Ann Dils (2008) writes about the images dance creates through metaphor on the blog Dance Dialogues: Conversations Across Cultures, Artforms and Practices:

> At its boldest, then, dance literacy reconfigures the dance curriculum as a set of interconnected knowledges through which we understand the body and movement, how these operate in various dance traditions, and what meanings they might hold for us as individuals and societies. As an activity in which people participate as doers and observers, dance conceived of as a literacy might spill over into many subject areas with any number of outcomes: individual physical, creative, and intellectual accomplishment; improved problem solving skills in individual and group settings; improved observation and writing skills; critical understanding of the body and dance as social constructs; social integration; historical and cultural understanding; and sensual, critical, intellectual, and imaginative engagement. Dance underscores the importance of bodily experience as an integrative agent in all learning.

To illustrate Dils's statement, we look at the research included in "Basic Reading Through Dance Program: The Impact on First-Grade Students' Basic Reading Skills" (McMahon, 2003). In this study, 328 1st-grade students from six Chicago public schools participated in a 20-session, curriculum-based reading intervention program consisting of dance-based movement activities, including letter shapes, sounds, and word dances. An additional 393 students from nine schools served as the control group. The program was designed to improve reading skills, as assessed by the PhonoGraphix Test, such as code knowledge (alphabet sounds) and phoneme segmentation (separating letter sounds within spoken words). Results suggest that the students who participated in the dance program improved significantly more than control students on all reading skills that were assessed.

Other studies have utilized dance notation to teach not only literacy skills, but to give preliterate students an understanding of storytelling and phrasing, and to empower them to create, using the building blocks of creative movement. Students interpret poetry through dance, imagine outcomes to problems through dance, and claim their dances through critical reflection and preservation via notation or motif. The effects of this engaged,

embodied, and literate learning include an increased ability to think abstractly, a freer fluency of ideas, and increased self-efficacy.

NATIONAL DANCE EDUCATION ORGANIZATION'S APPROACH

The National Dance Education Organization (NDEO), a nonprofit member service organization, is dedicated to advancing dance education centered in the arts. NDEO's approach to integration is philosophical rather than based on a specific model. NDEO believes that integrating dance across the curriculum is an effective tool for students and provides a way to expand the reach and respect for dance education. Arts integration also increases dance literacy, despite a concern many arts specialists have (including dance specialists) that arts integration will result in lost jobs and that the art form as a discrete discipline will be supplanted in schools. At NDEO we believe and support the idea that integration offers one way that students experience dance in a school. And we believe that all students benefit from the guidance of a certified dance educator, whether the dance experience takes place in a discrete dance class or an arts-integration setting, as referenced in the National Core Arts (Dance) Standards (National Coalition for Core Arts Standards, 2014).

The best recipe for a balanced dance education starts with a dance educator teaching discrete dance content, supported by a classroom teacher who integrates dance and the other arts through their curriculum. Add to that experience dance teaching-artists and dance companies from the community who provide curriculum enhancements, in both the dance and general classroom. In addition, offer students effective and engaging afterschool programming. The synergy created by these three components of comprehensive dance education—certified dance specialist, classroom teacher, and community-based dancers/dance companies—provides an effective balance for quality dance education and builds a basis for ongoing support of deep learning in and through dance.

This philosophical foundation is supported by research such as the aforementioned studies and creates a strong rationale for the use of dance integration strategies in both the general classroom and in the dance studio. Dance integration is therefore an important offering within NDEO's Online Professional Development Institute (OPDI).

The Online Professional Development Institute (OPDI), a program for dance educators offered by the NDEO, includes a broad range of online dance education courses featuring standards, teaching methods, pedagogy, history, assessments, research, and more. OPDI offers dance educators from across the nation the opportunity to experience in-depth learning with leading experts in the field, something only possible through the online format. OPDI has the ability to affect millions of children in the United States who

have the right to study dance from a highly qualified dance educator trained in standards-based, graduated, sequential, and age-appropriate curriculum. OPDI serves the depth and breadth of our members specifically: dance educators/teaching-artists in studios and private schools of dance, community settings, K–12 teachers, and those in higher education.

The NDEO Online Professional Development Institute helps dance educators and teaching-artists to accomplish the following:

1. Access affordable, quality online coursework taught by national leaders in the field of dance through asynchronous learning in which they learn in their own time frame.
2. Acquire the teaching skills and knowledge necessary to become an accomplished dance educator.
3. Become a part of a Professional Learning Community (PLC) dedicated to professional growth that reduces their sense of isolation.
4. Understand and implement best practices supported by current research.
5. Receive professional development points, certificates of course completion, and Continuing Education Units (CEU) that may assist them in retaining current certification or credentialing, elevate status and credibility, or achieve a pay raise.
6. Receive undergraduate and graduate credit on selected courses from the University of North Carolina–Greensboro (UNCG). UNCG has also opened selected courses to their dance majors, one of these being Creative Process for Dance Integration.

The OPDI has two courses that specifically address arts integration: Creative Process for Dance Integration and Introduction to Dance Education Theory and Practice. Creative Process for Dance Integration is a 12-module online course that approaches arts integration through the artistic processes of creating, performing, responding, and connecting. The creating process drives the performing, responding, and connecting as participants use text as the inspiration for original movement and choreography. While creating, the participants reflect on and provide feedback on their own work and that of their peers (responding) and share their works in a variety of ways (performing). The text provides non-arts content knowledge that is explored and deepened through the dance-making process. The processes support higher-order thinking, creativity, collaboration, and communication. The result is a deeper understanding of both dance ELA and other content (connecting). It is important to note that the processes, creating, performing, responding, and connecting, provide the framework for the National Core Arts Standards (NCAS) that were developed in 2014, therefore making this approach effective in aligning with NCCAS (National Coalition for Core Arts Standards, 2014).

Choreographers, like all artists, create artworks (dances) from an inspiration (idea). Put simply, the choreographer transforms an inspiration into a series of "moving images" for the audience. Writers also create images for the reader. As readers read text, they see "pictures or images in their mind." These pictures/images can be brought to life through dance. Text can be effectively used as a source of inspiration for the creation of original movements and choreography.

When dance educators use text as the source of inspiration for their choreography, it reinforces reading comprehension and can motivate their students to read. Often, readers can read the words, but they do not derive meaning from these words. This process allows their students to explore the words, demonstrate their understanding, and substantiate it with evidence from the text; essentially, the dance becomes an assessment for reading comprehension. Because text is common to all disciplines, this can be a natural way to integrate learning across the curriculum.

The structure of the course provides relevant content in each of the 12 modules and assigns performance tasks that participants will complete.

For example, participants will have their students complete the following tasks:

- Create "moving definitions" for identified vocabulary words
- Practice using the literacy strategy "visualization" to source movement ideas
- Transform ideas into "moving images"
- Compose original dances from created movement using choreographic principles and structures
- Respond to draft works and provide feedback
- Revise choreography
- Perform finished works
- Demonstrate an understanding of the content/language of dance in context to the original dance works
- Unpack choreographic process while connecting to cognitive skills.

Participants will videotape their students and post the work online for feedback from the instructor and peers.

In a second course, Introduction to Dance Education Theory and Practice, two of the 12 modules address arts integration: Module 6 (Connecting Dance to Other Disciplines) and Module 10 (Working In and With the Community).

Module 6 emphasizes making connections from dance to other areas of study. Participants share their own experiences and writing about learning transfer. The approach to transfer involves serving the outcomes in each discipline utilized, so a conversation begins with a shared understanding that when using dance as a means to know and understand another concept

or piece of information, dance outcomes must also be achieved. Participants begin to create a framework for an approach to the field of learning studies that includes cognitive-kinesthetic and social-kinesthetic connections as a part of whole learning. Goals include the following:

- To begin to understand the systems at play in learning transfer
- To develop sources for discovering benchmarks, expectations, and learning outcomes in a number of subject areas
- To develop examples of lessons in which dance supports and is supported by learning in other disciplines
- To articulate an understanding of learning transfer that is comprehensive and contains core values of dance

Module 10 involves investigating how dance programs work with community groups and community issues. Participants hear and see inspiring words about the role of the arts in a civil society and view videos that illustrate how dance can amplify solutions to problems that members of communities share. They read about community-based dance practices and national service possibilities for dance. Participants also learn about funding for such projects and partnerships and how to advocate for space, projects, and budgets, among other challenges.

Goals include the following:

- To define community-based arts practices
- To become familiar with several programs in community-based arts
- To understand national service programs and how the arts (dance) can facilitate these
- To begin to develop a budget plan for a community partnership project

STRENGTHS AND CHALLENGES OF THIS APPROACH

As we consider whether our arts-integration approach is successful, we first reflect on the field of dance education and the current method of delivery. Dance education in the United States has many challenges. It suffers from a lack of qualified dance educators who are trained in standards-based, graduated, sequential, and age-appropriate curriculum. Credential, licensure, and certification requirements for K–12 educators differ from state to state because of state requirements, legislation policies, and funding. No current certification or licensure requirements exist in the private sector. Professional development and higher education degree programs for dance educators, where they exist, are often financially or logistically inaccessible to those who need them most. By offering dance education professional

development online, OPDI makes it accessible to all dance educators in the United States who have Internet access. These educators might otherwise have limited exposure to quality teacher training in dance education.

Even though courses such as Creative Process for Dance Integration and Introduction to Dance Education Theory and Practice were designed for K–12 teachers, dance educators from all sectors have embraced the content of the courses and have found ways to enhance their teaching programs through implementation of arts integration. This enhancement is reflected in the words of former participants in Creative Process for Dance Integration:

> The ability to expand my students' experiences in dance. Working in a private setting it was a wonderful opportunity for my students to expand their choreographic exploration. Many students reported this was so much fun! They have been sharing their experience with friends outside of the dance class setting inspiring new students to consider dancing because of their excitement. The hands-on opportunity was a wonderful learning process for me.

> I would highly recommend this course for private studio owners. It is a wonderful opportunity to explore new ways of developing choreography! The process stimulates students to think outside the box and expands their knowledge of how they can apply their technical training to the choreographic process. As a private sector educator it was a wonderful experience and it stimulated new pathways for developing dance movement.

The NDEO approach to dance integration professional development has been highly rated by the participants. One hundred percent of those surveyed in an end-of-course evaluation rated the course content as "excellent" or "good." Specific comments include the following:

> I used the class process as an opportunity to create an integrated project video for my personal portfolio. Taking my students through the process of finding a topic, researching the topic, creating movement phrases based on their research; all culminating in the choreography of a dance; was a rich and wonderful experience for my students and myself. They loved it and I loved it!

> This Dance Integration course was a critical step for me in deepening my understanding of the creative process. It helped me to see beyond my own process and find ways to broaden my perspective of the task of choreography; such an important element of teaching.

Many of our ongoing challenges center on the delivery of the courses, predominately focused on how often we are able to offer courses. Currently NDEO's OPDI has a menu of 26 courses that are rotated around three semesters, with only 5 to 7 courses offered per semester. Consequently, we do not have a preponderance of evaluative data on these courses. The OPDI program has grown continuously since its inception in 2012, but it still has far to go. NDEO is challenged by limited resources both in marketing (both financial and human) and in the ability to reach out to audiences beyond our membership. Although we have planned to reach out to classroom teachers, we have yet to target that audience. It is also important that we expand our audiences to decisionmakers such as principals and superintendents. We do plan to work with national partners such as the Association for Supervision and Curriculum Development (ASCD), the National Association of Elementary School Principals (NAESP), and the State Education Agency Directors of Arts Education (SEADAE) to help us reach out beyond our membership.

CONCLUSIONS AND RECOMMENDATIONS

Through the OPDI, NDEO is providing professional development that is supplemental to offerings in higher education, while delivering high-quality training to underserved constituents. Through these programs, a national-level conversation about best practices in K–12 dance education can develop. We can learn from those practicing in the field, since the implications are great, not only for school arts programs, but also for studio teaching practices, community-based dance programs, and potential programs that institutions of higher education might be offering in the future.

Through these collaborative conversations, literacy about dance, in dance, and through dance is increased. Dance can and will be found as a useful and inspirational learning tool for all subjects, including dance itself. Movement, the original and primary modality for making sense of the world of objects and human expression, can return to the classroom as the meaning-making, creative, global modality it is. Access to literacy through and in dance can therefore return us all to our human sensibilities and our moving bodies as the communicative, expressive, and physically skillful beings we are.

REFERENCES

Dils, A. (2008, July 13–18). Dance dialogues: Conversations across cultures, artforms and practices. Proceedings of the 2008 World Dance Alliance Global Summit. Retrieved from ausdance.org.au/articles/details/why-dance-literacy

Grabmeier, J. A. (2014). Immersed in violence: How 3-D gaming affects video game players. *Ohio State University News Room.* Retrieved from news.osu.edu/news/2014/10/19/%E2%80%8Bimmersed-in-violence-how-3-d-gaming-affects-video-game-players/

McMahon, D. S. (2003). Basic reading through dance program: The impact on first-grade students' basic reading skills. *Evaluation Review*, 104–125.

National Coalition for Core Arts Standards. (2014, February 12). National core arts standards: A conceptual framework for arts learning. Retrieved from www.nationalartsstandards.org/content/conceptual-framework

Wolpert, D. (2011). The real reason for brains. [TED Talk]. Retrieved from www.ted.com/talks/daniel_wolpert_the_real_reason_for_brains?

The Resonant Heartbeat

Folk Dance, Physical Literacy, and Arts Integration

Colleen Hearn Dean and Terry Sweeting

Figure 13.1. CSUN Students Perform the Popular Urban Folk Dance Hip-Hop

Photo by Lee Choo, CSUN Today

What else expresses a culture more colorfully than does folk dance? Like a proverbial heartbeat, it resonates a people's joys and tragedies, ethics and aesthetics. Its very nature connects with culture, and the discipline of folk dance accentuates the living pulse of arts integration within the core curriculum. Students discover their own heritage as well as the traditions of other cultures while becoming physically literate in the world around and beyond them.

Today, changing demographics in the United States continue to regenerate interest in folk dance. This chapter explores specific challenges and benefits of integrating folk dance into the curriculum in accordance with the lifelong efforts of master educators. We continue by examining innovative approaches for elementary teachers introduced by California State University–Northridge (CSUN) and the work of two CSUN graduates who successfully use comparable programs in their high schools. Discover how our specialists interrelate contemporary moves, traditional steps, storytelling, and even math and science to nurture physical literacy and social understanding, while engaging students and the community within an energetic arts-integrated curriculum.

DEFINING PHYSICAL LITERACY IN FOLK DANCE

According to health specialist Margaret Whitehead, a student who is physically literate "moves with poise, economy and confidence in a wide variety of physically challenging situations; and is perceptive in 'reading' all aspects of the physical environment, anticipating movement needs or possibilities and responding appropriately to these, with intelligence and imagination" (Whitehead, 2001). Dance is unique among the arts in that its focus on the body as the instrument of expression promotes physical health. Folk dance also develops physical literacy as the student awakens to form, pattern, and movement.

Folk dance is a physically creative discipline that reflects the traditional life within a community through steps based on aesthetics and purpose in execution. Folklorist and educator Paddy Bowman points out that since many dances are sacred within their cultures, teachers must be aware of context when introducing them to students. She adds, "This traditional dance is defined by its practitioners, not textbook publishers, and is dynamic, always changing" (personal communication, September 2012).

Folk dance may embrace social, international, or ethnic dance, because of its dynamic representation of diverse communities. It possesses more than one cultural purpose. It may dramatize an ancient tale or reflect current urban street dancing. For educator Kadidia V. Doumbia, an officer of Conseil International de la Danse-UNESCO (CID-UNESCO), folk dance represents a "way of living—a part of almost every culture on earth. It unites us in joy and sadness. It is through dance that generations are united. Dance has the power to create a common understanding that cultures can share throughout the world" (personal communication, August 2016). Dancers may tell a society's story by drawing on its humanities, music, visual art, and language. In the process, folk dance may reflect a universal theme.

FOLK DANCE IN EDUCATION

Throughout history, dance has been hailed as well as scorned, according to the mores of a particular society. In the early 20th century, renowned educators Luther Halsey Gulick and Elizabeth Burchenal campaigned to place folk dance within the American public school curriculum to preserve the American ideal of a physically fit society. They worried that immigrants were now so deeply assimilated within American society that they risked losing their identities and traditions. They believed that folk dance must be preserved because of the social and physical fitness benefits it provided for the community. Gulick, as director of physical education of the public schools of greater New York, and Burchenal, as athletics inspector for the New York City public schools, developed inclusive standards within the curriculum. By the 1930s advocates of Progressive Education and Intercultural Education promoted experiential community-based learning at both the K–12 and college levels from Maine to California.

Folk dancing thrived until the 1950s, when the discipline appeared to have dubious value in many schools. Bowman noted, "By this time, we routinely danced ersatz Maypole and square dances in P.E. that were taken out of some commercial text, but bore little resemblance to dances of yore" (personal communication, November 2012). To counter this negative trend, two dance specialists set out independently to restore authentic folk dance to the schools.

ON A MISSION—DANCING ON AN AXIS

Growing up in the 1960s, Frank Russel Ross learned several basic dances, such as the polka and a pseudo "Mexican Hat Dance," but he was not taught any African American dances that reflected his own heritage. When he asked why he was not learning these dances in school, he was informed, "Oh, you can just do those at home." It became his mission as a physical education teacher and administrator to introduce African American dances into the classroom. His *Soul Dancing: The Essential African American Cultural Dance Book* (Ross, 2010) provided effective ways of teaching these styles through his in-depth lesson plans.

Ross emphasizes styles that not only reflect their rich cultural traditions but also break through racial barriers. "Just examine the great black cultural dance of the Mardi Gras parading gloriously through New Orleans, the dramatic percussion of *Steppin'*, the syncopation of jazz, or the smooth moves of line dances—and what excitement when such icons as Lewis Neal and Leslie Mallory demonstrate the Hand [Swing] Dance!" He continues, "Hip Hop is folk dance as evidenced by its genesis in the inner cities, complete with distinguished attire and accompanying music, reflective of everyday life

and the need to express this culture, especially by our contemporary youth" (personal communication, August 2016). Rarely today are young people denied instruction in these dances in their schools.

Students and educators both greatly appreciate Ross's success in bringing African American folk dance into the schools. "Dear Mr. Ross," one student wrote him, "I used to not feel confident about myself and was ashamed of my impoverished background. . . . African American dance is important not just to the black community but to our huge American society, I now hold my head high and say, yes, this is *my* heritage—thank you!" (anonymous testimonial, May 2016).

A colleague who had been a student 40 years earlier has diligently followed Ross's progress in bringing these dances to the schools:

> I marvel at his [Ross's] commitment to the art form of dance and its cultural implications . . . I have witnessed the sheer joy and enthusiasm expressed by those of many backgrounds who have participated in his classes and I have had the pleasure of accompanying him to New York City and Baltimore where he has conducted workshops for the school districts. It must be noted that he has played a central role in the ongoing development of national hand dance champions. . . . His passion for this art form is unsurpassed. (Lincoln Scott, testimonial, May 2016)

Another folk dance legend, William C. (Billy) Burke, has taught across the curriculum in American public schools for over 35 years and has traveled internationally as a professional folk dancer. His classes successfully integrate the arts, both at his school and as part of the California Arts Project. The interrelationships of math, science, and social studies with folk dance serve as important components of his teaching. While conforming to the California State Core Standards for Dance, he has transformed the curriculum into one that also supports the development of students' physical literacy. He encourages students to expand their ideas of movement for its own sake, proclaiming how "traditional dance both affects and is affected by life's experience" (personal communication, August 2016).

Burke's program emphasizes folk dances that represent people, places, or times within their social context. The program includes a wide variety of routines that range from basics from cultures such as China, Liberia, and the Polynesian Islands, to more complex dances from Bulgaria to Mexico. In addition, students research the origins of these dances. As they advance in technique, they learn the "how" and "why" of achieving strength, flexibility, and discipline. Burke explains other cross-curricular connections:

> As in math, contra and circle dance formations create movement shapes and patterns. Credit is given for projects that go beyond

performing dances, such as designing posters with dance terms that demonstrate the physics of how couples rotate around an axis as they revolve around the dance floor which correlates to planetary motion rotating around an axis. Warm-ups, steps, and choreography intersperse with history, socio-economics, health, and science. (personal communication, August 2016)

The individual benefits of Burke's teaching methods are abundantly clear. Students who previously struggled in school are challenged by the very nature of the instruction to improve their studies. For example, one student (whose father insisted that the folk dance program "saved" his son) excelled academically and eventually joined an internationally known modern dance company. Another is now a master's student at San Francisco State and is dancing with an aerial group. Three other former students successfully revived the Folklorico program at Santa Monica College (Burke, personal communication, August 2016).

Both Burke's and Ross's approaches develop the children's physical health while nurturing an appreciation for many cultures along with their personal and social accomplishments. Recognizing the potential impact of dance on the health of the whole child, they recommend that more higher education institutions implement innovative teacher training programs that integrate folk dance within the K–12 curriculum. They insist that this can only be accomplished through mentors in higher education programs. Burke argues that "celebrating a culture through its music and dance enriches the head, heart, and soul. To do so in one's own culture is a duty, to do so in the culture of others is an honor" (personal communication, August 2016).

In reaction to this need, the Consortium of National Arts Education Associations published the National Standards for Arts Education that included an appreciation of multicultural dance (National Association for Music Education, 1994). Other state and national education organizations introduced revised benchmarks with continuing emphasis on folk dance as a valuable and unique contribution to the country's educational system. CID-UNESCO likewise recognizes internationally the "universal character [of dance] as an art form, as a means of education and as a research subject" (Doumbia, personal communication, August 2016). And universities such as California State University–Northridge have developed innovative programs to prepare our future educators to teach all forms of dance as arts-integrative learning.

Arts Integration in Elementary Teacher Training

Folk dance as an essential part of arts integration connects physical education and kinesiology within the liberal arts. The faculty in the Departments

of Kinesiology and Elementary Education, Liberal Studies and Arts, and Media and Communication at California State University–Northridge collaborated together to create the Integrated Teacher Education Program (ITEP) to foster these connections. ITEP is an undergraduate teacher preparation program toward a bachelor of arts degree in Liberal Studies and a Multiple Subject Teaching Credential. Physical literacy is a critical component of one of the specializations, the Interdisciplinary Arts Concentration. Each visual and performing arts course conforms to California Visual and Performing Arts Framework and State Academic Content Standards.

The ITEP dance courses instruct students in the meaning of folk/social dance through several lenses of inquiry. Students explore critical questions of alternative perspectives and develop inquiry skills to investigate the inherent links of folk dance to culture, history, continuity/time, and geography/space. What is learned through the creation, performance, and observation of folk dance from social perspectives is further examined in class. Students analyze their own experiences and the role of dance within the elementary school curriculum. They examine how it is an effective tool for English language learners. Physical literacy within folk dance is a cornerstone for cultural expression toward the development of active, healthy children.

The goal of the Interdisciplinary Arts Concentration that emphasizes pedagogical knowledge and skills is to equally integrate all the arts within the classroom. The program concludes with a capstone course in the final semester that challenges students to expand their awareness of the unique contribution of each art form by designing forms of instruction through a holistic approach. Students learn to integrate all four visual and performing arts along with literacy skills to construct a big theme or perspective within the K–5 curriculum. For three to four weeks, students devise learning segments with a specific art in mind and then build on these concepts during the semester by integrating each additional art form as co-equal in content. Each component contains multiple literacies: Ways of Knowing Through Dance (music, visual art, and theater); Arts Infusion: Crossing the Curriculum; Inquiry: Purposeful Planning with and Through the Arts; and Integrated Learning Segment: Connecting the Big Idea to the Content Standards.

Physical Education Model Content Standards for California Public Schools (California Department of Education, 2006) defines folk dance for every grade level. The ITEP dance courses instruct students in the meaning of folk/social dance through several lenses of inquiry. Students explore critical questions of alternative perspectives and develop inquiry skills to investigate the inherent links of folk dance to culture, history, continuity/time, and geography/space. What is learned through the creation, performance, and observation of folk dance from social perspectives is further examined in class. Students analyze their own experiences and the role of dance within the elementary school curriculum. They examine how it is an effective tool for English language learners. Physical literacy within folk dance is a

cornerstone for cultural expression and the development of active, healthy children.

Arts Integration in High School

Two stories of folk dance instruction designed for middle and high school students by experienced CSUN graduates illustrate well the themes and activities of integrating folk dance across the curriculum in other schools.

World Language Week. Lilia Kibraska has been teaching World Dance at the Sierra Canyon School for over 12 years. Born in Bulgaria, she grew up learning many local folk dances and now admits, "Cultural folk dance has always been fascinating to me and I never perceived its studies as challenging" (personal communication, August 2016). Her extensive training in folk dance extends from CSUN to the California Institute of the Arts. Fortunately, her current school community has strongly supported student performances as well as the expansion of her World Dance section within the curriculum.

> The World Dance section lasts three weeks and culminates with a performance in the opening ceremony for our World Language Week which celebrates the diverse cultures of the school community. I teach African, Bollywood, and Balinese dance. We begin the workshop by discussing the importance of dance in a particular society. We watch videos of other dances from that region and compare them to the one we are working on. During the performance the students introduce the piece with a few words about its cultural significance. The dancers wear costumes representing the specific culture. An example of my World Dance instruction is a folk piece called Yamama from the Susu group of West Africa. This is performed annually, by village women, to honor and to make requests of the spirit Yamama. After these performances parents express gratitude for helping their children grow as creative, responsible human beings. (personal testimonial, 2016)

American Urban Folk Dance and Storytelling. Another CSUN graduate teacher, Dana Fukagawa, is honored to tell her story. She considers how folk dance, especially American urban styles, may enter the curriculum of current events with arts-integrated lessons.

> While at CSUN I was introduced to many types of folk dancing: how to perform traditional folk dancing in the Creative Dance for Children course, viewing professional international dancing at concerts, and performing story-based movement. I now incorporate this type of

dance into my teaching with the approach that stories can create movement and movement can tell a story. When choreographing for my students, the dance is usually based on a story or intention.

One dance was based on the reactions that people had when they first heard about 9/11 on the news. The piece was performed to the U2 song "Sunday Bloody Sunday." Dancers at first sat on a couch, looking as if they were watching T.V. When the music started each dancer reacted as if just seeing the events unfolding on that fateful day. Movement was based on their initial emotions, their personal interpretation of their feelings when they heard the news.

Urban folk styles such as hip-hop were a natural way for them to react. Moments when they danced together acted as commentary that even in our darkest hour we could unite as a community. (testimonial, August 2016)

CHALLENGES AND RECOMMENDATIONS

Every art form, whether music, theater, visual arts, or dance, is a medium of expression, a vehicle for expanding the communication of diverse cultural history, traditions, and beliefs. Because many American children communicate primarily through social media on a global scale, K–12 schools and teacher education institutions must provide students with critical opportunities to develop rich artistic skills through global expression.

The arts battle ignorance by translating human experience into meaningful, relevant stories. Too often, however, arts education is dismissed as unimportant in its own right or as a means to understanding the world around us. Folk dance especially has been at the mercy of the shifting pendulum of curriculum priorities as it is moved to a lower position in many schools. Billy Burke explained that folk dance "had previously been a physical education requirement for developing motor skills and socialization. However, this and many of the other arts, were eventually pushed aside, labeled only as extracurricular and deemed unnecessary to some school systems" (personal communication, August 2016).

Advocates for arts education need to be recruited from professions in diverse communities, such as higher education faculty, folklorists, administrators, classroom generalists, and specialists in both the core curriculum and physical education. But most important of all for this mission to succeed, parents, students, and the whole community must push for arts-integrated learning in K–12 schools across the United States.

Unfortunately, student teachers who have successfully completed education in the arts are too often provided with few opportunities to teach integrated classes. It is necessary to identify competent university supervisors and master classroom teachers who are educated in, and value, arts

integration, especially with folk dance. Student field experiences vary according to how much principals, teachers, and supervisors value arts integration within the classroom. Artists and scholars who perform in public often prove to be not only strong arts advocates and collaborators with classroom teachers but also outstanding role models. For example, Frank Ross has advocated for years to place more African American cultural dance in schools at all grade levels. He strives to clarify how these dances, so richly steeped in American history, differ from African dance "in history, technique and skill set . . . African American cultural dance must be studied, (cultural, not vernacular) at the university level and properly implemented into the world of dance" (personal communication, August 2016).

Public health policymakers often serve as friends of the arts. Music, visual arts, theater, and dance have for years served as popular therapies for various disabilities, such as autism, eating disorders, and post-traumatic stress disorder. The Centers for Disease Control (CDC) maintains that moderate to vigorous activity is critical to the health of both children and adults (Centers for Disease Control, 2016). In folk dance, the body is the instrument of movement that engages all participants in rigorous, healthy activity. Many folk dances have a recognizable pattern that can be performed by large groups on school playgrounds or at other local gatherings.

BEYOND "BEST PRACTICE"

So, why should we advocate for folk dance, physical literacy, and arts integration in the curriculum? When taught by passionately committed teachers, folk dance transforms into a kinesthetic artistic form that embraces the themes of struggle and triumph, and emotional journeys reflecting real-life experiences. Whether portraying the Yamama spirit dance of West Africa, emerging hip-hop culture, or flourishing Latin dances in communities across the nation, folk dance honors the customs and aesthetics developed over generations. Folk dance teacher Billy Burke fondly recalled a remarkable note from a former student:

> I appreciate you! My parents do thank you and my kids are lucky I had you in my life. I know I am a better person because of Tanza [dance troupe], I remember wanting to be a part of that magic, that special circle where culture overflowed. (testimonial, August 2016)

This testimonial demonstrates how "multiple measures of mastery" within folk dance extend toward "the integration of community resources beyond school walls" (Partnership for 21st Century Skills, 2016).

Now more than ever, in a world of political unrest and violence, and in a technological age that often discourages our youth from healthy exercise

or direct social interaction, folk dance encourages teamwork as it relates to all disciplines across the curriculum. The bottom line is that folk dance *humanizes* us. Because students today come from many cultures and ethnicities, folk dance reflects the essence of our differences, and we experience the world in a healthy, physically literate way. We are all unique, yet we share a great deal within our resonant heartbeat.

Acknowledgments: The authors wish to thank all of those who contributed interviews, which brought life to our concepts, and especially Michael Patrick Hearn, whose editorial magic helped make the writing of two authors flow like one.

REFERENCES

California Department of Education. (2006). *Physical education model content standards for California public schools.* Retrieved from www.cde.ca.gov/be/st/ss/documents/pestandards.pdf

Centers for Disease Control. (2016). Physical activity. Retrieved from www.cdc.gov/physicalactivity

Consortium of National Arts Education. (1994). *National standards for arts education: What every young American should know and be able to do in the arts.* Reston, VA: Author.

National Association for Music Education. (1994). National standards for arts education. Retrieved from www.nafme.org/

Partnership for 21st Century Skills. (2016). The arts: Interdisciplinary themes. Retrieved from www.p21.org/storage/documents/P21_arts_map_final.pdf

Ross, F. R. (2010). *Soul dancing: The essential African American cultural dance book.* Reston, VA: National Dance Association.

Whitehead, M. (2001). The concept of physical literacy. *European Journal of Physical Education, 6,* 127–138.

Kansas
Pioneering Arts Integration

Elaine Bernstorf

Arts integration in Kansas is based on fostering authentic connections between and among arts– and non-arts–based disciplines through collaboration and cross-training to meet diverse human needs and develop common conceptual understandings. Kansas has a rich heritage of innovative programs integrating visual and performing arts with non-arts disciplines in educational and community settings. The history of these programs has not been one of a single comprehensive educational discipline entitled "arts integration"; rather, it reflects a patchwork of overlapping programs with shared visions. These programs reflect arts-based efforts at multidisciplinary learning and leading. They share values and visions in their efforts to accomplish the following:

1. Authentically represent and honor one or more arts disciplines.
2. Maintain the centrality of the art form(s) throughout the educational process.
3. Naturally integrate arts and non-arts disciplines to work across developmental and learning domains and to maximize each individual's growth, communication, and creativity.
4. Collaborate between and among experts, agencies, and locations to provide quality services targeted toward maximum accessibility across the region.

While this chapter introduces several of the Kansas programs, the focus will be placed on programs for individuals with special needs. Emphasis on these progressive programs will illustrate how they develop arts-integration approaches for special populations.

Two major concepts are important in this discussion. First, the concept of cross-training as integral to the development of arts integration in these programs is used to connote training (an employee) to do more than one specific job. In this chapter we will share approaches in which professionals

(artists, art therapists, arts educators, special education personnel, and administrators) were cross-trained to do better work. Second, the concept of integration is reflected in the development of shared discipline knowledge and skills by professionals. Involvement in, and knowledge of, both concepts were integral to the development of arts-integration offerings in Kansas. As these various arts-integration projects and programs developed, there have been many challenges that forced decisions and propelled growth. Some of the challenges included aligning varied methodologies related to the different arts disciplines; philosophical differences regarding educational, therapy and artistic goals; and potential gaps and overlaps in scope of practice. The result was change for the individual professionals and the programs they represented, and ultimately the expansion of arts-integration work with special populations. Such cross-disciplinary and multidisciplinary work is now the focus of research in many fields, both in the arts and in education and related therapies such as occupational, physical, and speech therapies. Overviews of this research have been published by audiologist Nina Kraus (Kraus, 2016; Kraus & White-Schwoch, 2016) and special education professor Alida Anderson (2015). Stuckey and Nobel (2010) described research on creative arts in physical therapy. A comprehensive view of arts-integration practices at research universities was published by Mackh (2015).

HISTORICAL PERSPECTIVES

The development of arts-integration programming in Kansas followed historical milestones, especially in the fields of special education and disability services. Each of these milestones included adaptive leadership and risk-taking by individuals who had a passion for the arts, but who focused their interests outside of personal artistic growth into a service orientation within their arts discipline.

As early as the 1950s, Kansas arts professionals recognized the value of arts for learning within and between disciplines. Several of the early initiatives that today would be termed "arts integration" developed in programs for children and adults with disabilities. Kansas is recognized for pioneering work in the fields of music therapy, art therapy, and special music education. Each of these important programs had unique ties to the arts. Initial training was fostered by state universities in cooperation with public schools and private agencies. Among these were the following forerunners:

- Music therapy outreach programs developed at the University of Kansas–Lawrence and University of Missouri–Kansas City use music to accomplish specific and often *integrated* educational and wellness goals.

- Special music education at Wichita State University began as a master's degree project in the 1960s by Betty Welsbacher. From its beginning, courses in the special music education program and summer workshops for teachers integrated art, drama, storytelling, and dance as an outgrowth of the *comprehensive musicianship* philosophy and the learning theories of Jerome Bruner.
- Art therapy programs at Emporia State University furthered arts-integration work with the Menninger clinic in Topeka and established art therapy as a degree program in 1972 (see the Robert Ault Archives for the Association of Art Therapy).

Arts integration is an umbrella term that seems to define this new community. After several decades, the community has expanded with overlapping programs and increased interest. Telling the stories of early settlers and innovators is a common way of inspiring continued growth in any community.

Developing Statewide Programs

Various forms of arts integration were natural outgrowths of university-sponsored programs designed to accommodate learners with special needs. Given the proximity of these programs in the state of Kansas, there was a history of both collaborative and divergent interactions. Differences in philosophy and practice over the role of the arts (art for art's sake versus art to change behavior) were often at the center of discussions, presentations, and writings. Over the years, professionals with various degrees from different disciplines found themselves working in the same communities and even in the same programs. Again, a natural inclination to foster success for individual clients, as well as the documentation provided by student Individual Education Plans (IEPs), led toward more and more opportunities for collaboration among and between the arts professionals, as well as with other service providers (speech, occupational, and physical therapists). The result was a strong move toward *arts integration* across the arts disciplines and across arts and non-arts learning and behavior goals.

Leaders in Kansas recognized the unique contributions of the varied university training programs and their importance to students in special education programs in the schools. In 1980, the Arts for the Handicapped program was initiated by the Kansas State Board of Education and was housed at the Board of Education in Topeka, KS (1980–1985). Over time, the state-supported program moved to several locations across the state. These changes in location brought both exposure and alignment with the already established music therapy, art therapy, and special music education programs. In an effort to coordinate and support these programs and reflect the broadening of arts-related services for persons with disabilities, Accessible Arts, Inc., was formed to replace the Arts for the Handicapped

program. As the founder William Freeman (1990) stated in the preface of Accessible Arts' first monograph:

> The Arts can be utilized to support learning in other academic subject areas as well. Integrating the arts in teaching subjects such as reading, history, science and math can result in improved comprehension, memory, and critical thinking skills, as well as improved verbal and non-verbal abilities. The arts provide opportunities for the total educational development of special needs children and build bridges fostering integration with their non-disabled peers. (p. 1)

One of the challenges the professionals faced was broadening their various skill sets while continuing to work within their traditional scopes of practice. In the early days of special education, arts educators provided services to most children in the school. Over time, Individual Education Plans (IEPs) began to include "related services" provided by music or art therapists.

Depending on the background of the arts professionals, the scope of practice might be about concept and skill development in the art form. Other professionals might use the art form therapeutically to facilitate behavioral changes or learning of other academic subjects. Since the vast majority of arts therapists did not have teaching licenses, they were not eligible to hold arts-teaching positions. Many school districts would not hire both arts educators and arts therapists, but they would hire arts educators who had the special music education emphasis and adaptive PE teachers, since they were educators who held PK–12 teaching licenses in addition to their specializations.

Over time, higher education professionals realized that the goals of all programs were to facilitate student growth and well-being. These professionals overcame their disciplinary positions and made concerted efforts to support one another's programs in order to provide arts experiences for all students. The challenge that had previously been about turf (maintaining scope of practice) became more about sharing effective practices in every discipline. The result was a heightened demand for professional development that would broaden the skills of all arts professionals. Soon the special education and classroom teachers understood that these arts professionals had a lot to offer, especially when they were allowed to develop integrated learning activities that crossed disciplines.

Exploration without Exploitation

During this same time period, from 1980–1990, the Wichita Art Museum (WAM) hosted yearly one-day festivals sponsored by Very Special Arts Kansas (VSAK) and co-supported by the Kansas Arts for the Handicapped program, and later by Accessible Arts, Inc. In the early years, groups of

students with severe disabilities performed for one another at the art museum and participated in art exhibits that were the model for the national VSA festivals.

During these events, arts teachers, arts therapists, special education teachers, and administrators worked together to support the special performers. According to post-event surveys of those involved, the ability to observe one another professionally and to talk together at the event consistently rated as the most valuable aspects of the festivals. As these specialists networked they realized that their professional foci were different, yet complementary. As they shared their expertise, the museum staff and the director of the state Arts for the Handicapped program realized an opportunity to provide professional development between and among the arts professionals and special education teachers of the regions.

As the programs developed over approximately 10 years (1980–1990), more emphasis began to be placed on professional development workshops that were held the day before the students came for their festival experiences. Instead of the more traditional VSAK festival where students performed for parents and guests at their assigned time on the festival day, students attended a half-day of experiential workshops with local, regional, and nationally recognized clinicians. Some of these clinicians were arts therapists, others were arts educators, others were special education teachers who had arts expertise, and still others were artists who had a special interest in working with disability populations. The modified program was uniquely suited to the needs of the community, with an emphasis on teacher training in the midst of client experiences. The goal was for teachers to experience in real time on Wednesday evening what their own students would experience in their half-day sessions on Thursday and Friday. Also, there were specific professional development materials provided, with a focused debrief after each teacher's experience. This allowed the teachers to be peer models for parallel learning as the clinicians worked with their students. A goal of each session was the *integration* of arts-concepts learning, educational themes, group dynamics experiences, and fun.

The program was not titled *arts integration*, but the format and delivery certainly demonstrated the current Kennedy Center definition of arts integration:

> Arts Integration is an APPROACH to TEACHING in which students construct and demonstrate UNDERSTANDING through an ART FORM. Students engage in a CREATIVE PROCESS which CONNECTS an art form and another subject area and meets EVOLVING OBJECTIVES in both. (Silverstein & Layne, 2010)

As inclusion service delivery models increased, regular education teachers began to attend the workshops with their students. The result

was development of more cross-training between and among artists, arts educators, arts therapists, special educators, and other service providers, along with general education teachers. Interdisciplinary programs with an arts focus showed results, and collaborations increased. Local professionals voiced a strong preference for interdisciplinary workshops where they could observe their students working with members of the arts-teaching workforce (in this case art therapists, artists-in-residence, and arts educators) who seemed to work magic using an integrated-arts approach. Over time, the effectiveness of the arts-integration professional development program became the primary focus of the festival events.

Expanding Collaboration

Over time the desire for additional expertise and for statewide collaboration for arts integration intensified. A pinnacle initiative in the continued development across the programs was the Kansas Arts Resource Training System (KARTS), begun in 1985. Freeman, who by then was executive director of Arts for the Handicapped, obtained a U.S. Department of Education training grant to fund the three-year training program. This program fostered cross-training between and among artists, arts educators, therapists, special education teachers, school administrators, and higher education faculty in principles of arts integration. In addition to the experts within the state, he was able to bring leaders from across the nation to facilitate the work. As participants experienced their own professional and personal growth through arts-integration actions and events, the entire culture of the state was affected, as were targeted degree programs in both public and private universities. Arts integration and accessibility elements of the program were fundamental in the KARTS program, and these themes continue to influence Kansas schools to the present time. In fact, the state plan for special education specifically lists approved programs for related services, including art therapy, music therapy, dance movement therapy, recreation, therapeutic recreation, and special music education. The inclusion of these specialties was the direct result of the successful groundwork laid through Arts for the Handicapped and the recognition of strong arts and special education training programs at many of the state universities.

Dissemination and Continued Development

To foster statewide and national dissemination, the KARTS grant produced a series of professionally developed video inservice/preservice teaching modules. The series of video demonstrations with children in schools across Kansas provided real-time examples of techniques for arts therapy, arts education, and arts integration (Kansas Arts Resource Training

System, 1988). The printed modules and videos continue to be referenced in many arts and special education courses within the state. These documented forward thinking and provided effective approaches for current programs in arts integration.

As professionals moved toward more arts integration and broader inclusion, Freeman founded Accessible Arts Inc. in 1988. Accessible Arts Inc. had a mission beyond "arts for the handicapped." Freeman and his colleagues saw the arts as much more than a way to assist persons with disabilities. At the same time, the Kansas legislature designated a specific funding line designed to support arts-related special education/arts-integration projects to serve the state, with a specific mission to serve students at the Kansas State School for the Blind in Kansas City, KS. With this unequivocal support by legislators and a history of support from the Kansas Board of Education, Accessible Arts Inc. led the state toward a highly coordinated service system of professional development and model programming based on the earlier U.S. Department of Education grant, Kansas Arts Resource Training System (KARTS). During this time, the major challenge was detachment from national VSA and its model of arts festivals. KARTS has reconnected with national VSA since its evolution to supporting cross-disciplinary professional development through conferences and webinars.

In 1995, Arts Partners Inc. began work in Wichita, KS, under a Knight Foundation Grant in association with Young Audiences Inc. (www.artspartnerswichita.org). Many of the teachers who had experienced VSAK, KARTS (Kansas State Department of Education, 1988), or Accessible Arts Inc. (Bernstorf, 1997; Freeman, 1990; Hoernike, 1990) activities were among the first to support programs led by Arts Partners. The Wichita Arts Partners was the first affiliate of Young Audiences to be organized as a separate nonprofit rather than as part of a Young Audience chapter and was the first to be implemented districtwide in a major school district (Arts Partners, 2012). This organizational structure paralleled the statewide initiative of Accessible Arts Inc. In addition, Arts Partners fostered the support of numerous community arts organizations, many of which had been associated with the earlier teacher training supported by the Wichita Art Museum, VSAK/Accessible Arts, and university summer workshops at Wichita State University. Again, professionals of varied backgrounds found that through collaboration they not only provided higher quality services to their students and clients, they developed an integrated approach to the arts that cut across organizations, approaches, and even disciplines. Increases in special education inclusion, in other words, classrooms that included special education students, led school policy leaders to realize that all educators needed to know the principles of arts integration. The relationship between special education and arts integration also meant that the scope of arts integration should also become more inclusive.

Re-Pioneering Today

Since the KARTS initiative in 1985, organizations like Accessible Arts, Very Special Arts, Arts Partners, and local community arts agencies have collaborated with the universities across Kansas in arts integration. Preservice training and professional development for teachers, therapists, and other educational professionals has been central to many of the Kansas university arts programs since the 1980s. The approach of cross-training among arts educators, art therapists, educators, and related services personnel continues and has expanded. Current approaches to training are offered by the universities as well as by agencies such as Arts Partners and Accessible Arts. Audiences and presenters for these professional development offerings have expanded beyond artists and educators to now include engineers and science, business, and health personnel.

Multidisciplinary and cross-disciplinary approaches for preservice training, inservice learning, and professional development continue to expand in Kansas. Examples include two projects funded by U.S. Department of Education Professional Development in Arts Education (PDAE) grants. From 2008–2011, Wichita Public Schools collaborated with Wichita State University on the project Accentuating Music, Language and Cultural Literacy Through Kodály Inspired Instruction (AMLCL). In 2011, the Kansas City, KS, School District collaborated with the University of Kansas on a project, Project STArts: Skillful Thinking in the Arts. (See additional details on both grants at www2.ed.gov/programs/artsedprofdev/awards.html). Both of these grants embed arts-integration initiatives within their work.

No comprehensive arts-integration higher education degree program currently exists in the region, but existing arts therapy and arts education degree programs continue their arts-integration endeavors. The individual degree training programs have remained strong while their collaboration with community partners and with each other has evolved. Many of the university programs have implemented multidisciplinary and transdisciplinary courses and services, especially for teachers of preschool-aged children. The associations among higher education faculty and students developed through KARTS (Kansas Arts Resource Training System) in 1985 have been maintained. Wichita-based Arts Partners Inc., in conjunction with Wichita State, continues strong arts-integration programming. Many programs focus on STEM to STEAM (Science, Technology, Engineering, Arts, and Math) initiatives, including an expansion for infants, toddlers, and preschoolers, in association with Baby Wolftrap, a cultural arts organization based in Virginia. A new aviation magnet elementary school, Mueller Elementary, included arts-integration programming with STEM initiatives as a focus.

STEAM initiatives for professional development have emerged as arts and sciences faculty collaborate during service learning practicums and multidisciplinary research. New courses developed in the College of Fine Arts

at Wichita State University under CRATEL (Center for Research in Arts, Technology, Education, and Learning) are now housed and funded in the College of Engineering and a recently formed Institute for Interdisciplinary Creativity. The integration of arts and science is a major focus of this center, with collaborations toward cross-disciplinary exhibits, research solutions, and service learning approaches.

Integrated arts, STEM, and Common Core are now central to professional development training and preservice courses in education degree programs as well as other fields. For example, applied health courses regularly address the body of research demonstrating the effectiveness of the arts in treatment and health preservation. Academic departments work together in cooperative service learning projects, such as inclusion-based preschools and adult day programs for persons with disabilities. Students gain expertise through collaboration and cross-training of undergraduate and graduate programs in music education and speech pathology. These successful programs have expanded to include training in arts integration for interested audiology, early childhood, special education, and physician assistant students. The major challenges continue to be in scope of practice decisions, even in programs where arts integration has been successfully used. However, standardized coding for related services in education and health care leave little room for arts integration, even when the professionals involved are supportive and prepared. In addition, the challenges of standardized assessments and teacher evaluations put pressure on classroom teachers and arts educators to conform to standard teaching practices. Administrators often do not understand the principles of arts integration and may question what is being taught when they observe this type of arts-based learning.

RECOMMENDATIONS FOR HIGHER EDUCATION

Economic pressures and changes in educational foci may influence the manner in which arts-integration training is delivered within the universities and ultimately within schools and community agencies. As we see increases in the number of children with identified special learning needs, especially for the identification of autism, there is an implied and broadened need for what used to be the "unique" programs. The true future of arts integration may lie in reiterating the initial goal of the programs described above—that the survival of both arts excellence and academic excellence may depend on developing paths in which they merge through arts integration. Whether such goals are met by embedded training in already-established degree programs or through the development of comprehensive degree programs or certificate programs in arts integration remains to be seen.

We believe that arts integration can foster success for the entire continuum of learners. For decades, arts educators and therapists have used collaborative

arts integration to create inclusive communities for special populations. More recently, educators have invested in arts integration within the contexts of Understanding by Design (UbD) and Universal Design for Learning (UDL) (see Glass and Donovan, Chapter 3). The key word *design* may describe the most important link between arts integration and special populations. In reality, the best adapted curriculum and accommodations are actually design work that is supported by integration across traditional boundaries.

Pioneering programs in arts integration are the direct result of artists, teachers, and therapists working together to meet the unique needs of children and adults with disabilities. As we move forward in the field of arts integration, we can learn from our strongest training programs, which have fostered the natural excellence of individual arts disciplines coupled with professional cross-training and applied service learning opportunities. As we have seen the arts themselves become integrated through technology and media, arts-integration training must include collaboration between and across traditional silos. When the challenges of identity and scope of practice remain flexible, the synergy generates a ripple effect that creates an ever-wider circle of influence and inclusion.

The critical components of this community and collaborative approach to arts integration include the following:

1. Leadership from strong arts experts (artists, arts educators, arts therapists) who see the needs of individuals and identify the learning that comes through arts experiences.
2. Development of interdisciplinary fields through cross-training between arts professionals and those from other disciplines (initially between arts educators, special education personnel, and therapists).
3. Active networks that provide synergistic arts-based activities supported financially and philosophically by both arts and non-arts organizations within the region.

REFERENCES

Anderson, A. (Ed.). (2015). *Arts integration and special education: An inclusive theory of action for student engagement.* New York, NY: Routledge.

Arts Partners. (2012). About us. Retrieved from www.artspartnerswichita.org/about.html

Bernstorf, E. (Ed.). (1997). *Early innovators: Arts with special needs students: Monograph.* Kansas City, KS: Accessible Arts, Inc.

Freeman, W. C. (1990). Preface. In P. A. Hoernike (Ed.), *Arts with special needs students: Value, place and promise* (pp. 1–2). Kansas City, KS: Accessible Arts, Inc.

Hoernike, P. A. (1990). Making the arts accessible. In P. A. Hoernike (Ed.), *Arts with special needs students: Value, place and promise* (pp. 3–7). Kansas City, KS: Accessible Arts, Inc.

Kansas State Department of Education. (1988). Kansas Arts Resource Training System (KARTS): Final report on three (3) years. Retrieved from www.eric.ed.gov/ ERICWebPortal/search/detailmini.jsp?_nfpb=true&_&ERICExtSearch_Search Value_0=ED330150&ERICExtSearch_SearchType_0=no&accno=ED330150

Kraus, N. (2016). Publications. Retrieved from www.brainvolts.northwestern.edu/ publications.php

Krause, N., & White-Schwoch, T. (2016, June 9). Neurobiology of everyday communication: What have we learned from music? *The Neuroscientist*. doi: 10.1177/107385841665393

Mackh, B. M. (2015). *Surveying the landscape: Arts integration at research universities*. Ann Arbor, MI: ArtsEngine, University of Michigan.

Silverstein, L. B., & Layne, S. (2010). *Defining arts integration*. Washington, DC: The John F. Kennedy Center for the Performing Arts. Retrieved from artsedge. kennedy-center.org/~/media/ArtsEdge/LessonPrintables/articles/arts-integration/ DefiningArtsIntegration.pdf

Stuckey, H. L., & Nobel, J. (2010). The connection between art, healing, and public health: A review of current literature. *American Journal of Public Health*, *100*(2), 254–263. doi: 10.2105/AJPH.2008.156497

Conclusions and Recommendations
Different Strokes for Different Folks

Gene Diaz and Martha Barry McKenna

Educators throughout time and around the world have integrated the arts into and across their teaching. In ancient Greece, Plato reflected on drama as moral education and Pythagoras integrated science into music. In the Middle Ages, teachers used narratives in stained-glass windows and mosaic designs to reflect the stories of various religions and cultures. The pictographs of Chinese written language have always told their own stories, just as the colorful designs of Guatemalan *huipiles* are representative of the wearers' home villages. Hopi kachina dolls teach moral lessons, and the *griots* of western Africa have long been the storytellers for whole cultures. Even in the earliest schools of the United States in Boston, children were taught religion through music. It is only in our recent past that the many arts have been separated from learning across the disciplines or, worse, eliminated from schools entirely. The recognition that integrating the arts would require the professional development of the arts-teaching workforce led the authors of this publication to create a variety of approaches for such training. In this final chapter we offer recommendations for teachers, leaders, and community members based on the promising practices from these different arts-integration professional development approaches.

Artistic accomplishments represent some of our most enduring characteristics as a society. From the poetry of Emily Dickinson to that of Audre Lorde, from the music of the Shakers to the chords of John Cage, from the paintings of the Hudson River School to the sculptures of Henry Moore, and from the bare feet of Isadora Duncan to the challenging story of loss in Bill T. Jones's *Still/Here*, we demonstrate our capacities to imagine and create. With the withdrawal of resources from art programs and diminishing numbers of arts specialists available to teach in classrooms, teachers who recognize the value of achievement in the arts need more creative approaches for making the arts available to their students. At the same time, the increasing demands of accountability brought about through federal and state legislation have pushed teachers away from their professional

181

knowledge and toward test-driven teaching (Meier & Wood, 2004). Arts-integrated professional development for educators that encourages creativity, imagination, and risk-taking is an approach shaped by artistic creative processes.

Professional development in arts integration meets a need that has been recognized across the United States: the need for the arts to play a central role in learning. This was noted by those arts educators who crafted *Working Partnerships* (Arts Education Partnership, 2007), a document about promising practices in arts education partnerships. If arts education is to be transformed by a highly qualified arts-teaching workforce, these educators suggest that higher education must take a leadership role in the professional development of classroom teachers, art specialists, teaching-artists, and instructors in arts and cultural institutions to ensure that those who teach the arts have the highest possible artistic skills and pedagogical abilities (p. 10). The motivation to help create an arts-teaching workforce with these skills and abilities emerges out of a belief that the arts represent the highest achievements of our culture and society.

Although Peter Abbs (2003) suggests that in teaching there is "no room for charisma, only contracts. No room for radical questions, only ranked percentages. No room for aesthetics, only certificates" (p. 60), the authors of the chapters in this book strive to make room for questions, charisma, and aesthetics. As artists, they explore their worlds through expressive media; as scholars, they ask critical questions of educational institutions and practices; and as teachers, they inspire their students to take risks and imagine the world as a more just, humane, and equitable place. While we are not born artist/scholar/teachers, we are creative, so the challenge to create these approaches necessitates an ability to identify, support, and mentor educators who want to change their teaching through creative pedagogy. Educators with a solid grounding in aesthetic experience as meaning-making will engage students in the arts as craft-based inquiry, innovation, and discovery.

The recommendations we propose below derive from ideas generated by the chapter authors and have been grouped into four categories that address people in positions to create change. The first group, Recommendations for Designing and Implementing Arts Integration Programs, specifically addresses those in higher education and cultural arts organizations, including senior administrators who might support innovation in programming for arts integration preparation. The second group, Recommendations to Build Capacity in Schools, addresses those in school communities as they seek to increase understanding of the benefits for learners derived by integrating the arts through professional development in arts integration. The third group, Recommendations for Policy Actions, is addressed to those at the local, regional, and national level in education administration. And the fourth group, Recommendations to Grow the Community, speaks to all of the above.

RECOMMENDATIONS FOR DESIGNING AND IMPLEMENTING
ARTS-INTEGRATION PREPARATION PROGRAMS

The five recommendations below can be considered as options for those in higher education to consider as they contemplate next steps in their efforts to design and implement programs to prepare educators for arts integration. They have been illustrated by the authors in this book in such a way as to give a broad look at their adoption. In several chapters in the book the conversation begins with identifying a need and finding collaborators who recognize the need. Whether it is reaching students in special education or students who are English language learners, or making learning more relevant and accessible to all students, each of these efforts necessitates the collaboration of several individuals and groups. Collaboration permeates our work in arts integration, since by its very nature it necessitates participation from those who work in the arts and those who work in education at all levels.

Collaborate

> We recommend that faculty and leaders in institutions of higher education collaborate across disciplines and within the community in designing and implementing innovative arts-integrated preservice and professional development programs for educators.

Higher education can take the lead in designing collaborative programs that prepare educators for arts integration. Programs like Lesley University's Integrated Teaching Through the Arts master's degree (Chapters 1 and 3) illustrate collaborations in the program implementation when Lesley faculty collaborate with community artists across the nation and with cultural arts institutions like museums and performing arts organizations. In research on the program, Lesley faculty collaborated with the Ford Foundation and colleagues from Harvard University and Queen's University in Ontario.

Engdahl and Winkelman (Chapter 6) collaborate across education departments at California State University–East Bay to create a unique opportunity for preservice teacher candidates to offer presentations to educational leadership candidates on the skills and strategies for teaching arts integration. With the implementation of these presentations, the teacher candidates and the two faculty invited community artists to join in their efforts. Similarly, Dean and Sweeting (Chapter 13) describe the collaboration of the Departments of Kinesiology and Elementary Education, Liberal Studies, and Arts, Media and Communication at California State University–Northridge, which led to the creation of the Integrated Teacher Education Program (ITEP) that fosters integrated arts connections.

Create Partnerships

> We recommend that innovative leaders in arts integration create
> partnerships among higher education, schools, cultural arts institutions,
> community artists, and funders.

As the examples from Oklahoma (Chapter 4), Maryland (Chapter 5), and
Kansas (Chapter 14), have demonstrated, the creation of partnerships can
lead to effective professional development programs as well as to chang-
es in education policy. Frequently these partnerships include higher educa-
tion institutions that hold the primary responsibility for teacher education.
However, this is not the case in all instances of partnership. As the work
of the Arts Education Partnership (AEP) has demonstrated over the years,
partnerships can take many shapes. We note the work highlighted by Mears,
O'Dell, Rotkovitz, and Snyder (Chapter 5) as they describe the partnership
between the Arts Education in Maryland Schools (AEMS) Alliance with
the Maryland State DOE and the Maryland Artistry in Teaching Institute
(MATI) to foster professional development for educators. Marshall (Chapter
11) describes an ambitious partnership among science and art museums, a
school district, and a university. This partnership approach was character-
ized by a strong, committed, and active core team composed of education
specialists from member institutions. As she describes the importance of
institutional teamwork in the collaboration in San Francisco between San
Francisco State University, the school district, the California Academy of
Sciences, and the de Young Museum, she emphasizes the need to bring to-
gether the resources and expertise of these institutions to provide quality
professional development for teachers in the Science, Literacy and Art iNte-
gration in the Twenty-first century (*SLANT*) program.

Include Teachers and Leaders Together

> We recommend that arts-integration preparation programs include teachers
> and leaders working together to support student learning.

The three examples in Part III emphasize the value of including school
leaders along with teachers in preparation projects and programs for arts
integration. At CSU–East Bay (Chapter 6) we learn about how the edu-
cation leadership candidates developed new understanding of the value
of the arts in learning. The PAL program in Washington State (Chapter
7) most directly places the role of the principal as the lead in preparation
efforts.

Conduct Research in Arts Integration

> We recommend that scholars conduct research on art-integration programs and share the outcomes of their studies across various media.

Hallmark's research (Chapter 8) on the leadership of the school principal in one charter school dedicated to arts integration highlights both the role of the principal and the importance of research in documenting outcomes of arts-integration preparation projects. In order to share the evidence of the impact of any of the approaches presented in this book, we need to include published evaluation and documentation in each of our efforts. Several chapters have already been presented as research papers at conferences.

Teach Standards-Based Arts-Integration Curriculum Design

> We recommend that educator preparation programs include standards-based arts-integration curriculum design in their offerings, and draw attention to the alignment of the Common Core State Standards with the National Core Arts Standards.

Since educators in schools learn the basics of curriculum theory and design in their teacher preparation programs, this is where they can begin their learning about arts integration. Donovan and Glass (Chapter 3) suggest that we teach curriculum design in arts-integration preparation, and the converse suggests that we teach arts integration within curriculum courses. Charleroy and Paulson (Chapter 2) emphasize the alignment of standards in support of arts integration, providing us with a rationale and method for including arts integration in curricular decisions made by educators at all levels. As with the other chapter authors, they bring together their deep knowledge of the arts and education in support of the integration of the two.

Summary of Recommendations for Designing and Implementing Arts-Integration Preparation Programs

Collaborate	We recommend that faculty and leaders in institutions of higher education collaborate across disciplines and within the community in designing and implementing innovative arts-integrated preservice and professional development programs for educators.
Create partnerships	We recommend that innovative leaders in arts integration create partnerships among higher education, schools, cultural arts institutions, community artists, and funders.

Include teachers and leaders together	We recommend that arts-integration preparation programs include teachers and leaders working together to support student learning.
Conduct research in arts integration	We recommend that scholars conduct research on art-integration programs and share the outcomes of their studies across various media.
Teach standards-based arts-integration curriculum design	We recommend that educator preparation programs include standards-based arts-integration curriculum design in their offerings, and draw attention to the alignment of the Common Core State Standards with the National Core Arts Standards.

RECOMMENDATIONS TO BUILD CAPACITY IN SCHOOLS

In an earlier publication with colleagues from the Arts Education Partnership Higher Education Task Force, we identified the importance of centering professional development of the arts-teaching workforce in schools.

> Professional development is centered in schools where learning communities of equal partners are created, including pre-K–12 teachers, arts specialists, teaching artists, cultural arts instructors and higher education faculty. (Arts Education Partnership, 2007, p. 5)

We also found that it was important to create learning communities of equal partners, whatever one's role in the school. Building on the promising practice of successful professional development programs captured in this earlier study and repeated in many programs described in this text, we once again reiterate the importance of professional development in schools to ensure that all teachers, school leaders, arts specialists, and others are able to participate in the professional development activities. In addition to providing access for all members of the staff, locating the training within the school building leads to collaboration among the educators that results in stronger programs with more engaged participants.

Provide Inservice Professional Development in Arts-Integration Opportunities in Schools

> We recommend that arts-integration professional development opportunities be offered in schools to ensure collaboration, access, and application.

Examples of statewide programs that have centered professional development in schools include the work of Hendrickson in Oklahoma (Chapter 4) and Barnum in Washington State (Chapter 10). In both cases classroom

teachers worked closely with artists and higher education professionals to design integrated arts curriculum and instruction to be implemented in their classrooms. A critical element of each program's success was mentoring support provided by arts educators in teachers' classrooms. In cases where professional development in arts integration occurred in schools and included various members of the arts-teaching workforce as equal partners, the result was that teachers became more confident and skilled in engaging in arts-integrated activities in their classrooms.

Ensure Support and Funding for Arts Specialists

We recommend that adequate funding for arts specialists be allocated to ensure that these specialists are able to provide support for arts-integration activities across the school community.

Those who teach dance, drama, literary arts, media arts, music, and visual arts have a special role in the expansion of arts integration in their schools. As the resident "artists in the school," the art specialist can coordinate arts-integrated activities by working collaboratively with classroom teachers, community artists, and local arts organizations. Huser and Hockman (Chapter 9) point out the need to support art specialists in expanding their roles and increasing their numbers in schools. Other authors, including Bradley and McGreevy-Nichols (Chapter 12) and Charleroy and Paulson (Chapter 2) stress the importance of schools providing education in both the core arts subjects and arts integration. To create a school that is rich in the arts, the arts specialists who provide core sequential instruction in the individual arts should not be replaced by arts-integrated instruction; rather, the two approaches for arts instruction should support one another.

Prepare Principals to Serve as Leaders and Advocates

We recommend that principals engage in planning and implementing teaching and learning activities in collaboration with teachers, arts specialists, and teaching-artists for increased impact and sustainability of arts integration.

Central to the development of arts-rich schools is the role of the principal as instructional leader working with all members of the arts-teaching workforce in her school to ensure both core arts and arts-integrated teaching and learning of the highest quality. However, many principals, similar to classroom teachers, have had little experience with the arts in their own education, so they may not understand the full potential of the arts in educating the whole child by fostering creativity and engagement in learning. McAlinden, with her pioneering work in the Principals Arts Leadership (PAL) program in Washington State (Chapter 7), suggests an approach for

professional development that begins with the principal's experience of the power of the arts in her own life. PAL supports the principal in building a school leadership team made up of teachers, arts specialists, and community partners who work collaboratively to design and implement an arts plan that brings more arts into the school day while building an infrastructure to support and sustain arts learning. Engdahl and Winkelman (Chapter 6) suggest another approach in which professional development of the principal in arts integration occurs at the university as part of the training for the educational leadership credential. Hallmark (Chapter 8) recognizes the importance of the principal as leader in arts integration and recommends further research on successful models in which principals and teachers collaboratively design arts-integrated curriculum and pedagogy.

Connect Resources Within the School to Support Arts Integration for All Students

> We recommend that teachers and school leaders collaborate with special education teachers, counselors, and therapists within the school to ensure that all students are able to engage in arts education.

While principals play a key role at schools, professional development in arts integration involves all members of the school community, including teachers, special education teachers, counselors, and therapists, so that all students are able to engage in arts education. Glass and Donovan (Chapter 3) suggest using the curriculum design frameworks of Understanding by Design and Universal Design for Learning in their approach to professional development in arts integration for teachers, arts educators, and other professional staff to ensure that all learners are included in arts education. Similarly, Bernstorf (Chapter 14) suggests an approach for professional development focusing on students with special needs in which professional artists, arts educators, and arts therapists collaborate with community agencies to develop programs to serve this special population. The efforts in both of these cases have resulted in creative approaches to arts integration that works for all learners.

Collaborate with Local Community Arts Organizations

> We recommend that teachers and leaders identify local community arts organizations with which to collaborate on engaging students in arts-integrated learning activities in the schools and in the community.

Partnering with cultural organizations in the community increases resources to expand professional development in the schools. Marshall (Chapter 11),

whose *SLANT* program includes art museum and science museum educators, suggests such an approach for school-based professional development in collaboration with community-based arts organizations. Perhaps the most expansive model of collaboration of community arts organizations in professional development of teachers occurs in Maryland (Chapter 5), where a Fine Arts Education Advisory Panel includes arts organizations (such as the Walters Art Museum, Baltimore Museum of Art, and Wolf Trap), Young Audiences/Arts for Learning Maryland, and the Maryland State Arts Council.

Summary of Recommendations to Build Capacity in Schools

Provide inservice professional development in arts-integration opportunities in schools	We recommend that arts-integration professional development opportunities be offered in schools to ensure collaboration, access, and application.
Ensure support and funding for arts specialists	We recommend that adequate funding for arts specialists be allocated to ensure that these specialists are able to provide support for arts-integration activities across the school community.
Prepare principals to serve as leaders and advocates	We recommend that principals engage in planning and implementing teaching and learning activities in collaboration with teachers, arts specialists, and teaching-artists for increased impact and sustainability of arts integration.
Connect resources within the school to support arts integration for all students	We recommend that teachers and school leaders collaborate with special education teachers, counselors, and therapists within the school to ensure that all students are able to engage in arts education.
Collaborate with local community arts organizations	We recommend that teachers and leaders identify local community arts organizations with which to collaborate on engaging students in arts-integrated learning activities in the schools and in the community.

RECOMMENDATIONS FOR POLICY ACTIONS

Once again we want to emphasize that preparing educators for arts integration cannot be an effort carried out by one person or in isolation either in schools or in higher education. It is work to be done in a group, with all stakeholders making contributions from their various perspectives.

Convene Stakeholders

> We recommend that state education leaders convene stakeholders in arts in
> education to serve as advisors in support of arts-integration initiatives and
> to explore state-level initiatives.

As noted above, Mears, O'Dell, Rotkovitz, and Snyder (Chapter 5) offer
the example of the Arts Education in Maryland Schools (AEMS) Alliance,
which brings together all stakeholders across the state to make recommen-
dations for integrating the arts into schools. Once such a group comes
together, they can assess the state of their resources and make informed
decisions about the next steps necessary for including arts integration in
schools. Convenings of stakeholders offer the option of making decisions
in real time, without the need to consult with those not present. Whether
online or face-to-face, convenings can also generate ideas for smaller group
work to be carried out by professionals and practitioners to inform the
larger group. They might also transform into advisory panels or standing
committees that can continue to inform state, regional, or local decision-
making into the future. The programs in Oklahoma (Chapter 4) and Kansas
(Chapter 14) include examples of convenings across organizational borders
to include stakeholders in decisionmaking that affects educator preparation
courses and programs in those states.

Include Arts Integration Options in Educator Credentials for All Students

> We recommend that state credentialing for teachers and school leaders
> offer preparation in arts integration.

Examples from several chapters demonstrate ways in which arts inte-
gration might be included in preservice and inservice credentialing pro-
grams for educators and school leaders. Recognition of the importance of
arts-integration professional development in state practice has been led by
AEMS in Maryland (Chapter 5) and policy in North Carolina (Chapter
9), where S66 Vision for Arts Education now requires classroom teach-
ers to have coursework in arts integration in their preservice training.
However, challenges appear when these students enter public school for
their practical experiences and discover principals and teachers who do
not have this same value for arts integration. An example not yet men-
tioned is the case of Lesley's Integrated Teaching through the Arts master's
program, which meets the requirements for the professional-level teaching
credential for early childhood and elementary-level teachers in the state of
Massachusetts.

Require Arts Integration in Educator Preparation for Teachers of English Language Learners and Students in Special Education

> We recommend that state credentialing for teachers and other personnel working with English language learners and students in special education require preparation in arts integration.

Glass and Donovan (Chapter 3) suggest that using Universal Design for Learning basic elements in arts-integration curriculum design could enhance the capacity of teachers to reach all students, especially those with special needs, as well as English language learners (ELLs). ELLs have the disadvantage of lacking the language to express and communicate what might also be shared through visual art, dramatic arts (mime, etc.), music, and dance. Including training in arts integration then allows for more equitable learning opportunities for *all* students. Bernstorf's example of Kansas (Chapter 14) shows how arts-integration courses can be embedded within existing programs, and it illustrates the value of such offerings for teachers of students with special needs.

Promote the National Core Arts Standards

> We recommend that leaders in policy at all levels recognize and promote the National Core Arts Standards in support of arts integration.

Engdahl and Winkelman (Chapter 6) include a focus on a student in educational leadership who was not aware of the existence of the National Core Arts Standards. While these are a relatively recent addition to the constellations of education standards, making all students in education credentialing programs aware of them through statewide professional development could improve the chances of inclusion of arts and arts integration in schools. States and regional districts that offer professional development for teachers and school leaders might follow the leads of states like Kansas (Chapter 14), Maryland (Chapter 5), Oklahoma (Chapter 4), and Washington (Chapter 10) in aligning their own state standards with these national standards.

Now that we have looked at areas where individuals in specific roles might contribute to the inclusion of arts integration across the spectrum, let's look at how we all might contribute to the expansion of our community of practice dedicated to arts integration in schools.

Summary of Recommendations for Policy Actions

Convene stakeholders	We recommend that state education leaders convene stakeholders in arts in education to serve as advisors in support of arts-integration initiatives and to explore state-level initiatives.
Include arts integration options in educator credentials for all students	We recommend that state credentialing for teachers and school leaders offer preparation in arts integration.
Require arts integration in educator preparation for teachers of English language learners and students in special education	We recommend that state credentialing for teachers and other personnel working with English language learners and students in special education require preparation in arts integration.
Promote the National Core Arts Standards	We recommend that leaders in policy at all levels recognize and promote the National Core Arts Standards in support of arts integration.

RECOMMENDATIONS TO GROW THE COMMUNITY

These concluding recommendations focus on how educators, artists, and community members can participate in and contribute to the growth of communities of practice to ensure that all students have access to the arts in schools with trained teachers and leaders capable of providing quality arts-integrated teaching and learning. We began this book following a recommendation in the 2011 report of the President's Committee on the Arts and the Humanities that identifies the need to develop the field of arts integration:

> There is promise in creating **communities of practice** among model arts integration programs to identify best practices in arts integration, organize curriculum units, bring together training approaches, and create a common frame for collecting evaluation results. (President's Committee, 2011, pp. 5–6)

The report acknowledges the critical role of the arts in the education of all children, and recognizes that arts-integration programs are an important part of the overall arts education within schools. The report suggests that communities of practice in arts integration are needed to sustain and advance this important work.

Participate in Arts Education Partnership (AEP) and Other National Forums on Arts and Education

> We recommend participating in AEP and other national forums to collaborate with arts and education professionals to support their own work in arts integration.

Preparing Educators for Arts Integration is the result of a community of practice begun by the authors while participating in the Higher Education Working Group of the Arts Education Partnership (AEP) in Washington, DC. We find AEP to be the epicenter for all aspects of professional development in arts integration, whether through its forums or its website, including ArtsEdSearch.org. AEP continues to move the field forward through its educational opportunities and research and advocacy initiatives to improve arts education for all children. As discussed in this book, professional organizations on both the state and national level also provide resources for professional development or through participation in convenings to support the growth of arts integration across PK–16 education.

Collaborate with Others to Build Communities of Practice in Your Institution or Your Professional Organization

> We recommend collaborating with colleagues in a community of practice to increase capacity in and understanding of arts integration.

In many cases the authors of this book took a leadership role in creating communities of practice in their institutions or professional organizations. As a result of participating in these communities of practice, we were able to expand our knowledge and create programs that are preparing educators in arts integration across the nation. We recommend that readers identify the approach(es) to arts integration in this book that focus on an area of arts and education that best matches their own work and connect with the chapter authors to learn more about how they began this work in their institution and/or how to create a community of practice.

Contribute to the Dialog on Arts Integration

> We recommend articulating the value of arts integration and sharing examples across all fields through various types of media.

Since arts-integrated approaches for teaching and learning are still in their nascent stage in many areas across the nation, we are all called upon to speak about the value of arts integration and share the work that we are doing for the benefit of others. Whether through media across districts and

professional organizations or arts and education publications, it is important that we all contribute to the dialog, with best practices in arts integration demonstrating its positive impact on teaching and learning for all students. We should all consider creating a special-interest group or task force in our professional organizations to expand arts integration as a field of inquiry and practice.

Seek External Funding to Sustain Professional Development Programs

> We recommend seeking funds to sustain professional development programs
> for teachers and school leaders, as well as support for administrative
> positions that oversee or organize arts-integrated programs in the schools.

Finally, you will note that many of the programs providing professional development for arts integration began with external funding to support the research and design of the project. External funding for arts-integration projects and programs is available from public institutions that focus on the arts and on education. These include local arts councils and school boards, state arts and education organizations, and national institutions such as the National Endowment for the Arts and the U.S. Department of Education. Private funders include small, local philanthropists and businesses as well as the larger ones like the Wallace Foundation and the Ford Foundation. The goal of most funders is to support the creation of programs that will become self-sustaining over time, a development that the authors in this book strongly support.

Summary of Recommendations to Grow the Community

Participate in Arts Education Partnership (AEP) and other national forums on arts and education.	We recommend participating in AEP and other national forums to collaborate with arts and education professionals to support their own work in arts integration.
Collaborate with others to build communities of practice in your institution or your professional organization.	We recommend collaborating with colleagues in a community of practice to increase capacity in and understanding of arts integration.
Contribute to the dialog on arts integration.	We recommend articulating the value of arts integration and sharing examples across all fields through various types of media.
Seek external funding to sustain professional development programs.	We recommend seeking funds to sustain professional development programs for teachers and school leaders, as well as support for administrative positions that oversee or organize arts-integrated programs in the schools.

SUMMARY

As you have discovered, we have offered a wide variety of approaches for preparing educators in arts integration in this text. Drawing from research and practice in arts integration across the nation, we have included programs in higher education from the East Coast to the West, with many in between. These approaches include professional organizations focused on arts education, including the Arts Education Partnership (AEP), State Education Agency Directors of Arts Education (SEADAE), and the National Dance in Education Organization (NDEO). Other approaches include statewide initiatives such as Oklahoma A+ Schools, Arts Integration Leadership Model (Colorado), Arts in Basic Curriculum project (South Carolina), Art in Action program (Pennsylvania), and Arts Impact and Principals Arts Leadership in Washington State, all unique models of partnerships with scalable potential beyond their communities. Also included are national initiatives that are leading the way to reconsider the role of arts integration to meet the needs of all children, such as the College Board study on connections of the National Core Arts Standards and the Common Core State Standards, and Universal Design for Learning (UDL). Several of these programs have been chosen by the U.S. Department of Education as Model Demonstration Programs, such as those in Washington State highlighted by Barnum (Chapter 10). While some programs have influenced the teaching and learning of arts integration for decades, such as the programs in Kansas and at Lesley University in Cambridge, MA, others are just beginning to expand single arts education and advocacy to recognize the importance of a professionally prepared arts-teaching workforce that integrates the arts.

Many of the authors are leaders in their organizations and in the field of arts integration, with firsthand experience in designing new approaches to arts integration and to the infrastructure that will move these forward to successful implementation. All are entrepreneurs who have found partners to move with them from an idea to a program. All share a commitment to expanding the field of arts integration through continued research and documentation of promising practices and expanding our community of practice so that all students will have access to quality arts experiences in schools every day. Whether an ambitious partnership among science and art museums, a school district, and a university or a simple partnership of an arts specialist working with a classroom teacher to integrate the arts in a classroom, all have something to offer as readers consider how to move forward in their school, district, or organization to create arts-integrated professional development for their staff and community members.

And yet there are many more programs and projects across the United States not discussed here that have historic and current significance. These include the Chicago Arts Partnership in Education (CAPE), an arts-integration model replicated in nine cities across the United States, Canada, and

England (www.capeweb.org), and the Center ARTES program at California State University–San Marcos, which partners with school districts and arts partners to carry out projects such as the SUAVE program (Socios Unidos para Artes via Educacion, or United Community for Arts in Education) and the Learning Through the Arts initiative with the San Diego Unified School District (www.csusm.edu/centerartes/aboutus/index.html). Another example can be found in Minnesota, at the Perpich Arts Integration Network of Teachers (artsintegration.perpich.mn.gov). There have been many other smaller projects that integrate one or more of the arts into learning, such as The Learning Alliance in Vero Beach, FL, which promotes literacy through the arts (www.thelearningalliance.org), or Mary Brooks's visual arts and science integration project for high school students at the Whitehead Institute of MIT. Some projects use other terminology such as "arts-based innovative training," used in the Art of Science Learning project, a four-year Science, Technology, Engineering, Arts and Math (STEAM) project funded by the National Science Foundation (Goldman, Yalowitz, & Wilcox, 2016). And other projects are in development that we learn about each time we attend a conference or open a blog. Yet, until there is some consistency across the states in the preparation of educators in arts integration, we believe that the whole field remains in development.

As Bernstorf notes in Chapter 14, moving forward in the field of arts integration means learning from our strongest programs. We must also learn from programs and projects that have suffered setbacks and challenges as we build our community and continue to innovate. As the arts become integrated through technology and media, arts-integration preparation programs need to include collaboration across disciplinary, geographic, and organizational borders that challenges our sense of identity and scope of practice. Remaining flexible and adaptable will allow the synergy of all our efforts to generate a ripple effect that generates an expanding circle of influence and inclusion. We invite you to join in our efforts to expand the circle and contribute to an even more influential and inclusive community of practice in arts integration.

REFERENCES

Abbs, P. (2003). *Against the flow: Education, the arts, postmodern culture.* New York, NY: RoutledgeFalmer.

Arts Education Partnership. (2007). Working partnerships: Professional development of the arts teaching workforce. Retrieved from 209.59.135.52/files/partnership/AEP%20WorkingPartnerships.pdf

Goldman, K., Yalowitz, S., & Wilcox, E. (2016). Art of Science Learning: The impact of arts-based innovation training on the creative thinking skills, collaborative behaviors and innovation outcomes of adolescents and adults. Retrieved from artofsciencelearning.org/wp-content/uploads/2016/08/AoSL-

Research-Report-The-Impact-of-Arts-Based-Innovation-Training-release-copy.
pdf

Meier, D., & Wood, G. (Eds.). (2004). *Many children left behind: How the No Child Left Behind Act is damaging our children and our schools.* Boston, MA: Beacon.

President's Committee on the Arts and the Humanities. (2011). Re-investing in arts education: Winning America's future through creative schools. Retrieved from www.pcah.gov/resources/re-investing-arts-educationwinning-americas-future-through-creative-schools

About the Contributors

Sibyl Barnum is an independent consultant specializing in arts integration, curriculum development, teacher professional learning, and grant-writing. She directed the nationally recognized Arts Impact professional learning program from 2003 to 2013. During her tenure, Arts Impact received six U.S. Department of Education Arts in Education research grants. She is currently president of Learning Forward Oregon, an affiliate of Learning Forward International, a professional organization devoted exclusively to educator professional development. Before joining Arts Impact, Sibyl served as education director for Eugene Ballet and Eugene Opera in Oregon. She was a teaching-artist in K–12 schools throughout the state of Oregon. She holds a Master's of Music from the University of Oregon.

Elaine Bernstorf is professor of music education at Wichita State University–Kansas. As associate and interim dean (2001–2009) and a Cohen Honors College founding faculty fellow, her specializations include elementary and special music education; arts integration; and voice, fluency, child language and literacy. Bernstorf co-authored *The Music and Literacy Connection* and has a chapter in *Exceptional Music Pedagogy for Children with Exceptionalities*. She served as chair for NAfME Exceptional Learners SRIG (2016–2018), as co-chair for Kansas MEA Special Needs (2013–2016), on the national advisory board for Organization of American Kodaly Educators, and as administrator column coordinator for the *Envoy* journal.

Karen Bradley is a Certified Movement Analyst and director of Graduate Studies in Dance at the University of Maryland. She is the author of *Rudolf Laban*, a volume in the Routledge series on 20th-century performance practitioners, and numerous articles on dance, arts education, and neuroscience. She coauthored an article in the journal *Frontiers of Human Neuroscience*, "Neural Decoding of Expressive Human Movement from Scalp Electroencephalography (EEG)." Recent projects include Moving Stories: Digital Tools for Movement, Meaning, and Interaction, and ReImaging and ReImagining Choreometrics, which addresses dance films in the Lomax American Folklife Center at the Library of Congress.

Amy Charleroy is the director of Pre-AP Arts Curriculum and Instruction for the College Board, where she oversees the design and development of instructional and assessment resources for middle and high school teachers of the arts. She previously directed the College Board's four-year Arts at the Core initiative. As a former museum educator, she managed artist residencies in New York City public elementary schools as part of the Guggenheim Museum's Learning Through Art

program, where she also coordinated The Art of Problem Solving. She holds a BFA from the Maryland Institute College of Art and an MA in Art Education from Rhode Island School of Design, and is currently enrolled in the EdD program in Art and Art Education at Teachers College, Columbia University.

Colleen Hearn Dean has performed and studied dance in India, Spain, New York City, and Washington, DC, and is a member of the Conseil International de la Danse–UNESCO. She was instrumental in developing the "Let's Move–Let's Dance" program, a national health initiative. Her professional writings and presentations range from anti-bullying campaigns to dance as healing for those affected by war. She is senior editor of *Dance Arts Now!*, an NDEO publication that highlights creative works of young dancers, and she directs the adult dance program at Ida Lee Recreation Center in the town of Leesburg, VA. She earned the Meritorious Service Award presented by the International Council for Health, Physical Education, Recreation, Sport & Dance.

Gene Diaz is an international educator and former Fulbright scholar who integrates the creative process with teaching and research. As a visual artist and educator, Gene has taught all levels, from primary school to graduate students, both inside and outside of classrooms, including visual art, computer science, EFL, critical ethnography, curriculum theory, visual literacy, and creative process as pedagogy. She completed a PhD at the University of New Orleans in Curriculum, and a BS in Electronics Engineering at San Diego State University. As professor of distinguished achievement at Lesley University, Gene now provides faculty development and arts program evaluation and lives in Arlington, MA. She can be contacted at diaz.gene@gmail.com.

Lisa Donovan is a professor in the Fine and Performing Arts Department of Massachusetts College of Liberal Arts. Previously, she served as associate professor of education and director of Lesley University's Creative Arts in Learning Division. Lisa has broad experience working as an arts educator and administrator in arts organizations including Jacob's Pillow Dance Festival; Berkshire Opera Company; Barrington Stage Company; University of Massachusetts' Theater Department; and Boston University's Theater, Visual Arts and Tanglewood Institutes; and she has served as executive director of the Massachusetts Alliance for Arts Education. She is coeditor/author of an arts integration book series published by Shell Education.

Eric Engdahl is the chair of the Department of Teacher Education at California State University–East Bay. He teaches visual and performing arts methods, arts integration, and early childhood arts education courses. He has published on the use of Alternate Reality Games in arts instruction. He is currently at work on a book about using theater exercises to promote elementary writing.

Don Glass is research manager at the John F. Kennedy Center for the Performing Arts. He is an artist, learning designer, and developmental evaluator who has held positions at the Annenberg Institute for School Reform at Brown University and the National Commission on Teaching and America's Future. He was also a Universal Design for Learning (UDL) Leadership Fellow at Boston College. He teaches, presents, and publishes on inclusive curriculum design and evaluation,

and conducts evaluation work with arts educators, including the Turnaround Arts program of the President's Committee on the Arts and the Humanities.

Elizabeth F. Hallmark serves as a member of the Rochester City School District Board of Education. She holds a PhD in Education with a focus on arts, professional development, and curriculum. She teaches at Nazareth College and is currently on the Arts Learning Standards Review Committee for New York State.

Jean Hendrickson is director emeritus of Oklahoma A+ Schools® and educational consultant. Her work is documented in articles, books, and films. Oklahoma's National Distinguished Principal in 2001, Jean serves on numerous boards and consults with groups worldwide to bring more creative approaches to children in schools.

R. Scot Hockman served as the Education Associate for the Visual and Performing Arts at the South Carolina Department of Education. He has served as president of the South Carolina Art Education Association as well as the South Carolina Alliance for Arts Education. He was a writer of the 2003 South Carolina Visual Arts Curriculum Standards and Curriculum Guide. In 2003, Scot was recognized as the National Arts Education Association Middle Level Art Educator of the Year. He has received the Teacher of the Year Award from the South Carolina Association of Supervision and Curriculum Development and the Outstanding Professional Accomplishment Award from the South Carolina Consortium for Gifted Education.

Joyce Huser is fine arts consultant for Kansas Department of Education, where she provides guidance for arts education; general education group leadership in curricular standards; and design, instruction, and program planning. She is a National Board–certified teacher in Early/Middle Childhood Art; a high school, middle school, and elementary art teacher; the director of the Cultural Arts Program; and an adjunct instructor for the University of Kansas and Washburn University. She has served various roles in professional associations such as SEADAE, NAEA, NASDAE, NAfME, KCA, KMEA, KAEA, KSAAE, and Kansas Thespians. She is a writer of National Course Code Descriptors, 21st Century Arts Skills Map, and National Core Arts Standards.

Julia Marshall is a professor of Art Education at San Francisco State University and the design and development consultant to the Integrated Learning Specialist Program of the Alameda County Office of Education. Her interests and scholarship lie in creativity and learning, integrated learning through art-centered inquiry, and the uses of contemporary art in the classroom. She has written widely on these topics for *Studies in Art Education, Art Education Journal,* and the *International Journal of Art Education,* as well as for various art education anthologies. She is coauthor with David M. Donahue of *Art-Centered Learning Across the Curriculum: Integrating Contemporary Art in Secondary School Classrooms,* published by Teachers College Press.

Una McAlinden is a catalyst for consensus-based, action-oriented visioning and planning. Una served for 10 years as executive director of ArtsEd Washington, a statewide not-for-profit. Taking a systems approach, she developed programs that

supported school leaders and engaged the community with local education systems. Having created a nationally recognized principals' leadership program, she is regularly called on to present about systems change and community engagement at both the state and national level. A former attorney, Una brings innate abilities to guide groups through focused conversations, trusting their collective wisdom in solving the challenges they face with creative, feasible, and sustainable strategies.

Susan McGreevy-Nichols is the executive director of the National Dance Education Organization, a nonprofit organization dedicated to the advancement and promotion of high-quality education in the art of dance. She is the developer of a cutting-edge reading comprehension strategy that uses text as inspiration for original choreography created by children and is co-author of five books: *Building Dances* (1995, 2005), *Building More Dances* (2001), *Experiencing Dance* (2004, 2014), *Dance About Anything* (2006), and *Dance Forms and Styles* (2010).

Martha Barry McKenna is university professor at Lesley University teaching courses in the arts, creativity, and aesthetic education. She also directs the Creativity Commons to support faculty and doctoral students in engaging in creative exploration of innovation in teaching and learning. As an extension of this work, she oversees the Cambridge Creativity Commons, designed to engage students and teachers in the Cambridge public schools in exploring creative ideas and solutions to critical issues in society. She is Fulbright Specialist Scholar and serves on the Advisory Board of the Arts Education Partnership and chairs AEP's Higher Education Task Force. Dr. McKenna holds a doctorate in Music, the Arts, and Humanities from Columbia University.

Mary Ann Mears founded Arts Education in Maryland Schools (AEMS) Alliance, serves on the Maryland State Department of Education's Fine Arts Education Advisory Panel, co-chaired the Governor's P-20 Leadership Council's Task Force on Arts Education in Maryland Schools, and is a trustee of Maryland Citizens for the Arts. Her commissioned sculpture is sited in Florida, North Carolina, Michigan, Illinois, Connecticut, New York, Washington, DC, and Virginia. Maryland sites include Bethesda, Rockville, Cheverly, Belair, Glen Burnie, Silver Spring, Columbia, and Baltimore. She is the recipient of an honorary doctorate in the Fine Arts from the University of Maryland, Baltimore County (UMBC).

Kathy O'Dell is associate professor of Visual Arts at the University of Maryland, Baltimore County (UMBC), where her scholarly focus is modern and contemporary art. Author of *Contract with the Skin: Masochism, Performance Art, and the 1970s*, she is currently completing a coauthored text with Kristine Stiles titled *World Art Since 1933*. Dr. O'Dell is also UMBC's special assistant to the dean for Education & Arts Partnerships, chair of AEMS's Higher Education in the Arts Task Force (HEAT Force), and a member of the Maryland Commission on Public Art and the Board of the Greater Baltimore Cultural Alliance (GBCA).

Pamela Paulson is senior director of policy for the Perpich Center for Arts Education, a Minnesota state agency; is responsible for advocacy at the legislature; has connections with state and national organizations; is part of the administration of the statewide Perpich Library; and is a supervisor of the Arts Integration Project, the

Turnaround Arts MN initiative, and the MN State Policy Pilot Project. She is one of the founding directors of the Perpich Center. Paulson is a trustee of the College Board, a Minnesota representative for the State Education Agency Directors of Arts Education, is on the Governance Committee for the National Coalition for Core Arts Standards, is on the Arts Education Partnership Advisory Committee, and is a past president of the National Dance Education Organization.

Susan J. Rotkovitz holds degrees from the University of Maryland–College Park and Baltimore Hebrew College, and earned a second BA and MFA in Theatre from Towson University. At Towson she teaches Script Analysis and Acting, oversees the Towson Theatre Infusion (a high school outreach program), and is director of the Arts Integration Institute. A professional actor/director/dramaturg with stage, screen, and commercial credits, Susan presents nationally and serves on Arts-in-Education panels and task forces for the Maryland State Department of Education and AEMS (Arts Education in Maryland Schools) Alliance.

Lori Snyder is the executive director of the Arts Education in Maryland Schools Alliance. Prior to this position she led the implementation of the USDE AEMDD grant that transformed Anne Arundel County's Wiley H. Bates Middle School, which is recognized by the College Board, the Arts Schools Network, and the George Lucas Educational Foundation for its excellence in teaching all children in and through the arts. With statewide arts partners, she developed and implemented AACPS's first Performing & Visual Arts Magnet Programs. Lori was the recipient of the NAEA 2011 Maryland Art Educator and the AACO Arts Council 2014 Arts Educator Annie Awards.

Terry Sweeting is a professor in the Department of Kinesiology at California State University–Northridge, teaching courses in elementary physical education and children's dance. Terry's scholarship focuses on developing programs to combat childhood obesity through physical and nutrition education in low-income schools, and teacher education in children's folk and creative dance. Her publications include book chapters and journal articles in *JOPERD* and *JTPE*. She served for three years as the publications unit director for the National Dance Association. She collaborates with teachers and administrators in Singapore at PESTA (the Physical Education and Sports Teacher Academy), serving as a consultant in elementary physical education and children's dance.

Peg Winkelman is professor and chair in the Department of Educational Leadership at California State University–East Bay. Educational leadership for social justice is the focus of her work and her research. Her experience as a teacher, principal, and district coordinator of curriculum and staff development supports her pursuit of partnerships with school districts and counselor, teacher, and administrator preparation programs. As past president of the California Association of Professors of Educational Administration, she advocates for professional standards to promote access and opportunity for students. With Dr. Rolla Lewis, she is currently coediting a book on lifescaping practices in school communities.

Index